The Photographed Cat

We gratefully acknowledge the generous contributions received to support publication of *The Photographed Cat: Picturing Human–Feline Ties, 1890–1940.*

ALICE RANDEL PFEIFFER

Gifts in honor of
SANDRA L. CARRIER
LILLIAN AND SOPHIA BRANG

MICHAEL AND JULIE SHARKEY

The Photographed CAT

Picturing Human–Feline Ties, 1890–1940

Arnold Arluke and Lauren Rolfe

Syracuse University

∞ The paper used in this publication meets the minimum requirements
of the American National Standard for Information Sciences—Permanence
of Paper for Printed Library Materials, ANSI Z39.48-1992.

For a listing of books published and distributed by Syracuse University Press,
visit our website at SyracuseUniversityPress.syr.edu.

ISBN: 978-0-8156-1026-7 (cloth) 978-0-8156-5246-5 (e-book)

Library of Congress Cataloging-in-Publication Data
Arluke, Arnold.
The photographed cat : picturing human-feline ties, 1890–1940 /
Arnold Arluke and Lauren Rolfe. — First edition.
pages cm
Includes bibliographical references and index.
ISBN 978-0-8156-1026-7 (paperback : alkaline paper) 1. Cats—Pictorial works.
2. Cats—History. 3. Cat owners—History. 4. Human–animal relationships—History.
5. Photography of animals—History. I. Rolfe, Lauren. II. Title.
SF446.A75 2013
636.8—dc23 2013024766

Manufactured in the United States of America

For Delilah and Ginger

ARNOLD ARLUKE (PhD, sociology, New York University) is professor of sociology and anthropology at Northeastern University. He has published more than one hundred articles and eleven books, many of which examine contradictions in human–animal relationships, including *Beauty and the Beast* (2010, with Robert Bogdan), *Inside Animal Hoarding* (2009, with Celeste Killeen), *Between the Species* (2008, with Clinton Sanders), *Brute Force* (2007), *The Sacrifice* (2006, with Lynda Birke and Mike Michael), *Just a Dog* (2006), and *Regarding Animals* (1996, with Clinton Sanders). His research has received awards from the American Sociological Association, the Society for the Study of Symbolic Interaction, the International Association for Human–Animal Interaction Organizations, and the Massachusetts Society for the Prevention of Cruelty to Animals. With Clinton Sanders, he also edits the Animals, Culture, and Society series for Temple University Press.

LAUREN ROLFE (BA, political theory, Vassar College) is an avid collector of early-twentieth-century animal photographs. Over the past decade, she has amassed a private archive of more than a thousand real photo postcards, cabinet cards, stereoviews, and individual snapshots that depict human–animal relationships of all kinds. Although her collection is diverse, its principal focus is cats.

Contents

Illustrations

Foreword

John Grady

The original narrative of progress casts people—armed with science and technology—as warrior kings subduing nature. Confidence in this tale, however, has eroded since the mid–twentieth century. Today, people no longer admire large corporate organizations for their machinelike efficiency but instead view them warily as entities that could genuinely nurture intellectual creativity and teamwork but often do not. The successes of the civil rights movement legitimated demands for inclusion by those relegated to the bottom levels of any social hierarchy, while the women's movement challenged patriarchal ideals and entitlements that celebrate male aggression as a social value and that, among other ills, make despoiling nature seem, well, a natural thing to do. Finally, a renewed environmentalism has nurtured an ecological awareness that places humanity within, and not above, nature as one link in a horizontal chain of being that spreads throughout the biosphere. Granted, human beings inevitably will place themselves at center stage in anything that concerns their interests, but today this new and emerging consciousness reminds them that they need to imagine—and conduct—their transactions with the "rest" of nature not just as stewards but also as partners.

Animals have been more recently drawn into the conversation we are having about what it means to be human and where we fit in with the rest of nature. Animals were first considered as resources worthy of being conserved for various human pleasures, but over time more and more initiatives have focused on delineating—and protecting—their claims to existence. Thus, a vibrant animal rights movement has emerged that includes commitments to making zoos more comfortable for their inhabitants, eating vegetarian, protecting endangered species, and espousing numerous other causes. The sociologist Norbert Elias (1998) has warned that our awareness of how we manage our affairs and arrangements with other people has often been distorted by facile dualisms that identify conflicts between, say, the individual and society, as though it could even be possible to understand anything about a human society without discussing particular people and their affairs or acknowledging that every single person is a thoroughly socialized being.[1] Much the same criticism can be leveled at the distinction we so easily make between animals and society. Apart from the fact that other animals also live with tangled social arrangements, our lives—and the institutions we have developed to sustain our existence—are intellectually and materially inseparable from the doings of other animals. Human history and values have emerged from our relationships with them, whether they are sources of food, beasts of burden, pests and vermin, or carriers of disease.

1. The best introduction to Elias's work is Mennell 1999.

And then there are pets! There is a long history to the custom of keeping various types of animals as ornaments or companions, but it was only in the mid- to late nineteenth century that a fashion among the few became a mass phenomenon, mixing up our relationships with other animals in new and far more intimate ways. We feed pets and keep them in the house, but just what do they do for us in return? And why was it at that particular point in history that so many of us found an intimacy with birds, dogs and cats to be rewarding? This is the question that Arnold Arluke, a distinguished scholar of human–animal relationships, and Lauren Rolfe, a collector of early-twentieth-century animal photographs, have posed for us in *The Photographed Cat*. Their focus is on the house cat, a species that fascinates us because cats seem to have maintained their connection to the wild while adapting with relative ease to their human caretakers' ways of life. In great detail, Arluke and Rolfe document that our relationships with these animals are multifaceted and socially and psychologically nuanced. The authors are meticulous and thorough scholars who make a careful and convincing case that our treatment of cats is an important development in that long transformation of manners and sensibilities that Elias has called the "civilizing process."

Put simply, Elias (1998) reasons that over the last five centuries or so the expansion of Western society into ever larger social units put pressure on monarchs to disarm a feudal nobility that was, in essence, little more than territorially based groups of armed thugs who ran their domains as protection rackets, which then allowed them to expropriate as much wealth as possible from the peasants under their control. By creating a monopoly over the instruments of military force and wealth, the monarchs disarmed the feudal nobility and absorbed them into their courts. Thus reinvented as courtiers, they were compelled to channel their aggression into increasingly elaborate and choreographed displays of manners to flatter and influence the king and his ministers. The most important long-term psychological effect of this process of social and political change was that members of an emotionally unbridled warrior caste learned to rein in their appetites and desires and to devote themselves to cultivating the art of what we today would call "impression management" and "impulse control."

The next stage of the civilization process occurred when human settlements—and the resources that flowed into them—became larger, denser, and more complexly intertwined; cities were transformed into huge agglomerations that for the first time housed those who ruled society and garnered the lion's share of its wealth in close propinquity to those who actually produced this largesse through their labor. This latter group was a heterogeneous lot that included industrial workers and the businessmen and shopkeepers of the middle class. The interactions between rulers and producers were conflict-ridden and engendered a moral crisis of social expectations. How, then, should people live and interact in what was increasingly becoming a community of strangers, which pushed them together with people they were expected to distance themselves from but now were unable to avoid? These new classes of urban dwellers initially addressed the problem by mimicking the code of conduct that the nobility had developed when the royal court pacified them. During the nineteenth century, however, the middle class embrace of this code took on an enthusiastic and religiously informed moral earnestness, which encouraged elaborate practices of self-control and, by extension, a self-righteous commitment to control those other groups that the middle class experienced as disorderly.

Needless to say, because these "others" resented the middle class's attempt to control them, and because their resistance to such attempts made the struggle for control a generally unpleasant experience, it took several generations, from the late nineteenth to the early twentieth centuries, for the middle class to be able to balance self-restraint and sensitivity to others with the experience, open expression, and management of feeling and emotion.

Elias refers to this maturation of the "civilizing process" as "informalization" and describes it as a general relaxation of rigid moral standards (Elias 1998). These relaxed values included respect for marriage as a form of friendship, increasingly open sensuality and sexuality, the rearing of children through tenderness, and the development of strong bonds of friendship with people who are not related to you. Informalization as a cultural configuration had become deeply rooted by the mid–twentieth century, especially in the immediate aftermath of World War II.

While the civilizing process can be seen as an adaptation to social and economic opportunities, the informalization phase set in motion a cultural imperative of its own—a sort of polymorphously perverse desublimation[2]—where the self yearns for diversity, the transgression of established boundaries, and the embrace of new experience. Nevertheless, the generations that have come of age in the aftermath of the 1960s have learned that the many pleasures and opportunities that an openness to embrace the world makes available still require manners and a moral code that conjoins a respect for the rights of others and a responsibility for personal conduct even while exploring new possibilities of being human. And this code—for all its flexibility—may become just as demanding as that which regulated the Victorians over a century ago. Moreover, *The Photographed Cat* strongly suggests that a loving concern with the rights of animals should be seen as an important component in this emerging code.

The Photographed Cat clearly illuminates how one dimension of the informalization process took form. The book focuses on the period from 1890 to 1940, yet it delineates how this period emerged from what preceded it and subsequently established the basis for current arrangements and sensibilities. As Arluke and Rolfe report, dogs and cats initially performed useful functions for their masters. They could either warn or mouse and were granted the freedom to patrol the immediate environs of the home. Dogs and cats were gradually invited to move into the physical confines of the house as privileged servants. In time, they were reimagined in a unique way: as beloved kin and boon companions. Dogs are eager for human attention, but cats have a different temperament and, as popular lore has it, often seem to accept humans only on their own terms. Accordingly, building a relationship with a cat is harder to do than with a dog and requires that the cat's "master" actively pursues and nurtures a new type of relationship. Whatever this relationship may be—friend or companion—in the end, being a "master" is no longer quite apposite.

One of the most distinctive aspects of *The Photographed Cat* is its use of visual materials to explore how a new moral order and sensibility were formed. Photographs can show us how a photographer decides that a scene or situation should be depicted and what we should value in the various elements in the frame and in the relationships established between them. There are individual vision and taste in all of this, of course, but even more salient are cultural conventions. Reflecting customary values in this fashion is especially true of vernacular photography, where the photographer is very much aware of what a community likes and desires. Many of the photographs of cats in this book are by commercial photographers who made their living pleasing their customers and who often shared their communities' values. Arluke and Rolfe use more than a hundred portraits of cats produced during the early part of the last century to show how people first imagined them as aesthetic objects—not unlike still lives of inanimate objects—to seeing them as prized companions with distinct personalities. The authors are

2. I have blended the concepts of "polymorphous perversity" (Brown 1985) and "repressive desublimation" (Marcuse 1964), which were put forward separately by two influential social theorists of the late 1960s. Each of the texts, within which these ideas appeared, sought to define—whether to legitimate or to caution—this cultural imperative especially as it was embraced and performed by younger Americans.

interested in what the photographs reveal about the pet "owners" as they reevaluate the human-animal relationship. Thus, we see that the people in these photographs are actively letting go of something—the keeping of another species at a distance—and gaining something in return, a way of expressing a sensual love of nature embodied in a particular relationship with a specific animal that is clearly an "other." In explaining such a possibility, E. O. Wilson (1984) has suggested that human beings have an innate love of nature or "biophilia." Elias would argue that should this be so, it would have to have been cultivated. It is Arluke and Rolfe's contribution to show us just how this process of cultivation emerged during the first decades of the past century.

Apart from their obvious intellectual and analytic skills, the authors have been greatly aided by the existence of an enormous repository of photographic data that is largely unknown to the public and community of social and cultural researchers. It is only in recent years that this treasure trove of arrested experience has been recognized for what it is: an exhaustive documentation of how we as a people saw ourselves when we were becoming modern.

The vast majority of the photographs in this book are composed of "real photo postcards," a widespread craze that was at its height from about 1907 to 1912 but nevertheless lasted in attenuated form well into the 1940s. In a nutshell, thousands of commercial and amateur photographers took photographs of an amazingly diverse array of communities and people, which they printed directly onto postcards and sold by the millions. These cards often were commissioned to keep in touch with loved ones and friends in a society where few, if any, people had telephones. In addition, many merchants had portraits made of their establishments and wares, which they used for promotional purposes. Finally, local photographers took photographs of just about anything in their town and nearby communities, which they thought they could sell on their own or through local establishments, such as pharmacies and general stores. In any event, these photographs were generally of extremely high quality and were mailed with postmarks, names and addresses, signatures, and accompanying messages, all of which provide a rich context for interpreting the images.

The Photographed Cat mines innumerable archives and private collections to tell its story. It builds on a rich body of work that includes Robert Bogdan and Todd Weseloh's *Real Photo Postcard Guide* (2006), Bogdan's *Picturing Disability* (2012), and the precursor to the present book, Arluke and Bogdan's *Beauty and the Beast: Human–Animal Relations as Revealed in Real Photo Postcards: 1905–1935* (2010). Each of these books provides penetrating insights into social and cultural history and models the use of photographs as evidence in historical and sociological research. Furthermore, Arluke and Rolfe explore new territory by drawing on sociological and psychological investigations of gesture, body language, movement, and the ways in which relationships are presented for public display in everyday life. Relying on a close reading of Erving Goffman and visual sociologists such as Howard Becker, Dick Chalfen, Doug Harper, Eric Margolis, and Jon Prosser, *The Photographed Cat* is one of the most carefully executed, sustained, and insightful uses of visual data for social and cultural inquiry produced in the past quarter-century. Along with Arluke and Bogdan's *Beauty and the Beast*, it joins Gregory Bateson and Margaret Mead's *Balinese Character* (1942) and Erving Goffman's *Gender Advertisements* (1976) as a contemporary masterpiece of visual analysis. Arluke and Rolfe also enrich and expand upon Norbert Elias's powerful insights concerning a dimension of human existence that he treated only in passing.

The view of the world that the images in this book embody—as the authors are quick to remind us—is an "official story" of individuals, families, establishments, and communities. Nevertheless, it is important to note that what people believe, or want to believe, about themselves is as much

an aspect of their lives as what they may actually do. The authors remind us that photographs of people smiling and cuddling cats are not saying that there were not moments when they, or people in their communities, were neglectful of, or even cruel toward, the same or other animals. But what is depicted in the images they consider is usually quite different from what came before the period covered and appears to be consistent with important changes in attitudes and behaviors toward cats in that period, suggested by other documentary sources. Moreover, as time passes, even this new way of photographing cats continues to evolve in the same direction of increased openness and emotional warmth. People smile more, cuddle more, play more, and—together with their families, friends, and, yes, cats—create new worlds of human possibility.

April 2013

Preface

We wrote *The Photographed Cat* for many audiences. Pet lovers and others interested in domestic animals, especially those having cats themselves can enjoy seeing how photographs depicted human relationships with cats a century ago. Our book is quite different from the scores of photography books about cats, whether they are presented as funny or fat, in Greece, "in love," or simply "crazy," because only a few such books include photographs of people interacting with cats, and their focus is contemporary rather than historical. Noteworthy examples include Louise Taylor and Barbara Cohen's *Cats and Their Women* (1992), Jean Claude Saure's *The Big Book of Cats* (2004), Jules Farber's *Classic Cats* (2005), and Bill Hayward's *Cat People* (1978). The few books that do look at early-twentieth-century cat photography such as *Postcard Cats* by Libby Hall and Tom Phillips (2005) and *The Cat in Photography* by Sally Eauclaire (1996) are "coffee table" books that present photographs "cold," without analysis or context to understand their meaning and use. These cat photography books, whether modern or historic, are just showcases for these images. Of course, if readers are interested only in looking at photographs, our book has approximately 130 striking images that can be enjoyed on their own.

We also wrote this book to be more than a collection of rare and engaging photographs of cats and the people in their lives. For readers who have a deeper interest in cat keeping, human–animal relationships, and the history of photography, we wanted to explore the meaning and symbolism behind these images because they capture the emergence of the modern human–pet relationship—or at least the relationship that people developed with cats. Although humans have always kept pets, pet keeping's modern iteration evolved and took hold around the same time that photography became available for the masses in America, beginning at the turn of the twentieth century. Novelists, journalists, and biographers of this period articulated the voice of pet owners and started to crystallize the contemporary idea of what it means to interact with these animals and why they are important to so many people. Rapidly growing pet food and supply businesses further articulated the meaning of human–pet relationships in a multi-billion-dollar industry. Photographs, by far, most transparently exposed the thoughts and feelings of those people who had cats in their lives, literally enabling them to put on display how they regarded their animal friends. What do these images say about our connections to cats a century ago as the modern sentiment toward pets was rapidly emerging and gaining a foothold in America? And how did photographers and their human subjects collaborate to depict these connections? These are questions we put to our photographs.

However, our book is not a social or pictorial history of the entire range of human–feline relationships that existed in early-twentieth-century America. There is a "dark side" to humans' treatment of cats that was not photographed, including but not limited to their abuse, torture, abandonment, and neglect. Our book does not discuss this

unseemly part of human–cat history, let alone feature pictures of cats being exploited or harmed. It instead includes pictures and text that demonstrate the loving and affectionate side of human–animal relationships. These photographs enabled us to analyze how people depicted close ties with cats and to ask whether these depictions mirrored reality.

We are particularly indebted to those who permitted us to use photographs from their extensive collections. Special thanks to Robert Bogdan, Brian Buckberry, Jan Holmquist at the Massachusetts Society for the Protection of Animals, Nannette Maciejunes, Catherine Mastrovito, Bruce Nelson, Nancy Perin, and Connie and Todd Weseloh for sharing their cat images. Others helped by reading drafts of our book and suggesting ways to see more in our photographs than first meets the eye. For making these thoughtful comments, we thank Janet Francendese, Glenn Gritzer, John Grady, and the anonymous reviewers of our first draft. Others provided encouragement to pursue this project in its early stages and support to complete it once it was under way, including Hal Herzog, Alan Klein, Jack Levin, Patricia Morris, Michelle Papazian, Gary Patronek, Uta Poiger, Clint Sanders, Steven Vallas, and the College of Social Sciences and Humanities at Northeastern University. We also owe special thanks to Robert Bogdan for allowing us to draw from passages in *Beauty and the Beast* that relate to the history of photo postcards and to John Critchley and Gary Patronek for their photo-editing expertise. Finally, we thank everyone at Syracuse University Press for their enthusiasm and thoughtfulness at every stage of the publishing process, from submission to copyediting. Our gratitude goes in particular to Deanna McKay, who spirited our manuscript through the review and editorial stages of production; Fred Wellner, who brought out the best in our photographs; and talented freelancer Annie Barva, who edited our writing with great diligence and skill.

Abbreviations

R. Bogdan coll.	Robert Bogdan collection, Orwell, Vermont
B. Buckberry coll.	Brian Buckberry collection, Knoxville, Tennessee
N. Maciejunes coll.	Nannette Maciejunes collection, Granville, Ohio
C. Mastrovito coll.	Cathy Mastrovito collection, Clinton, Massachusetts
MSPCA Archives	Massachusetts Society for the Prevention of Cruelty to Animals (MSPCA) Archives, Boston
B. Nelson coll.	Bruce Nelson collection, Portland, Maine
N. Perin coll.	Nancy Perin collection, Lake Linden, Missouri
T. Weseloh coll.	Todd Weseloh collection, Syracuse, New York

The Photographed Cat

1

Picturing Friends

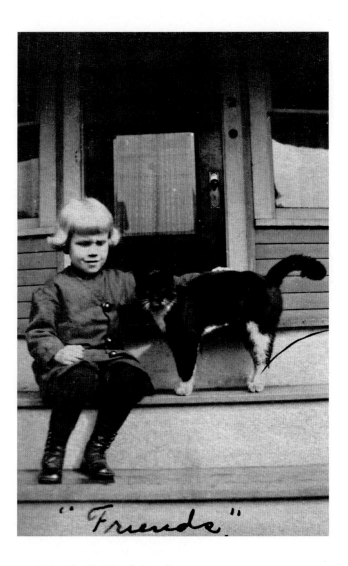

1.1 Friends. T. Weseloh coll.

their favorite pets[1] or trophy-winning cows (Grier 2006). The development of the camera changed all of this. Average people could suddenly afford to have photographers make animal portraits at much less cost and in far less time than oil paintings. Daguerreotypes and "cabinet cards" gave way to photo postcards and snapshots by the early 1900s as photography came to the masses with the introduction of the Kodak Brownie camera. People took photographs, both formal and casual, of everything they experienced and valued, including but not limited to their homes, their cars, their children, and, of course, their animals (Arluke and Bogdan 2010).

A century ago many Americans had everyday contact with many different animals. Horses took them to work, backyard chickens provided eggs for breakfast, and deer made for hunting trophies and meat. People photographed these and other animals as personal memories to keep in leather-bound albums or to send as postcards to friends and family far away. Pets of all kinds were often the camera's subjects; they were important enough for people of all backgrounds to photograph (Arluke and Bogdan 2010). It is not hard to find old photographs of dogs because they were by far the most popular pets, along with birds, but old photographs of

Until the 1880s, people had only one option for making treasured memories of their animals. Those who could afford it had studio artists paint

1. We respect the growing sensitivity in language to refer to "animals" as "nonhuman animals" and to "pets" as "companion animals," but we have chosen to use the briefer referents for ease of reading and because the conventional terms are in keeping with the period analyzed in this book.

pet horses, deer, goats, and baby coyotes are also available.

Cat photographs are another story. They are by comparison rare, except on commercially mass-produced postcards, even though as many as twenty-five million Americans had pet cats in the early 1900s (*New York Times* 1917). What is surprising about these photographs is that they were made at all, given how cats had been viewed and treated over time. For centuries before the introduction of photography, cats were much maligned in Europe and America as witches' familiars, disease carriers, pests, or simply convenient targets for animal abuse (Darnton 1984; Serpell 1988). There is some anecdotal evidence that fewer people even by the mid–twentieth century regarded cats in quite the same way we do now. For example, the veterinarian and anthropologist Elizabeth Lawrence (2003) notes that, unlike dogs, cats as late as the 1950s were so devalued as pets in America that they were rarely taken to veterinarians for care when sick or injured and were left to recover by themselves or die; the few cats that received veterinary attention were operated on surgically without anesthesia.

Unlike the sedentary dog curled up on a living room chair or a caged bird, cats were usually not so readily available to photograph. Although people kept cats as pets, cats were less likely to be allowed inside homes or to stay there indefinitely, instead being relegated to an outdoor life perhaps as "barn" cats or "mousers" to control rodent populations, where their freedom and independence made it more difficult for owners to find and train their cameras on them. It is easy to assume that people with cats did not bestow great affection on these animals or treat them as individual members of the family.

Cats that could be tracked down to photograph were more difficult to shoot than the family dog or favorite horse, goat, or cow because they were much smaller and often refused to remain still enough for the photographer to get a clear and well-composed shot. A photographer can command a dog to sit for its picture and cajole the animal to focus its gaze on the camera lens, but few cats so readily respond. As a consequence, there are more technically bad photographs of cats from this period than of any other pet images, even when compared to pictures of wild animals.

The magazine *Photo Era*, commenting on cats' "restlessness" and the need for patience and perseverance to produce good pictures, said of them, "[N]o living thing is so changeable, so difficult to portray, so unmanageable to pose and so variable in expression as a cat, and the successful cat photographers of the world, like the successful cat painters, may be counted on the fingers" (1898, 22). Charles Bullard, America's most famous cat photographer of this period, similarly lamented how hard it was to take these pictures. Recalling his first attempts in 1897 to photograph cats, he said: "I borrowed all the cats in my neighborhood. But I soon found that it was no easy job to photograph a cat. He is very unreasonable as to staying where he is put, and the only system is to use infinite patience. I have worked half a day trying to photograph a cat in a particular pose, and then had to give up in despair" (Ranck 1915, 57).

Not all agreed with this sentiment. Writing in a popular photography magazine in 1908, the British photographer Carine Cadby reassured readers that cats could be cooperative subjects, even though many people regarded them as "strangely independent, wild and undisciplined." Cadby advised that "they can learn to stay where they are put, which is half the battle when it comes to photography," by rewarding them with treats. Then cats can become an "easy model" and "wonderfully accommodating" (1908, 310).

Despite the challenges of photographing cats, after a decade of collecting these pictures we found hundreds of exceptional images from this period. Although we concentrated mainly on vernacular cat photography from America, we came across many exceptional commercial cat photos from Europe, where photographs of cats were a "craze" at the beginning of the twentieth century. Cadby claimed that the most popular subject for animal

photography on the continent was without question the cat: "Prints of cats greet us in Paris, and cat picture postcards stare at us from German shop windows. Knowing as we do that neither of these nations is, in the very least, devoted to cats, we conclude the pictures of them must be a craze, whereas in England they represent the sentiments of a big majority" (1908, 308).

Why did people photograph these cats, let alone make dedicated portraits of some, when they were "just" animals in the minds of many? What did these images mean to the people who took them and to others who viewed them? What did they say more generally about human relationships with cats and the significance of pets to people a century ago?

The Modern Pet

Trying to answer these questions is no idle or obscure academic pursuit. There is ample evidence of the ever-growing importance of cats and of pets more generally in modern life. Since the Industrial Revolution of the late 1800s, demand for pets grew significantly in America as the country became more urban, family size declined, and the middle class expanded—an expansion that brought with it more expendable financial and emotional capital to spend on pets as both luxuries and necessities (Grier 2006). Although there are no reliable animal population figures because it was not until the late 1990s that dogs were added to the census form, we do know that many more people today have pets. Since World War II, the number of American households with cats and dogs has escalated from about 40 to 63 percent. Surveys estimate that about thirty-eight million American households own ninety-four million cats (APPA 2009–2010).

With the growing interest in pet keeping, ideas have changed about how owners—or, as some call them, "guardians"—should interact with their pets or "companion animals." Over the past century, people showed an increased willingness to anthropomorphize their pets, viewing and treating them

like humans. It is no longer the exception but the rule to treat these animals as "members of the family" and in many cases to regard them as infants, children, siblings, or partners (Harris Interactive 2012). We allow pets to sleep with us on our beds at night, although not long ago these animals were not allowed inside homes; we carry photographs of them in our wallets or cell phones; we create legal trusts for them to provide for their care; we take them to pet day care and puppy "kindergarten" classes; and we pay for state-of-the-art veterinary care to manage or cure sophisticated, chronic, or life-threatening illnesses. We dress them in human clothing; we fret over their "sadness" when we leave them alone at home; we give them human names and call them our babies and refer to ourselves as their mommies and daddies; and we even buy them birthday and Christmas presents (Harris Interactive 2007).

Many pet owners also confide in their animals—now part of the family circle—about personal troubles and turn to them for consoling during hard times (Melson 2005), feeling so close to them they would give a scarce drug to their pets in preference to a person outside the family (Cohen 2002). A person's attachment to a companion animal can even be closer than his or her relationship with a human companion (Carmack 1985); and some people experience more security in relationships with their pets than with their romantic partners (Beck and Medresh 2008).

The roots of this modern view of pets as having a privileged status in the home might be detected, if we look carefully enough, in the photographs people took of them just when this new attitude was starting to take hold a century ago. Although we like to think that our modern sentiments—in general, not just those toward animals—are distinctly more advanced than those expressed by former generations, looking closely at photographs and what they suggest about human–animal relationships might reveal a different story, perhaps one showing more similarities than differences. We may see more of our feelings for animals in

photographs taken a very long time ago than we might first guess. The clothing, hair styles, and home furnishings will look quite dated, but the feelings for animals reflected in the photographs may seem strikingly familiar and were apparently present long before our contemporary willingness to elevate the status of pets to near human levels, accord them rights, and treat them almost as fetishes (Fernandez and Lastovicka 2011; Wallendorf, Belk, and Heisley 1988).

HISTORICAL ETHNOGRAPHY

The goal of ethnography is to capture a group's perspective—specifically, what the group takes for granted, the behaviors it expects of others, and the meanings it attributes to events, objects, and situations. When we think of ethnographies, we usually picture a field researcher immersed in a group's way of life to experience and observe it firsthand. But we may also want to understand culture after the fact when it is no longer immediately accessible to the ethnographer as a present and ongoing group into which he or she can be placed to function as a marginal native.

Photographs taken years ago provide a retrospective window into former cultures because they represent past ways of life and positioned points of view (Margolis 1988; Marshall 1994), just as do written or oral histories of a group. Those trying to mine these photographs for cultural meaning look at them differently than did the people who first made and shared them. Some of this difference has to do with when these photographs were made. The images in this book were shot only a few decades after the invention of photography. Photographers of this era were influenced by nineteenth-century realist schools of art and used their cameras to document natural landscapes and individuals. The resulting photographs were regarded as snippets of reality, typical or factual moments that directly reflected what the camera captured.

The nature of picture taking itself also makes determining the meaning of historical photographs very different now compared to a century ago. Photographers, subjects, and viewers found immediate meaning in the photographs taken at the time and considered them newsworthy. They understood the details and significance of the images, who was in them, and what the images said about those subjects. Years later these same images may have no such connotations for us. We may not be able to decipher exactly what historical photographs meant to those who made and shared them decades ago, unless some supporting text accompanying the images hints at how people used and understood them. And even then we will likely get only a partial understanding of what the picture takers and subjects thought and felt at the time.

Yet historical photographs can nevertheless be used in a much wider context to get a glimpse of everyday social life in former periods, to capture past societal norms and values, to compare these norms and values to present-day expectations, and to examine the way the devices of photographic representation were used to indicate certain meaning and sentiment (Becker 1995; Peters and Mergen 1977; Wexler 1997). Extracting such values from historical photographs requires a nonliteralist approach to their content.

Thus, rather than viewing these photographs as literal documents of reality, we approach them as a form of interpretation much like spoken language. To understand the intent behind and meaning of conversation, we have to examine more than just the words themselves, but also the participants' perspective as to why and how they speak a certain way and what listeners take away from the talk. The meaning of photographs is similarly ambiguous because it comes "from the way the people involved with them understand them, use them, and thereby attribute meaning to them. They are social constructions, pure and simple" (Becker 1995, 5). As social constructions, historical photographs are "indexical" archives whose meaning and use can be analyzed by situating the images in a prior time and social scene (Morton and Edwards 2009; Scherer 1990). Taking this approach allows us to

ask what "reality" the photographer and his subjects tried to capture by making a particular image and how viewers of that photograph understood its meaning.

Our review of hundreds of early-twentieth-century cat photographs clearly indicates that the reality put on film differed from the everyday treatment of cats at this time. Although cats have always been regarded with great ambivalence (Lawrence 2003), photographs did not capture this inconsistency as they did with other human–animal relations. People took photographs of wolf hunts, dog fights, pig slaughter, and cattle branding, but they did not picture everyday acts of abuse toward cats or more serious torture of these animals that took place then as it does now (Arluke and Bogdan 2010). Instead, early-twentieth-century cat photographs capture only "positive" attitudes toward cats, so to speak. If anything comes through about attitudes toward cats in these photographs, it is that the humans depicted with them show an adoration and enjoyment of these animals that are quite familiar to contemporary cat owners or aficionados.

Showing this affection for cats was probably more orchestrated than accidental. Photographers and their human and animal subjects collaborated to carefully construct this complex visual expression. Although some candid "snapshots" were made of cats, most of the photographs we found were apparently planned to depict these animals in a particular way. Owners posed cats to show off their personalities, preferences, and abilities or posed with them to show how they felt about their pets. That these images are mostly posed does not lessen their value as windows into early-twentieth-century attitudes toward pet cats. Photographs reflect prevailing norms and attitudes, and the work of photographers and their subjects is to interpret culture and communicate their view and experience of life for others to see. In other words, the images are how photographers and their subjects want themselves, their animals, and their relationships with these animals to be seen by others—a

practice that sociologist Erving Goffman (1959) called "presentations of self."[2]

According to Goffman's dramaturgical approach to everyday interaction, social encounters are stagelike performances where people carefully create certain impressions of themselves for audiences to see and understand in an intended way. Some of these performances, observed Goffman, are in frontstage regions where people are putting on a public show about themselves and their lives. The photographs we examine, as a type of frontstage show, convey a story to viewers about how people of the time regarded these pictured animals. These stories are what sociologists call "staged authenticity," a practice observed in the making of family and tourist photographs where people visually create places, myths, social roles, and social relationships—as much dreamed-of worlds as they are lived-in ones—to show a certain reality to friends and family members as well as to oneself (Larsen 2005). Thus, a different reality, what Goffman called the "backstage region," might have existed behind early-twentieth-century photographs of the human–cat relationship, a reality in which people allowed their masks to be temporarily lifted because they were not performing for an audience. Images of owners gently stroking their cats or smiling at them may have hidden a backstage where deeper ambivalence or even disregard for animals existed.

Constructing these deliberate images of an animal's personality or relationship with a human must have been challenging in the period studied because, as we noted earlier, the independent and mercurial nature of cats can make it difficult to produce a good photograph. This challenge must have forced owners and/or photographers to work harder to create a pose and image that would

2. Scholars have rarely used Goffman's thinking about the presentation of self to understand photographs. Two notable exceptions can be found in Aubert 2009 and Mendelson 2007.

convey certain aspects of their relationships with cats for viewers to see and appreciate. Ironically, this photographic challenge makes cat photographs all the more interesting and valuable as windows into how some people regarded pets a century ago; they are intentional visual displays of one set of cultural attitudes toward animals that existed at the time. We chose the title *The Photographed Cat: Picturing Human–Feline Ties* to capture the idea that cat photographs can depict such a relationship between humans and their animal subjects.

How this depiction was accomplished and what it says about the sentiment and ties between people and cats of the time guided our analysis of the hundreds of photographs we compiled and borrowed over the years. Of course, these images are not only about what cats meant to people; they are also about what it meant to be a man, woman, or child a century ago. Vernacular photographs, including those with and of pets, are what ordinary people say about themselves, what they do, how they think and feel, and what they aspire to in life (Chalfen 1998). As reflections and products of culture, the images can be studied as monologues that tell us about ourselves by the way we depict our connections to cats. In this regard, our book asks not only what stories these photographs tell about our ties to other animals, specifically cats, a century ago, but also what these stories say about the human condition and the possibility, in some people's minds, that other species should be included in our social and moral order.

PUTTING SOCIAL TIES IN THE PICTURE

How can a photograph of people with cats communicate the idea that its interspecies subjects are somehow connected together? And what do these suggested ties say about the sentiments that people have for their cats? The dramaturgical approach to everyday social interaction provides a powerful analytic tool for unearthing the ways photographs suggest ties between humans and by extrapolation between humans and cats. According to Goffman

(1971), people signal how they are connected to each other by displaying "tie signs" or "with markers" that are evidence of relationships between persons and other "things," whether these connections are to objects, events, ideas, or other people. Although Goffman focused on the relational indicators of dyads, such as wearing a wedding ring or sharing a glass of wine (Morris 1971, 1977), the idea that people display their ties to one another extends even to larger groups. Family members, for example, make it clear they are connected when they are in public during leisure activities (DeVault 2000) and even when they are not together, as happens when in the privacy of their own home they find old family photographs in the attic and comment on their knowledge of pictured relatives and their connections to them.

Humans create tie signs with animals, too, enabling others to identify them as a couple or unit when in public. For example, leashes, mutual gazes, nuzzling behavior, petting, and speaking between people and their pet dogs signal that they are with each other in a companion–animal relationship (Sanders 1990, 1999). Of course, tie signs mutually displayed between a person and his or her pet might be somewhat different from one person to the next, and these signs are not limited to human–dog relationships. Regardless of the pet's species, carrying off tie signs in public does not require that each party of the unit, whether human or animal, actually view him- or herself as connected to the other party. What matters is the perception of them together.

To further this image, making or carrying photographs of one's pet can itself be "proof" of such ties. Closer inspection of the details of these images can reveal what kind of connection is being displayed and how the people pictured want others—and perhaps themselves—to understand their animal relationship. Examining advertisements that feature only humans, Goffman (1976) demonstrated the value of looking at such photographs for their displays of tie signs. He showed that these photographs are a valuable source of data about

the nature and variety of human tie signs and their ability to affirm society's social arrangements. Ads using models of men and women are a type of "social fuss," according to Goffman, that reveal a great deal about social life ordinarily hidden in unformulated courses of activities and experiences regarded as trivial. Despite the ordinary quality of photographic ads, close inspection of them tells us about who we are and how we are expected to behave in the presence of others. To be clear, ads do not show how men and women actually behave; their purpose, argued Goffman, is to convince us that this is how women and men are, want to be, or should be. They are "glimpses" of roles and relations that prop up and maintain the social order by giving individuals "an opportunity to face directly a representation . . . a mock up of what he is supposed to hold dear, a presentation of the supposed ordering of his existence" (1976, 69).

Photographs depicting normative expectations can reflect and reinforce very real inequalities of status and power, whether the subjects are humans or animals. Goffman, of course, focused only on the former. By closely inspecting photographic ads of people, Goffman and those following him (Afifi and Johnson 1999) have shown the subtle ways that gender stereotyping and subordination are created by carefully posing subjects in terms of their relative size, position, expression, touch, and glance. In theory, therefore, tie signs in cat photographs should also reflect and reinforce socially unequal roles between the species that likely existed at the beginning of the twentieth century.[3] Even if pets were beloved and treasured, large status differences nevertheless separated people

and their pets. From Goffman's perspective, we expected to find visual reminders of these differences in photographs of humans with cats. But we discovered that most photographs, as seen in this book, appear to minimize the very real and often large physical and social differences between humans and cats. In fact, most of the hundreds of images we found show people diminishing rather than drawing distinctions between themselves and their cats, if not idyllically putting cats on an equal footing with humans, at least visually. Although in reality theirs was a relationship based on subordination if not domination, the tie signs in these photographs suggest otherwise.

How should we read these depictions of tender inequality or apparent equality in pictures of people with cats? They can be attributed to society's ambiguous rules for interacting with pets. Jay Ruby (1983) points out that there is greater "plasticity" in human–pet relationships than in other types of human relationships, where norms are clearer and more formalized—for example, regulating parent–child and sibling behavior. The former is an "anomic" area of behavior characterized by unclear norms—an area that certainly existed during the early 1900s. From this perspective, the failure of human–cat photographs to depict rigid status distinctions between people and cats a century ago may have had no larger significance other than that people felt freer to avoid these distinctions than they did in images only of people.

However, we believe that the portrayal of tender inequality has more meaning than this. One way to reveal this deeper meaning is to take sentimental tie signs at their face value rather than to question their sincerity. Despite role differences between the species, people can still regard their cats as friends because friendships among unequals can be built upon patronage (Pitt-Rivers 1973) or have inequality structured into them (Bridge and Baxter 1992). These images of friends can then be seen as expressions of the warmth, affection, trust, and goodwill we associate with close relationships.

3. We are not suggesting that animals, relative to humans, should be regarded as unequals. Especially a century ago, long before the modern animal rights movement emerged, most people saw significant differences between the moral status of humans and that of animals and exercised substantial dominion over animals, paralleling how women and African Americans have historically been treated (but see note 6 on this comparison).

Some support for reading genuine sentiment in depictions of tender inequality can be found in studies of how people understand the meaning of pet photographs.[4] Researchers have found that present-day amateur snapshots[5] of pets reveal real as opposed to staged sentiment for animals because the pet owners emotionally interact with these images by recalling the particulars of the animal's pose and the situation surrounding the taking of the photograph. For example, Morris Holbrook and his colleagues (2001) have confirmed that pictures of family pets often reflect the caring and deep affection felt by the humans pictured with their pets. Even after pets have died and left the family scene, former owners can point to photographs of them and note how the images demonstrate their prior happiness and bond with the pictured animals (Chalfen 2003).

Modern snapshots of humans with their pets provide stronger evidence that their poses are not merely sentimental or meaningless. Psychiatrist Aaron Katcher and veterinary ecologist Alan Beck (1983) examined twenty-five hundred modern photographs submitted to a national dog and cat photography contest and found that the human–animal poses in these photographs expressed three kinds of affection. First, photographs depicted an "intimate dialogue" where one person and one animal formed a dyad in the center of the image, often posed as parent and child, and where people and animals touched each other, often with the animal's and human's heads close together. Second, Katcher and Beck noted a "peaceable kingdom," with 23 percent of the human subjects lying down with animals, almost half of whom were asleep. And finally, there was a relationship of "idle play," where the pet became an extension of the human subject's self in place of the two as a dyad. In these images, the human subject's gaze was not fixed on the animal; instead, the person's eyes were unfocused as if in a state of reverie or directed somewhere else in the photograph with a low level of attentiveness, comparable to staring at fish in an aquarium. In other words, humans in contemporary pet photographs appear to benefit emotionally from their pictured ties with animals.

A different way to read tender inequality is to view it as a dramaturgical performance where people are staging a sentimental image of themselves with or through their animals rather than documenting genuine feelings for them. From this perspective, we cannot know the thoughts and feelings that the photographed people had for their pictured cats or their actual treatment of them, but we can try to figure out what impression they wanted to create. As a deliberately orchestrated display of goodwill toward and affection for cats, the photographs in this book suggest cats were thought of and cared for as good friends, despite their subordinate role as "just animals" in society at large.

This reading of tender inequality means that the surface images presented in these photographs might have glossed over what was a less esteemed life for the pictured cats, a life where they were more likely treated as "just" animals than as members of the family, although this does not mean that these animals were mistreated given standards for the care of pets at the time. Scholars reading a very different kind of visual inequality, slave photography, take this approach, saying that these images were meant to be construed as a kind of propaganda picture that falsely downplayed the very real

4. Unfortunately, most visual studies of animals focus on the portrayal of wildlife in modern, post–World War II photography, film, and television and on what these portrayals say about general social attitudes. For example, Angus Gillespie and Jay Mechling's (1987) collected volume about the depiction of wildlife in popular culture uses visual images as evidence of America's contemporary attitudes toward race relations, sexual norms, and class tensions.

5. Still photography is not the only medium that can reveal human emotion for animals. A study of video recordings of people with their pets also demonstrates that emotions can be interpreted from nonverbal behavior shown in these images (Konecki 2008).

and large distance that existed between whites and their slaves (Wexler 1997; Willis 1996). These images were domestic representations that worked by organizing and staging a sentimental version of the family; it was as if all photographic subjects were considered to be part of the family because slaves were included and grouped together with whites. Although included in the images, slaves were often placed in the background or at the margins of the picture's focal point, making them appear more as objects than as family members.

Like photographs of slaves, cat photographs can be seen as producing sentimental fictions about domestic and personal life with another species.[6] As fictions, these photographs can serve ideologically to maintain the status quo by affirming traditional ideas, upholding conventional values, and supporting institutions, as did slave photographs. So it is possible that they mask what in reality might have been less than perfect lives where the pictured cats were not such close friends or well-treated family members. But, unlike the case with slave photography, these stories can also challenge the status quo. The photograph, as a dramatic field for the creation of personal and social myths, can be forward thinking. Rather than affirming societal expectations for our behavior, photography can allow individuals to express new and even unorthodox social arrangements. These imagined arrangements can be experiments in what might be possible rather than mere affirmations of what is.

We do not want to pit these two approaches to reading sentiment in cat photography against each other. Rather than considering them contradictory approaches to mining the meaning of the images in this book, we see them as complementary ways to view and think about such images. *The Photographed Cat* thus considers photographic sentiment as both sincere *and* staged in early-twentieth-century cat images. Taking this approach means that we look at the surface details of cat photography as a document of sentiment while looking at the imaginative edges of cat photography as a sentimental wish for an idyllic relationship with other animals, where interspecies distinctions are largely diminished and animals are put on an equal footing with humans, at least visually.

THE PHOTOGRAPHS

Over the past decade, we have assembled a large collection of American and western European cat photographs (more than five hundred) dating from the late 1800s to the late 1930s.[7] This collection includes personally acquired images as well as those that photograph collectors around the country have shared with us and given us permission to reproduce for this project. Most of the photographs have no attributions to photographers or companies; the few that do are typically about eighty to one hundred years old and cannot be traced. Overall, the images are very reproducible because they are in sharp focus, with good composition and lighting, although in a few cases we had to alter the contrast slightly or enhance the resolution to create a better view of the subjects.

Despite the prodigious size of our collection, the images we collected are not a random sample

6. We realize that making this comparison is a sensitive and political issue to those who feel it diminishes the significance of the oppression of African Americans. Like Marjorie Spiegel (1997), who argues for making the "dreaded comparison" of human slavery to the treatment of animals, we are not saying that the oppressions suffered by African Americans and animals have taken identical forms. Rather, we are noting that these two groups share a similar relationship between the oppressor and the oppressed and that this relationship can be muted in photographs.

7. We also reviewed but did not acquire more than one thousand photographs of cats in museum archive collections, such as those at the Boston Athenaeum, the Otis House, and the Harvard University library, as well as those in private collections on the Internet.

of early-twentieth-century human–cat relationships that would reflect the diversity of cat owners, the different kinds of cats (e.g., "barn" or stray), and the range of ways people interacted with their pets. Although we could not collect such a broad and all-encompassing sample, we did reach what ethnographers call "saturation," a point when fieldworkers start hearing and seeing the same themes from their subjects again and again. As we continue to collect cat photographs, we no longer see new patterns in how people a century ago depicted their pet cats or how they posed with their animals.

Almost all the photographs we collected and that appear in this book are American "real photo postcards."[8] Photo postcards were immensely popular in the United States from approximately 1905 until 1935, truly becoming the people's photography (Bogdan and Weseloh 2006). Photo postcards were the most popular format for both commercial and amateur photographers at the time, with millions produced. People were wild about them; they were a craze, a fad that lasted longer than most. Their appeal was that they were less expensive than alternative photo formats, were a convenient size for collecting, and were practical for mailing to friends and family. People of every socioeconomic level, ethnic group, and geographic location produced, bought, sent, and collected them as a hobby or put them in family albums to document their lives, so a huge number of them are available for study.

An untold number of real photo postcards of animals were produced between 1905 and 1935. People were often fond and proud of the animals they owned, whether the animal was just the family pet, their favorite horse, or a prize-winning cow. They wanted photos of them. They either took the pictures themselves or called upon local commercial photographers to capture their living possessions. Not just cats, but horses, cattle, pigs, sheep, rabbits, dogs, and other species were so ubiquitous in early-twentieth-century American life that it was difficult to take a town or farm view without including them. They appear as natural parts of ordinary life.

In addition to people's interest in pets, game, and animals in various other roles, other factors account for the profusion of animal images. The major manufacturers of photo postcard stock (the paper used to print photo postcards) and other photography equipment capitalized on the human–animal connection by encouraging the idea that photographers' portfolios and family albums should include images of animals. They marketed this idea by including pictures of animals in their advertising. Doing so added impetus to the public's inclination to photograph animals. Kodak led the way in promoting animal photography by providing its retailers with personalized versions of animal-illustrated advertising—for example, featuring a litter of adorable pups or kittens.

The large number of animal photo postcards was also the result of a significant transition in the history of photography. Before the period we are discussing, commercial photographers took most photographs. In 1900, the Brownie and other inexpensive cameras were introduced and more people took their own family pictures rather than having local studio portrait photographers do so. As the postcard format became the rage, studio photographers attempted to interrupt the decline in their customer base by printing their studio portraits on postcard stock.

8. We also include a few cabinet cards, glass-lantern slides, and snapshots from this period. By the late 1800s, cabinet cards, so called because they could be displayed on cabinet shelves, were the most popular form of photo portraiture. They were larger than postcards, making them easy to see from across the room. Glass-lantern slides were positive transparencies sandwiched between two glass plates and then projected through a "magic lantern" onto a screen or wall. These slides and projectors were not common in American homes but were widely used by various institutions for teaching purposes.

With the increase in amateur photographers, many commercial photographers moved from being predominately picture takers to merchants selling photo equipment and frames as well as providing developing, printing, and other services. Some were able to remain photographers, if only part time, by producing town views and other images on postcard stock. They sold these photos in their own stores as well as wholesaling them to local stores, hotels, and tourist establishments. When postcards were at the height of their popularity, they were a significant source of income for some photographers. Because customers wanted variety, the number of views proliferated. This proliferation, combined with snapshot amateur photo postcard production, accounts for the huge quantity that was produced. Because of real photo postcards, the first third of the twentieth century was likely the most photographed period of American history.

We had other reasons for choosing photo postcards beyond their abundance. They provide an enormous and relatively untapped visual archive to document and investigate our topic. Yet social scientists often dismiss photos as a source of data because they are difficult to interpret. Scholars argue that they cannot understand what place these images had in the cultures that produced them, what photographers thought they were depicting, and how those pictured in or viewing them understood their meaning or the photograph's social context. Because we have spent time studying not only the images in this book, but also those who produced and used this genre of photography, we believe, however, that we have gained a deep understanding of the place photo postcards held in American culture and in people's lives.

In addition to our understanding of the social context of photo postcards, the cards themselves can provide more information about their meaning than do other forms of photography. Some cards have captions or notations on the image side that describe the photos, offer commentaries about their importance, and help decipher where and when the images were produced. Also, photo postcards were produced with a space to send a message. They are the only form of photography that invites commentary. Many postcard senders and owners made use of the space to write notes describing the image and what it meant to them. Other senders commented on themselves and their own lives. Some senders included remarks about the pictured animals, personalizing and articulating the meaning of the animals to them.

Obviously, the most meaning about these images comes from the animals and people depicted on the photographs, and much can be learned and inferred from these depictions. We can see how people nonverbally created an image of intimacy, communicated the idea that their cats were kin, and related differently to their cats based on their own gender. Yet there were also limits to what we could see and compare. With regard to social class, for example, we know that people from all socioeconomic backgrounds kept pets (Arluke and Bogdan 2010; Grier 2006), but we hesitated to look closely at such differences in the representation of cats because we could not easily discern the human subjects' class in most cases, as we could gender or race. In theory, we should be able to analyze racial differences in depicting cats, but we found only two photographs of African Americans with cats in more than one thousand images, and their quality was unfortunately so distressed that they could not be clearly reprinted. As with class, there are no data available on African American ownership of cats or even pets in general from this period.

Understanding the meaning of these photographs also depends on who took them and why they were made. As noted, the vast majority of cat photographs are unattributed to a photographer or company. Most were done by local town photographers or amateur picture takers whose images both documented the times and are documents of their time. For the most part, the photographers were part of the communities they photographed, insiders to their subject matter, folk documentarians.

Some of them were common people with an uncommon talent. Their intimacy with the people and places they captured resulted in a vernacular record of the life and times of the period unavailable in other kinds of photography (Bogdan 1999, 2003; Bogdan and Weseloh 2006). *The Photographed Cat* focuses on these vernacular images of people and their cats because they are attempts to capture a "real" moment, a snapshot, of the everyday lives of subjects who were far less deliberately posed than when they were in a photographer's studio sitting for a portrait or for a commercial image to be widely sold (Chalfen 1998). Although not part of the community, itinerant photographers who traveled from town to town freelancing or designated photographers on naval ships also produced vernacular cat images, so we felt they are important to include as well.

Far less candid but equally important to consider are commercially made and formal studio photographs of cats. Although photographs of animals were usually taken on location, it was also common for animals, especially house pets, to be posed in photo studios. Individual photographers often used animals, especially dogs and cats, to boost their own business prospects. When photo postcards became popular, large commercial firms began producing them to augment their line of printed cards. Both the large-run commercial cards and those produced by public organizations were made for the mass market and thus are more uniform and professional looking than those by local and itinerant photographers. The few of this type that we have included here illustrate mass marketing of animals and their use by organizations for public relations.

The fact that these mass-marketed images were made far from a cat's everyday life and the cat was posed in unnatural or formal ways, compared to vernacular shots, does not make them less valuable for us to consider. They also tell us about how people thought about cats and our human relationships with them because the constraints of culture impinge on the posing and subsequent reading of all images. Whether posing candidly in the privacy of one's home or formally in a studio, subjects will feel pressure to pose in ways that are consistent with broadly accepted expectations for appropriate behavior. Like the clichés of language, photographs show us the clichés of culture (L. Berger 2011), and in that sense vernacular photography, studio portraiture, and commercial photography share much in common. Although the approach taken by each to represent cats might have been different, only when we consider them together as a set can we more fully understand how cats and their ties to humans were depicted and what these depictions might have meant a century ago.

The Plan

Our main question, then, is: How were domestic cats and their connections to humans represented in early-twentieth-century photography? Each chapter focuses on a different way that photographs created a human–cat connection. Detecting these connective cues has enabled us to speculate about the perspective of those who made and viewed the images we present—a perspective, as we will see, that demonstrates an emerging modern sensibility toward cats as well as a sense of their timelessness as friends.

Not all early-twentieth-century cat photographs pictured human–cat interaction. Photo portraits were made featuring one or more kittens or cats as the only living thing in the picture. Not all such portraits were the same; they varied widely in terms of their purpose, audience, and method of portraying cats. Commercial photographers popularized stand-alone cat portraits as artistic ornaments that had no visual elements in them except for the animals, or the cats were pictured sitting near physical objects, such as bowls of fruit. Other mass-marketed, commercially made portraits were meant to be cute or humorous images of cats. By contrast, there were also vernacularly made cat

photo portraits, snapshots of family pets, made by individuals for personal use and sharing with long-distance friends and family. Although these different kinds of portraits, by definition, did not explicitly depict human interaction with cats, they are still important as a starting place to unpack the ways that photographs a century ago communicated the idea that friendship crossed the species gap.

Chapter 2 thus looks at how portraits portrayed cats as either still or "unstill" life, preventing, facilitating, or revealing some connection to them. Goffman saw why portraits could be interpreted so differently. He noted that humans interact with and establish the meaning of "things," which can include objects, other humans, or abstract ideas. Following this thinking, people can virtually interact with pictured cats as things and assign meaning to them as either lifeless objects with whom viewers have no imaginary or real ties or as subjects that have a personality and perhaps life experience and with whom viewers can create some connection or acknowledge one they already have.

The ability to interact virtually with pictured cats requires some commonality between the cat pictured and the person looking at the photograph of it. One way to establish this commonality in the early twentieth century was for portraits to depict cats as either juvenile or adult humans. Some photographs, primarily those commercially made for large-scale distribution, achieved this personification through playful anthropomorphism; pictured cats could elicit a "cuteness" response, humor, or curiosity in viewers. Although playful anthropomorphism gave life to pictured cats, this animation was clearly done in jest and entirely in human terms; these cats were subordinated and reduced to objects by being anthropomorphized. However, other photographs, mostly homemade and studio portraits, suggested that cats were not mere objects to the makers of these images. Here, even if done playfully, the cats are in poses or are accompanied by messages that convey each animal's unique

personality. These cats were not still-life objects; they clearly occupied a special place in the lives of those who took the time to make these images.

Of course, depicting close ties to cats on film was more apparent when humans were paired with them in a dyadic relationship, the most elementary form of friendship. We found hundreds of photographs from a century ago that show adults, children, and infants coupled with a cat as a unit rather than incidentally featuring a cat as an aside or accident to the "real" human focus of the shot. The viewer "knows" by quickly looking at these images that there is an intimate connection between the cat and the human. That such a perception can occur requires the joint efforts of photographers, subjects, and even viewers who want to create and see a certain kind of relationship on film.

Chapter 3 examines how tie signs in photographs of humans and cats visually link the two so they are seen as having a special bond and communication with each other. The use of posture, gaze, gesture, touch, and joint activity prevented viewers from seeing the pictured humans and cats as totally separate entities who randomly appeared together in the same picture. People are shown cuddling cats, sometimes bringing them close to or directly against their faces, resting their heads on them, sleeping with them, actively playing with them, sitting serenely with them, and smiling in their presence. In most cases, touch connects human to cat, or, if not, a gaze suggests the two are connected. The result is that those who view these photos understand that the humans and cats were experiencing a sense of joy, contentment, or security when caught together on film.

Tie signs can be more complex than a mere dyad, encompassing a larger social unit, such as a family, for all to see. Some photos depict just such increasingly complex social ties with cats as family members. That we found pictures like this should not be surprising. With the growing popularization of amateur photography and the photo postcard craze, many people were quick to show

visual evidence of what the prosaic expression "we treat our pets like members of the family" meant to them. To understand what this expression meant a century ago, we looked closely at how photographs included cats inside the home and as part of the routine and ritual of everyday family life. We are lucky that photographers caught some of these domestic behaviors as they regularly occurred in homes or were deliberately posed by their human and animal subjects to communicate the nature and significance of the cat's position in the family to those viewing the images.

Chapter 4 explores how photographers and their subjects depicted cats as kin in both formal studio portraits and informal family snapshots. From a dramaturgical perspective, these images creatively used the geography of the home and spatial relationships among family members to suggest an elevated and inclusive role for cats. Cats were included in large group portraits of multiple generations from grandparents to grandchildren and simpler portraits of cats with individual family members of all ages. Subtler visual devices, too, extended family status to cats. Photographs documented that cats were allowed inside the home, catching them sleeping on desks or living room chairs. They also showed that cats were included in routine family activities, such as eating dinner, as well as special celebrations, such as holidays, and were regarded as pseudo–family members by depicting them as babies, children, siblings, and pals. Perhaps the subtlest way of extending kin status to cats was to associate them in photographs with other animals, especially dogs, that had a clearer and more established role already as family members. In these ways and more, photographers and their human and animal subjects showed themselves and others that cats, as their close friends, were considered family.

Although cats could be depicted as part of domestic life, photographs of close relationships with them revealed a mixed message. The process of visual depiction is always embedded in a culture that shapes the creation of images, including who gets to be in them, how they are posed, and what if any text is added to comment on the intent and meaning of the image, in addition to how viewers read the finished product. These decisions reflect ideological thinking and social rules about intimacy and close relationships. More specifically, shared understandings of what is considered gender-appropriate behavior influence how photographers and their subjects collaborate to create certain images, whether they are aware of these ideological forces at work or not. Our dramaturgical approach to photographs asked whether these gendered expectations appeared to shape human poses with cats and, if so, how. We found that photographers and their male and female subjects expressed and captured an ambivalent role relationship with cats, suggesting that some people resisted these ties at least in front of the camera, whereas others wholeheartedly embraced them.

Chapter 5 shows that men and women were not pictured as friends with cats in quite the same way; women were far more often posed in intimate ways with cats than were men. Photographers and their subjects captured or created this gendered identification with or separation from cats in bold and subtle ways. Sheer numbers tell us something because there are many more images of cats with adult women than with men. Although it is true that men may have been reluctant to be pictured with cats, they appear as often or more often than women in photographs with dogs and horses. Body language also tells us something. In the few pictures where adult men are paired with cats, the men are in far less intimate poses than are women with cats. Whereas women are often shown cradling cats or bringing them close to their faces, men are more likely shown with cats sitting on their shoulders or perhaps sleeping on their laps, and the men's hands aren't touching them. Women are not only depicted as embracing the role of animal nurturer but are sometimes engulfed by that role. Portrayed as far more intensely interested in cats than are

men, women are sometimes photographed holding multiple animals, whereas men are rarely caught on film showing this degree of enthusiasm for and interest in cats.

In a very different situation, outside the home men broke these gender prohibitions and allowed cats to be photographed with them as close friends. Depicting intimacy between men and cats could occur when, dramaturgically speaking, a collective frame existed that defined the animal's friendship as shared among many men rather than being solely enjoyed by one person. In this manner, photographs captured cats as part of a larger group or community when they served as mascots to men at work, where friendship was shared with them as public animals, whether they were companions to cooks, firemen, librarians, transit workers, or postal employees. Mascots meant a great deal to many people and played what were often very important if not vital roles. As public pets and good citizens, these animals provided emotional benefits and carried out useful tasks. Even when many people were involved, cat mascots could be companions, coworkers, and fellow travelers who entertained and comforted their human friends, uniting the group by being a common focus for everyone to enjoy and becoming symbols that embodied key features of a group's identity and mission, such as cunningness or good luck.

Chapter 6 considers how cats were depicted as mascots onboard American and English naval ships in the years shortly before and after World War I. Cat portraits were intentionally constructed through poses with sailors, text about the cat's behavior, naval clothing, and ship-related objects to connect the animal's identity with the ship and its crew. Cameras captured cats sitting in cannon barrels, perched on life preservers, and walking across brass ship nameplates. Group photographs taken onboard of mascots and sailors of all ranks show cats as the center of attention being played with, fed, petted, and fawned over. Images also reflected deeper affection and respect for these mascots, whether showing cats sleeping in specially made hammocks or being treated as honorary crewmen. Indeed, the very act of photographing mascots was part of the process of creating a collective frame that defined the animal as a common friend to all because many sailors were often involved in setting up individual shots and then appearing in them, too.

The final chapter invites readers to step back and consider all the images in *The Photographed Cat*. We believe that when looked at as a set, these images reveal a sentiment reminiscent of Edward Hicks's *Peaceable Kingdom*, an iconic nineteenth-century painting that depicts close friendships among wild and domestic animals as well as people. At the heart of this vision is a mutual experience of comfort and security, an intimate dialogue between humans and animals where each party benefits from the close ties of friendship.

Photographers of the early twentieth century captured the idea that peacefulness and caring could extend between animal species, first by depicting cats as thoughtful caretakers of other animal species. For example, cats might be pictured feeding litters of squirrels or foxes, with superlatives written on the negative to proclaim that the cat was the "best mother" or "most reliable friend" to needy animals. This interspecies caring was reversed by taking photographs of animals showing apparent kindness to cats, such as a dairy cow sharing its milk with a barn cat. To complete the picture of a peaceable kingdom, photographs also show people calmly enjoying the company of their cats and reaping the benefits of this companionship. People are pictured in what appears to be a blissful state, picnicking with their animals, gazing into their cats' eyes, smiling in their presence, sitting calmly with them in an idle moment, or laughing at their antics. We rein in, at least to some degree, the idea that such photographs document the benefits of humans associating with cats. Rather than viewing these images as documents of what was experienced by both human and cat subjects, we

suggest they are better understood as an idyllic fantasy where the elements of photographs serve as tools to express a desired relationship with cats. From this perspective, the peaceable kingdom between humans and cats is a wish expressed on film for a moment—or perhaps for a future—when the moral and social world separating animals and people is reduced or erased entirely.

2

Unstill Life

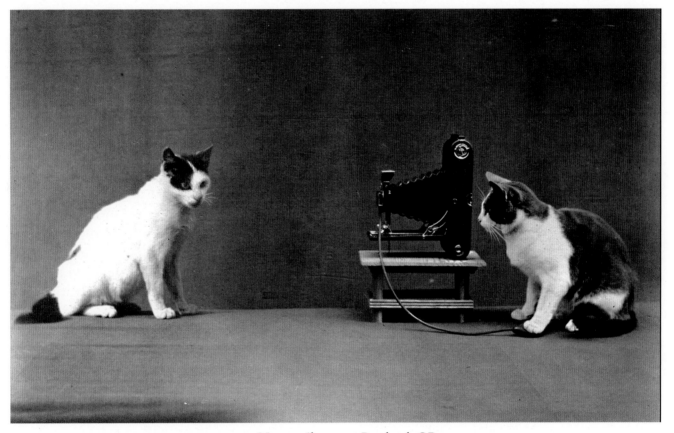

2.1. Now smile, 1911. Portland, OR.

Photographic portraits focus on a person's face and expression, although entire bodies or backgrounds are sometimes present. Rather than being mere snapshots, these photographs can be composed or staged, with subjects often looking directly into the camera and in turn at the viewer of the image. Others are candid shots of subjects caught in a private moment or in the process of doing something.

Although photo portraits of celebrities, public figures, and models are mass-produced for everyone to see, vernacular portraits are for private enjoyment and sharing. The latter are pictures taken of family members and good friends at home, at play, or in studios. Sometimes framed and hung on the wall or placed on a tabletop or perhaps kept in an album, wallet, or cell phone, they are used to remember a person or group. Vernacular photo

portraits also can be used to commemorate a special occasion and holiday, such as a special family trip, Christmas, or a birthday.

Whatever the reason for taking them, good photo portraits do more than depict the subject's physical appearance. Viewers believe that in representing rather than mirroring, portraits reveal something deeper about an individual's personality, character, or even mood because they have a symbolic side that appears to capture a person's uniqueness rather than his or her status as the mere object of a camera's lens. The work of presenting an impression of what someone is like through a portrait involves the viewer who is invited to impute a self to the picture's subject (Schwalbe 2009). Seeing this individuality asks people to make more of the subject's intentionality than may have been the case by attributing interiority to the subject, thereby creating an illusion of capturing his or her real character (Trachtenberg 2000). Making sense of the subject's appearance, pose, and context in this manner creates a story or frame about the image, but doing so is problematic with portraits of those who are strangers to the viewer because there is no personal information to create this frame.

Even more complicated is imputing individuality and selfhood to cats in photo portraits of them made a century ago. Many of these photographs rendered cats as objects, subordinating them as beautiful ornaments or anthropomorphizing them as humans. Although ornamental depictions of cats, by definition, reduced them to pictorial objects, anthropomorphic depictions did so by disregarding and dislocating their nature and life and then transforming them into mock humans. Although stripped of much if not all of their uniqueness in terms of personality, preferences, and living situations, these humanized cat objects could still be related to as more than mere bowls of fruit or vases of flowers. Like portraits of people, portraits of cats could serve as canvases onto which viewers could project their own thoughts, feelings, and experiences. But unlike the case in which viewers' project thoughts and feelings onto portraits of

anonymous humans who obviously share the same species with the viewers, the species difference between viewers and cat subjects, combined with heavily anthropomorphized portraits, encouraged projections that denied the cats' nonhuman nature and rendered them curious or entertaining objects.[1]

Other cat photo portraits challenged the subordination of pictured cats as pretty, cute, or funny objects by suggesting they had their own thoughts, feelings, and special experiences. Many of these photographs were deliberately made to record a cat's uniqueness: how it looked to its owners, what was special about its personality, or what its everyday life was like. And by including situational props or inscriptions about the cats, the content of these images could help viewers picture the cats' personalities and imagine how they might interact with them, rendering them more as subjects than as objects.

Although simple in their portrayals of cats and often not profound in their message, these early photo portraits scratched away, often with humor or cuteness, at the distance from these animals at the start of the twentieth century. By playfully toying with the prevailing rigid and clear-cut boundaries between the species, they provided the basis for a more complicated intimate dialogue between cats and people. How the photographers, the subjects, and the viewers of these images laid the pictorial groundwork for friendship is this chapter's focus.

ORNAMENTAL PORTRAITS

Rather than recognizing cats' sentience and perhaps individuality, some photos portrayed them as objects to admire simply for their beauty. Photographers making these portraits regarded such portraits as a form of fine art akin to an oil painting

1. The subordination of subjects into objects by anthropomorphizing them can also occur when humans view portraits of other humans (Haladyn 2006).

of a beautiful still-life composition. This newly discovered interest in capturing cats as artistic objects was part of a broader trend in making portraits of pets (Grier 2006) and the Victorian fascination with animals in general (Ritvo 1989). The European postcard craze at the turn of the century included reproduced paintings of pets that heavily influenced cat photographers and ensured a fine-art approach to how they styled and composed their subjects. For example, the postcard of "pretty models" (illus. 2.2) features two cats that served as the artist Arnold Henry Savage Landor's frequent subjects for his cat studies series, which photographers later copied for its style and composition. Despite Landor's attachment to these cats, their artistic rendering merely as beautiful objects belied his private feelings for them.

As early as 1899, camera and art enthusiasts recognized the commercial appeal of cat portraits. According to the magazine *Photo Era*, "Photographic studies of still life, of animal life in its higher and lower forms[,] were rapidly catching on as artistic and yet truthful reproductions from nature" (1898, 20). By likening animal portraiture in photographs, especially of pets, to that in paintings, this new technologically advanced art form was granted some legitimacy. As the *Photo Era* article noted, "Animal life, and notably the life of our domestic animals, has long been a favorite study by artists in whom stirs that sweet sympathy with our dumb companions. . . . And now the camera is doing for this branch of art among our four-footed friends what has long been possible in portraiture and landscape work" (20–21).

By the start of the twentieth century, photo portraits of cats were the rage in America as well. Hundreds if not thousands of photo portraits of cats posed as aesthetically appealing objects were made and sold as postcards throughout the country. Regarded as a form of fine art, they were offered to the trade through leading art stores in cities such as Boston or could be purchased by mail directly from the photographers (*Photo Era* 1898).

Charles Bullard of Peterboro, New Hampshire, and M. T. Sheahan of Boston were the most well-known and commercially successful American cat photographers of this era, and the Davidson brothers established similar renown in England. Working out of their studios, these photographers kept a small menagerie of cats specially trained to pose

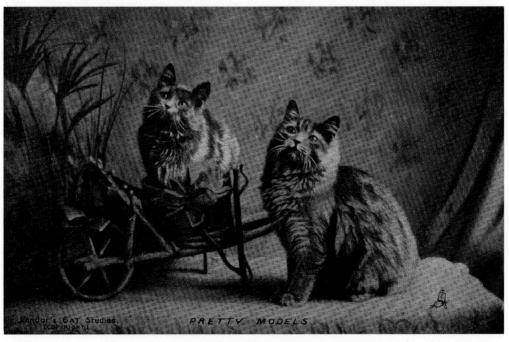

2.2. Pretty models. Arnold Landor.

and a staff of a few men who helped in the production and shipping of these photographs. Their almost exclusive focus on making cat portraits did not escape the humor of one journalist, who noted: "It is a very common experience to hear stories of men who have 'gone to the dogs,' but one never hears of men who have 'gone to the cats'" (Ranck 1915, 56).

Photographers such as Bullard and Sheahan often shot their ornamental portraits in soft focus and composed them to accentuate the idea that cats were beautifully rendered objects to be appreciated solely for their appearance. Early versions of these photographs were not made with much forethought other than waiting until the subjects were still enough to shoot. Simply having them sit and look into the camera was an achievement; no antics or special poses were needed. The goal of creating photographs that looked like still-life paintings is apparent in Sheahan's photo "Parlor Ornament" (illus. 2.3). The pictured kitten, long-haired and wide-eyed, is elevated on a doily-covered pillow and simply waits to be admired.

The artistic goal of these portraits was to capture the beauty of the cat's form, its sleekness, thick coat, and penetrating eyes. Approaching cats merely as beautiful objects meant that even people who disliked them could still admire their appearance. One photography writer of this period elaborated: "There is no doubt that cats are great ornaments. The grace and beauty of this most pictorial of animals appeal to the artistic sense of those who might find it difficult to love them for their virtues, always graceful" (Cadby 1908, 308).

Aspiring portrait makers were advised not to capture their personal connections to cats or the animals' real personalities and everyday lives and instead to focus only on the essential elements of ornamental photography (Cadby 1908).[2] These

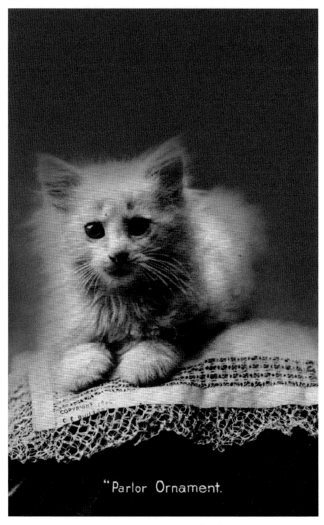

"Parlor Ornament.

2.3. Parlor ornament. M. T. Sheahan, Boston.

elements included a plain background so the cat appears distinctly and good exposure to capture some detail in the shadows as well the glisten in the cat's eyes, a shine on the nose, and detail in the

2. Ties sometimes existed between photographers and their cat models behind the scene, as was true for Bullard, who confided that he had developed a deep affection for his cats even though at the same time his photographs seemed devoid of sentiment for them. He reportedly was closest to Judy, one of his most famous and commercially successful cat models, saying of her: "Judy, the old cat, was a wonder. She seemed to understand what I wanted and worked with me. Judy posed for many of my best pictures. She lived to be twenty years old, and when she died I felt as if I had lost a child" (Ranck 1915, 57).

fur. The model's pose was equally important, according to Carine Cadby, who praised the compositional value of the cat's tail to balance the overall design. Also, both eyes should show rather than none, and profiles were to be avoided.

The final element of an exceptional cat portrait, claimed Cadby, was a subject's temperament. Models must appear to be good-tempered, pleasant, and civilized, as noted in this anecdote: "The writer will not readily forget the injured comments she received on showing a rather characteristic study called 'The Disagreeable Cat.' Cat lovers rather resemble fond parents, who like to ignore this side of their darlings' characters altogether" (1908, 310). Having a "good-tempered" model probably meant that the cat should be docile enough to make for easy and still posing. Less obviously, the cat's pose should suggest that it is a "good" pet in everyday life—not messy, noisy, unfriendly, and destructive. Photographers also tried their best not to take pictures of cat models if they showed their teeth or claws because these poses suggested bad cat behavior. As Cadby noted in her advice to photographers, there can be "irresponsible little models of cats and kittens" that make for "imperfect results. . . . If only Pussykins had not struck out quite so violently with his paw! etc." (1908, 311). In other words, the model had to be both compliant with the picture taking and not shown to be a mischievous troublemaker; it had simply to sit and do nothing in the photograph to suggest anything other than a still life.

The combination of shooting in studios and waiting for cat models to be still meant that these portraits never showed cats scratching furniture, carrying dead mice in their mouths, or otherwise wreaking havoc on domestic order. This dislocation eliminated undesirable pet traits that were thought to make photographs unappealing to potential buyers of commercially produced images or to clients paying for studio-made portraits. The dislocation also meant that it would be harder for viewers of these photo portraits to enter into an imagined intimate dialogue with the cat subjects because they were depicted as beautiful still-life objects rather than as autonomous, unpredictable, and somewhat wild creatures that had distinct personalities. Something fundamental about cat nature was lost in the visual translation from real to portrait animal.

Although comparing pet portrait photography to fine art probably seemed like a stretch to many people then, as it does even now, the photographer-artist's intention to provoke an emotional reaction in the viewer may have been no less than in the creation of fine art. The cats in these photographs were aesthetically like a bowl of fresh fruit suspended in a blank, meaningless context; the animals were prized in and of themselves as decorous. Yet as beautiful objects, the subjects of these portraits could elicit some emotional response in viewers for their perfection as things.

"First Prize" (illus. 2.4), for example, has all the correct photographic elements needed to make for a successful commercial postcard in the ornamental tradition. The well-behaved "prize-winning" cat is lying down balanced by its tail, looking directly at the camera with its eyes wide open, while being framed by a simple dark background. This composition presents the cat's body as a specimen to be admired; even people with little interest in the species could wax on about the animal's visual appeal. Both the cat portrait's caption, even in jest, and the elaborate frame in the photo remind us that this animal is to be regarded as fine art for its beauty, grace, and docility.

Photo portraitists did not strictly adhere to Cadby's elements of fine-art composition, especially as demand grew for pictures that elicited a "cuteness response" in viewers (Burghardt and Herzog 1980). Drawn to images of kittens because of the kittens' infantile appearance as dependent and helpless (Gould 1980; Lawrence 1986), people found them particularly appealing and adorable even though the subjects were still presented as ornamental objects. Kittens were an obvious and

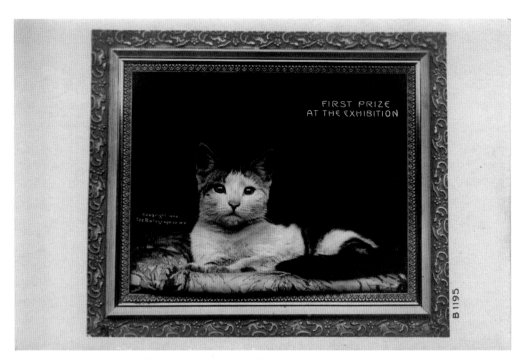

FIRST PRIZE
AT THE EXHIBITION

2.4. First prize at the exhibition. C. Mastrovito coll.

easy tool to get this response because they have all the features of infants, including big eyes, no snout, and large heads relative to body size, which are perceived as cuter than smaller eyes, longer snouts, and smaller heads relative to body size.

Commercial cat photographers capitalized on the cuteness response to make people want to buy and send these images to friends or perhaps to keep the photo postcards for themselves. Bullard even titled his kitten portraits the "Cute Kitty" series on the address side of the photo postcards. Staged group portraits of kittens were among his most successful postcards. More difficult to arrange and shoot, these portraits featured several kittens bunched together looking askance or directly into the camera lens, no easy feat for the photographer, but one guaranteed to make an image that would be seen as cute enough to buy. Cadby described this photographic feat: "a row of pretty kittens gazing up with innocent smirks, or a group, perhaps arranged on the branch of a tree, or a couple peeping out of a hamper or stuffed into a basket" (1908, 310). Just such an image can be seen in illustration 2.5, with its kittens looking up

at a feather or wire being waved by the photographer's assistant. That one kitten extends its paw over the ledge only adds to the appeal of the image and its marketability.

Simple ornamental photographs of kittens took advantage of their charming and endearing qualities by posing them in studio-created scenes far removed from cats' everyday lives. Many of these creations had a fantasy quality to them, as does illustration 2.6, which capitalized on the then popular fascination with pictures made of people and animals posed on half-moons or with the moon in the background. The kittens in such photos were still fine-art objects, just portrayed in a light way to increase their sales potential.

Cat portraits offered design possibilities that were appealing as a form of popular culture, appearing on everything from calendars to thermometers and being sold in storefronts as well as in five-and-dime stores, drugstores, and any location that had room for a postcard stand. Portraits of cats were molded into the shapes of flowers, vases, and even numbers to celebrate special occasions or to send a thoughtful message. The photo

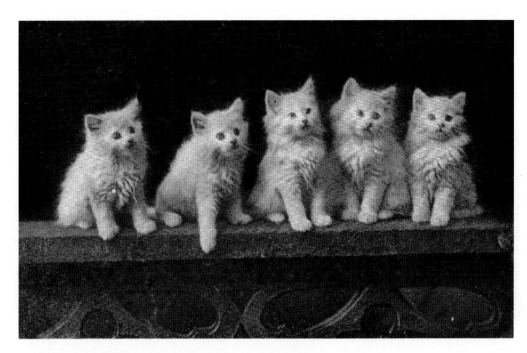

2.5. Five white kittens, 1897. C. E. Bullard.

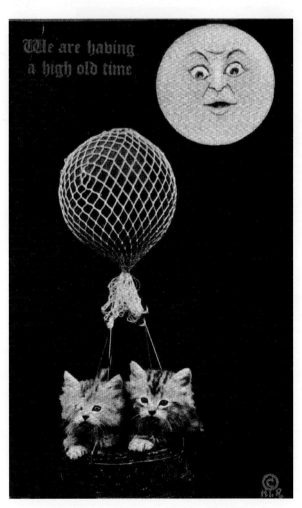

We are having a high old time

2.6. We are having a high old time.

postcard in illustration 2.7 packs a number of cat images into the date 1906 to make a New Year's greeting.

Dislocated portraits of inactive cats taken in studio conditions gave way to photographs of kittens appearing to cause minor trouble outside. Action shots, of a sort, became the rage that showed feline "incidents" or "mischief" that viewers might consider cute. Photographers staged this misbehavior by "encouraging" their kitten "actors" to be active in some way—upsetting a jug of milk or playing with a skein of wool. Lucky photographers would work with cats that were naturally very active. Companies seeking to advertise their products in eye-catching ways quickly saw the marketing value of including cute, active kittens in ads for their products. A postcard advertising Carnation Milk (2.8) captures three rambunctious kittens trying to break into a carton of unopened milk, still evoking a cuteness response despite their destructive activity.

These portraits of more devilish behavior nevertheless dislocated the cat sitter, revealing little or nothing about its own disposition or real-life situation. The cat is admired as a cute and pretty object or ornament. Its apparent naughtiness

2.7. Best wishes for 1906.

2.8. Carnation milk. T. Weseloh coll.

comes across as endearing, a far cry from the havoc that some cats wreak when they scratch furniture, kick dirt from potted plants, knock over precious objects, or rip apart bags and containers holding food—behaviors that few owners would regard as attractive and worthy of being captured on film.

The photographic transformation of the cat as an object that can be distantly admired to a subject seen as having lifelike qualities or even an individual personality required presenting it as more than a mere ornament. This transformation occurred largely because of changing fad and fashion in photographing cats. The creation of ornamental

portraits in the first decade of the twentieth century gave way to a much more popular and profitable genre of commercial photography that humanized the cat subject. Although anthropomorphizing these cats hardly captured or validated anything unique or individual about the pictured animal's own real character or lived situation, it nevertheless brought viewers one step closer to considering these cats as subjects they could interact with, care for, and enjoy as living creatures.[3]

ANTHROPOMORPHIC PORTRAITS

Not all anthropomorphic images are the same (Epley, Waytz, and Cacioppo 2007). When anthropomorphizations are deep, people truly believe that the nonhuman agent possesses human mental, physical, or behavioral traits or characteristics. When they are weak, people do not sincerely make these attributions but instead engage in an "as if" way of thinking that enables them to express some sentiment or idea through the anthropomorphism. In other words, they do not firmly believe that the agent possesses these qualities, but they find this metaphorical thinking to be a useful device to accomplish other goals.

In this manner, cats were apparently anthropomorphized in some commercial portraits not to acknowledge the humanness of cats or even the fact that they were living creatures, but simply to be funny or silly in order to sell more postcards. Keeping with this aim, cat models were little more than objects to pose and dress up, with the hope of catching potential buyers' attention by spoofing the notion that cats could be subjects. The appeal of these comedic portraits on the surface seemed simple and innocent, but their success in catching people's interest and willingness to buy them

was more complicated because it depended on the viewer's ability to deny or ignore whatever individuality and personality were behind the model and to focus on the photo's anthropomorphic depiction. The viewer had to maintain his or her weak anthropomorphic glance to enjoy the joke behind the image.

Cats doing human things such as driving cars, reading books, drinking beer, or looking at photo albums was a common theme in comedic portraits. These portraits' use of weak anthropomorphism provided humor by depicting cats as engaged in a distinctly human activity. Note the postcard, for example, showing two cats seated on chairs eating their meal off a cloth-covered table with plates, cups, and a teapot (illus. 2.9). Of course, cats ate, too, but otherwise any real similarity between the species was irrelevant to the entertainment effect that the image had for some people.

By far, the most common comedic cat portrait featured the subject dressed in human clothing. Although popular with the masses, these photos did not amuse everyone. According to photo critic Carine Cadby, "The comic, dressed-up cat photograph . . . suits the ordinary public, though real cat lovers rather sigh over such indignities" (1908, 308). Although Cadby also wondered whether it would be beneath some photographers' professionalism to make such light-hearted photographs, she acknowledged "a voracious public" interest in humorous images and saw their value, noting: "A dressed-up cat is such a very easy way to get an effect, and though the humour of it be not of the subtle kind, it is very certain to earn a smile. In these strenuous and ambitious days, too, it is a little bit of a relief to see our earnest craft not being taken quite so dead seriously" (310).

Some owners wanted studio photographers to make formal portraits of their treasured cats wearing human clothing. Outlandish studio creations, or what Cadby called "odd-looking bundles" (1908, 310), were sometimes reported in the news. One such photographic event involved a pink Persian kitten that sat for its portrait wearing a golden

3. This approach to anthropomorphism falls in between two common and opposing views that see this process either as a sentimental misrepresentation of animals' nature (Benson 1983) or as a way to better understand them (Eddy, Gallup, and Povinelli 1993).

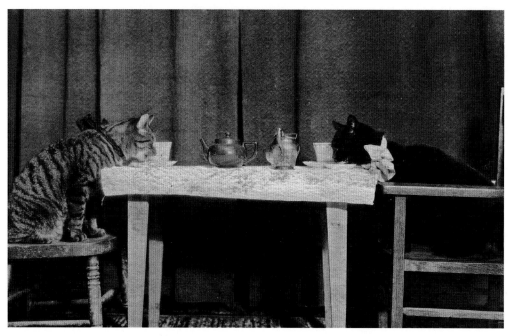

2.9. Cats at dinner table. T. Weseloh coll.

crown and a gold order around its neck. Mrs. Brooks, a socialite from New York City, owned this kitten and made sure that it had a perfumed bath every morning, after which it enjoyed pawing the keys of a grand piano. Mrs. Brooks had also dressed up her previous cats for portraits, with "President Roosevelt" wearing necklaces and diamond earrings, "Governor Hughes" adorned in a pink corset, pink shoes, and pink stockings, and "Admiral" draped in a navy blue coat, striped trousers, and an admiral's hat (*New York Times* 1909). The owner of the cat in illustration 2.10 found it amusing to dress her pet in a clown's suit from head to toe.

Commercial photographers took advantage of the public's keen interest in seeing and buying images of cats dressed like humans, along with other playful anthropomorphic depictions. Cadby even advised portraitists how to photograph dressed cats who were supposed to "look ridiculous and make people smile," considering how difficult it could seem to make these pictures. However, clothing made it easier to take these photographs by controlling the movement of the cat model. "The clothes will help to keep the model still, though they do not always cause a very sweet expression! It is a great thing, though, to keep the cat from moving, because one has to be more than ever exacting over exposure." Cadby warned that getting cats to wear hats could be the most challenging part of dressing them, but also the most effective way to present the cat as a recognizable human character. "The hat is so often the chief feature. It strikes the note and gives the suggestion of the character our model is impersonating. The difference the hat can make is surprising, and we realise how many parts a cat can play" (1908, 310).

At the beginning of the twentieth century, the Rotograph Company of New York capitalized on the growing popularity of photos of dressed animals. The company hired photographer Harry Frees to make these images using cats and kittens, dogs and puppies, rabbits, chicks, and ducks for their highly successful line of postcards; in fact, one of his favorite early models was his own pet, Rags the cat. Frees began adding simple props and accessories such as bonnets, hats, scarves, or shawls to pictures of his own pets or of neighbors and friends' pets. His mother made specially tailored outfits that held the living animals in place.

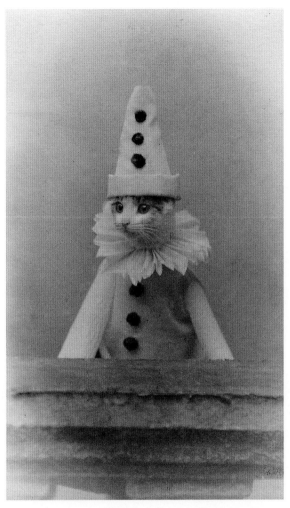

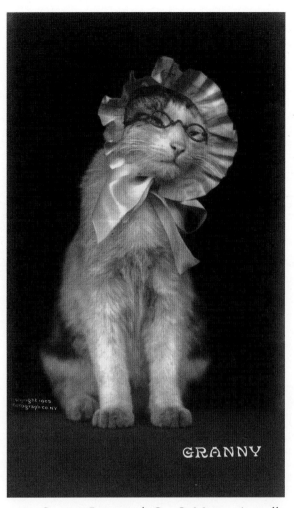

2.10. Cat in clown outfit. T. Weseloh coll.

2.11. Granny. Rotograph Co. C. Mastrovito coll.

By dressing up cats and other animals, the Rotograph series poked weak anthropomorphic fun at fundamental distinctions made among humans, such as gender and age. Although done in jest, these animal metaphors reinforced existing demographic boundaries, just as anthropomorphism can do in contemporary advertisements (Lerner and Kalof 1999). Cats could be dressed in either men's or women's clothing. Bonnets or top hats on cat models were just enough apparel to suggest each cat's suggested gender. Age distinctions were also easy to stage and poke fun at in the Rotograph studio, assuming cooperative cat subjects, by putting age-related clothing or props on them, such as granny glasses, along with suitable captions on the postcards (illus. 2.11).

Over time, the props and scenes used to make the photo postcards of anthropomorphized animals became more complex. Animals were posed reading newspapers, smoking pipes, riding horses, jumping rope, going on strike for more food, and even making fine-art paintings. Although intended to amuse both children and adults a century ago, these once popular images are now likely to make some people uncomfortable at the sight of cat models being restrained by props so that viewers can see their apparent woefulness or darkness as cute or funny (illus. 2.12).

The harm of weak anthropomorphism is that its sentimentality prevents people from making any effort to understand or relate to the animal on its own terms (Irvine 2004). Yet weak

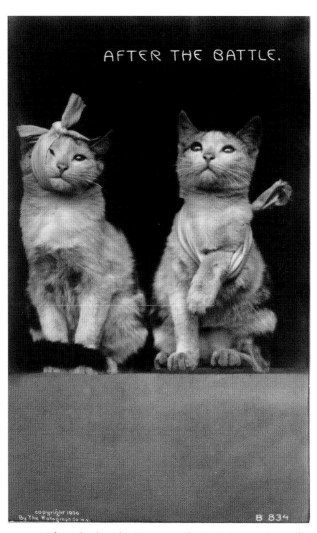

AFTER THE BATTLE.

copyright 1906
By The Rotograph Co N.Y.
B 834

2.12. After the battle. Rotograph. C. Mastrovito coll.

anthropomorphic metaphors can still affect behavior when people think about or act toward agents in ways consistent with these metaphors. Thus, the very lightness of weak anthropomorphism gently moved cat portraits a notch closer to depicting friendship with cats by allowing viewers to safely make the leap from seeing cats as beautiful things to thinking they are like us. In the minds of many who viewed these images, the pictured cats still did not have individual personalities or real-world life experiences of their own. But by means of the visual joke that cats were "just like us," some viewers of these images could temporarily leave behind the idea that the pictured cats were just still life.

POLITICAL PORTRAITS

Rather than trying to be cute and funny, political portraits of cats made a serious statement or expressed an important view about humans or animals. Although the photographers' goal differed from the goal of those who made comedic portraits, cats pictured in political ways could still be portrayed in weak anthropomorphic terms. In some of these portraits, the animal itself held no interest as a sentient creature, but it did have visual value as a handy device to make a statement about the human condition. Organizations whose goals focused on human interests, concerns, or social problems could use cats as stand-ins for people or as eye-catching attention grabbers.

For example, suffragettes in England produced several postcards that featured cats dressed as humans demanding the vote (illus. 2.13). The anthropomorphizing of these suffragette cats had nothing to do with trying to understand the animals' inner state, appreciate their everyday experiences, or demonstrate some connection to them as friends. It served, instead, as a visual tool and metaphor. Imprisoned suffragettes used hunger strikes to protest the inordinately long prison sentences given to them and the fact they were not treated as political prisoners. Once the British government realized that suffragettes would use hunger strikes to gain early release from prison, the authorities introduced forced feeding (Williams 2008). Recognizing the potential for public outcry against a process labeled as torture, the British government then passed the Prisoner's Temporary Discharge of Ill Health Act of 1913, better known as the "Cat-and-Mouse Act," which ordered that women who engaged in hunger strikes should be released from prison when they fell ill but would be rearrested once they recovered their strength. The act's nickname came about because of a cat's habit of playing with its prey before finishing it off.

Whereas suffragette postcards used cats metaphorically as a form of protest and to mobilize

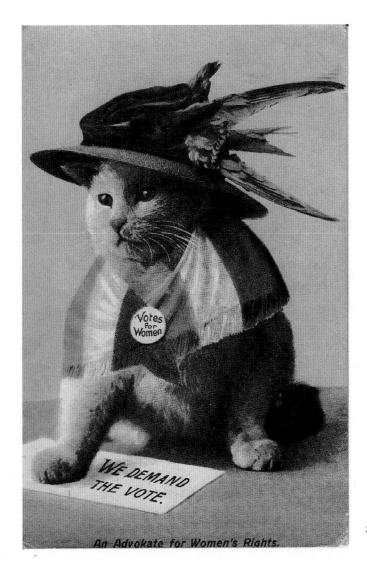

An Advokate for Women's Rights.

2.13. We demand the vote.

people to vote, other portraits made a political statement more directly about how people should view and act toward cats themselves. The anthropomorphism in these political portraits challenged viewers to consider pictured cats on their own terms. Cast as subjects rather than objects, the cats were, of course, to be admired and enjoyed as well as respected for what was not human about them. Their portraits allowed for the possibility or perhaps even tried to document that cats had their own thoughts and feelings, including some that might be distressful.

Humane organizations expressed the latter concern and used anthropomorphic photographs of cats to champion the cause of animal welfare and protection. In the early 1900s, these groups were fighting an enormous battle to improve the lot of stray and abandoned animals. Spay–neuter programs, common today, were nonexistent, and the public's attitude toward adopting unwanted animals, let alone toward donating money to shelters and welfare organizations, was lukewarm at best. Photo portraits of cats on postcards or printed in magazines might stir the emotions of viewers and spur them to contribute to these organizations and be responsible pet owners.

Boston's Animal Rescue League, for example, printed the expressive cat postcard in illustration

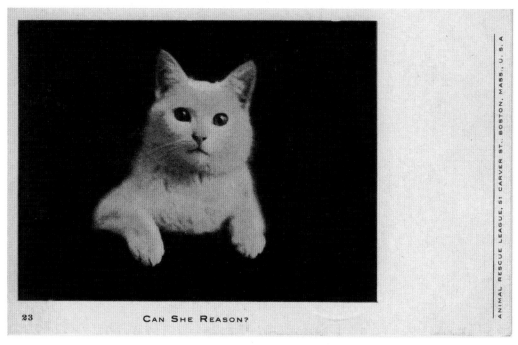

2.14. Can she reason? Animal Rescue League, Boston, 1908. T. Weseloh coll.

2.14 to provoke viewers' thinking and feeling about animals as sentient beings. The message "Can She Reason?" rhetorically articulated the league's sentiment about cats' intelligence, integrity, and value; referring to the cat as "she" rather than "it" should not be overlooked for its symbolic value. Unlike comedic, weak anthropomorphism, this kind of political anthropomorphism expressed deeply held beliefs about the existence of cognitive abilities in cats as a species. The sender of this card wrote to its recipient: "This card speaks for itself and represents what I believe we are both fond of. We have three here."

The glass-lantern slide shown in illustration 2.15 was reproduced many times by the Massachusetts Society for the Prevention of Cruelty to Animals (MSPCA) as part of its continuing campaign to find homes for lost, needy, and abandoned animals. Some of these reproductions appeared in the society's popular magazine *Our Dumb Friends*. The MSPCA wanted such emotionally disturbing images to provoke enough concern and empathy in viewers to get them to adopt shelter animals or perhaps even donate to the society.[4] Describing this kitten as "hungry and forlorn" effectively used anthropomorphism to accomplish the MSPCA's aim.

Whether these political images with a humane focus triggered feelings of sadness or altruism in people, they helped viewers make an imaginary connection to cat subjects who were not to be regarded as mere ornamental objects or still life. Although still anthropomorphized, the cats were nevertheless sentient subjects, a far cry from the Rotograph cats, who were merely whimsical and silly doll-like objects dressed like humans to get a laugh and make a dollar for the company. Though political portraits acknowledged the sentience of cat sitters, their status as subjects was generic. The cats were depicted as a species rather than as

4. Other MSPCA photographs presented a more hopeful image of rescued cats. For example, one glass-lantern slide depicted a cat being taken in a basket to a place of "safety." The MSPCA also incorporated the portraits of rescued cats, dogs, and birds on the identification cards of members of its youth organization, American Band of Mercy.

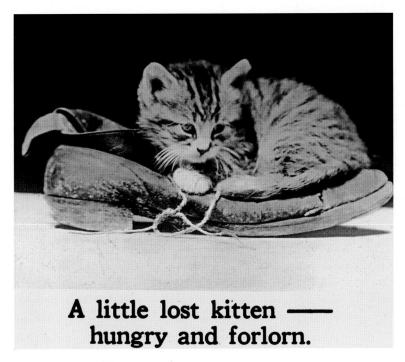

A little lost kitten —— hungry and forlorn.

2.15. A little lost kitten. MSPCA Archives.

individual animals. They were not yet pictured as someone's friend.

PERSONAL PORTRAITS

Rather than being mass-produced for profit as a commercial product, vernacular portraits of cats were made in single copies or small numbers for personal enjoyment. If not taken at a photographer's studio, many of these portraits were shot at home by an itinerant photographer or by owners themselves if they used a Kodak Brownie camera. These cameras made it convenient and relatively inexpensive for people to make their own photo postcard portraits of family cats to put in albums, to frame, and perhaps to mail to distant friends and family. Although not as carefully crafted, polished, and well composed as commercial portraits sold to the masses, these portraits started to reveal directly, rather than indirectly hint at, the existence of friendships between humans and cats.

Specific information on photo portraits provide some evidence that the featured cats were seen as subjects rather than as objects, as individuals rather than ornaments. Comments on the front or back of images might mention where cats came from or how much they were loved. A 1908 postcard of a black cat reads: "This is a picture of my cat. We think lots of her and I thought we'd send one to you. I hope you are well." Another postcard, this one of a white cat sitting on a table, had its birth and death dates noted on the back: "J.J. born October 1904, died October 12, 1920," which meant this cat had a long and most likely close history as part of a family. These details, although brief, recognize the pictured cats as individuals and acknowledge they had a specific and welcomed placed in human society. The inscription on the photo postcard in illustration 2.16, for example, locates the cat, most likely a store mascot, in Leonardsville, a hamlet in the middle of New York State.

Vernacular portraits often had little or no specific information on them about the cat's identity, personality, everyday behavior, or situation, yet we still learn that at least their owners regarded them as special if not unique creatures worthy of affection. For example, the tuxedo cat in illustration 2.17 attentively rests on the back of a chair for its

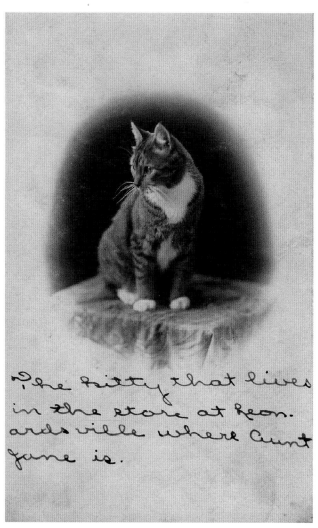

The kitty that lives in the store at Leonardsville where Aunt Jane is.

2.16. The kitty that lives in the store.

portrait at a photographer's studio. Although we know nothing about this cat, not even its name, the shear making of the cabinet card portrait along with the cat's pose strongly suggest that someone or some family regarded it fondly, thoughtfully cared for it, spent time enjoying its company, and "knew" its personality and eccentricities. Some might say that getting this cat to "sit" for a formal portrait in a photographer's studio and to be coaxed to look directly at the camera as though it knowingly posed for the shot might be merely an anthropomorphic trick to create the illusion of formal portraiture, but hardly a sign that the cat is being depicted as a subject rather than an object. We feel this view downplays the symbolic significance

of creating a pet's anthropomorphic pose from the owner's perspective. In this very posing, the owner probably saw his or her cat's individuality coming through—a contrast to ornamental or comically anthropomorphic portraits.

The personal portrait in illustration 2.18 depicts an even clearer anthropomorphic pose. The owner and photographer managed to pose and catch the cat at just the right moment as it stands like a human on its rear legs while resting against a sawhorse and looking directly into the camera.

Rather than using nonverbal, humanlike poses, other personal portraits relied on written comments to depict cats as active social partners, something that anthropomorphic commentary can do (Serpell 2005). Those who mailed these portraits sometimes included information about their pets for friends or family to read. These comments often referred to the cat by name in the message or even had the name inscribed on the photograph. Clinton Sanders (2003) and Mary Phillips (1994) have discussed the power of naming to transform animals from objects to individual beings. Use of a name on a photo postcard demonstrated not only human ownership and responsibility for the animal, but probably some degree of affection and attachment because not only was a portrait photograph of the cat being made, but the cat was marked as an individual by being named.

The portrait of "Duke" (illus. 2.19), for instance, met none of the commercial photographic standards for cute cat portraits. He was not posed looking at the camera, wearing some human costume, or playing with a ball of string. Duke is merely a cat caught on film with his name and the date on the image. Because the photograph reveals nothing about his owners or his domestic life that might make the picture interesting to other people, it most likely served as a keepsake for Duke's human family. Naming and dating the postcard documented their close ties with Duke, enabling the image to be included in the family's photo album, where it no doubt triggered memories of their friendship for years if not generations

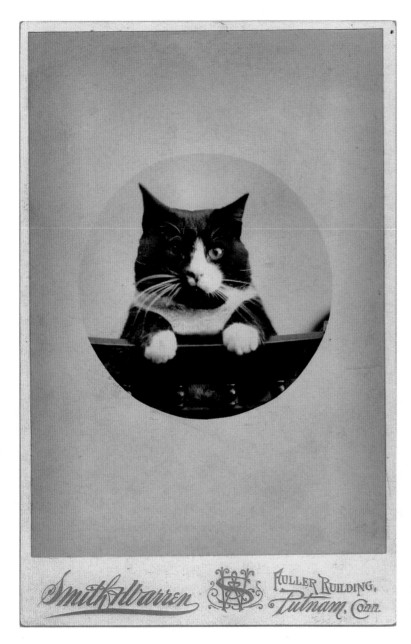

2.17. Tuxedo cat. Smith and Warren, cabinet card. C. Mastrovito coll.

to come. But Duke's owners also wanted to share a picture of him with friends and relatives and reveal more about his personality in the postcard's written message: "Rather of a high minded kitty as you will see. We will try posing him again some day."

Written notes on photographs that made cats appear to "speak" overshadowed such prosaic commentary. Betty the cat (illus. 2.20) appears to have composed a message to "Sport," probably a pet owned by a relative of Betty's owner. After the cat author expresses a desire to be with Sport in the countryside, where it would be easy to run around,

she warns Sport to take care of his grandfather or face a scratching. The writer of this photo postcard is speaking through his or her pet cat, a practice now taken for granted among many pet owners as an indicator of attachment to and affection for animals (Tannen 2004).

More detailed anthropomorphic characterizations of pictured cats drove home the idea that their owners did not regard them as objects. Some postcard writers, in good humor, enjoyed personifying cat personalities or abilities to express their affection for them. Ed, the proud owner of Budge

2.18. Standing cat. R. Bogdan coll.

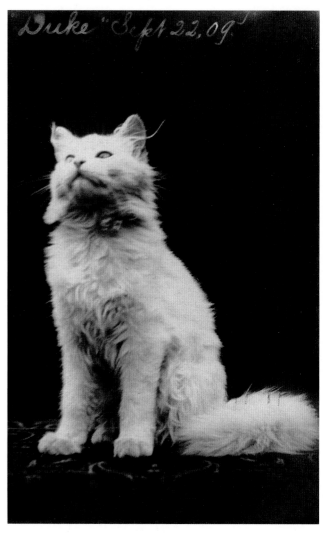

2.19. Duke, September 22, 1909. T. Weseloh coll.

the cat, mailed a photo postcard (illus. 2.21) to a friend in New York State with this humorous description of "Our Budge" on the back: "Budge by name. Dinner not on wheels—buffet service—no tips, napkins, or pickles—no chaffing dish—no experience required to appreciate superiority."

More rarely, portraits could capture pet cats revealing their individual dispositions or personalities in nonanthropomorphic ways. An occasional image might show a cat with a bird or mouse in its mouth or appearing to be startled or frightened, moments that would never be printed as ornamental or cute portraits because they violated the standard for tranquil, well-behaved, and contented-looking cats. The owners of the cat in image

2.22, in contrast, were probably delighted to have their pet's own personality or nature caught on this cabinet card, even though its arched back probably signaled some degree of fear or aggression. Such stretching is something many cats do, but it is not an activity that commercial or amateur portraitists typically sought to capture.

Whether personal portraits caught the instinctive nature of cats or provided an anthropomorphic rendition of them, they were a far cry from portraits that sought only to showcase their objectlike beauty or their silliness as anthropomorphic objects. Although it is easier to see a cat's individuality or nature in portraits of them stretching or catching small animals, they can still be perceived as individuals in

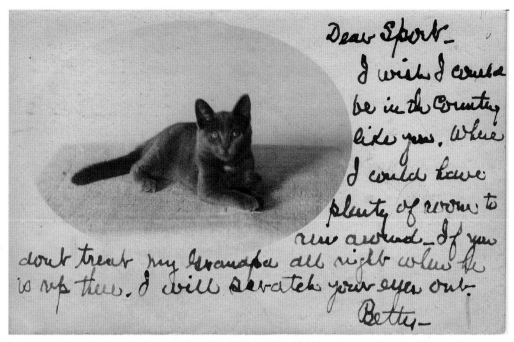

2.20. Dear Sport. T. Weseloh coll.

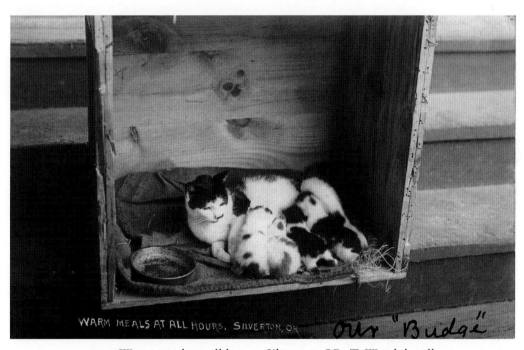

2.21. Warm meals at all hours. Silverton, OR. T. Weseloh coll.

anthropomorphized portraits where anthropomorphism is not of the destructive sort that subverts or denies the pictured cat's individuality. Whether naming them, speaking for them, or explaining their behavior, this use of anthropomorphism in the early twentieth century might have been the only way owners could communicate the sentiment that they regarded their cats as individuals and subjects. Vernacular portraits, whether anthropomorphic or not, strove to represent cats as friends, reminding

2.22. Cat with arched back. N. Maciejunes coll.

the images' viewers, whether one hundred years ago or today, that a relationship, most likely a close one, existed between the pictured cats and the people in their lives.

A FEELING FOR THE SUBJECT

On the one hand, we have seen that most ornamental and comedic portraits separated cats from their everyday lives and their animality by presenting them as still-life objects or by using a weak form of anthropomorphism to depict them as mere decorations or tools to elicit a laugh. That cats were depicted as objects, whether as a form of still life or as a human toy, relied on the photographer's ability to dislocate the cat model from any real context, a practice paralleled in some human portraiture. For example, Liam Buckley's (2006) study of studio portraiture in West Africa shows how photographic images can dislocate subjects from their everyday context by separating them from their surrounding material culture. As Gambian nationhood emerged during the postcolonial era, an ideal image was advanced of the good citizen who was prosperous and content with his or her comfortable surroundings, even if this were not the case. Individuals having their portraits taken would routinely be pictured in an elegant parlor with lace-covered tables and modern televisions that was a far cry from the subjects' real homes.

The same kind of subject dislocation was easily accomplished in cat portraiture a century ago. Indeed, as with any studio photograph of a person, it was easy to leave out details of cats that would conflict with the desired image because the photographer could pose an expressionless subject in front of a blank background facing the camera and then perhaps add in other beautiful objects, such as vases of flowers or bowls of fruit, to cement the visual effect of cats as still life. The result was that studio and commercial portrait photographers at the beginning of the twentieth century completely

dislocated the pictured cat from its everyday behavior, stripping away its individual character and in so doing making it difficult for the image's viewer to have much if any sentiment for and connection to these lovely but lifeless ornaments.

Dislocation could also be accomplished by anthropomorphizing cats in portraits. Whereas ornamental portraits pictured cats as still life, comedic portraits suggested otherwise: cats were to be regarded as unstill life, but the life they had on the image was just a parody of being human that poked fun at differences between species by making them seem the same. Nevertheless, these portraits moved away from viewing cats as pure objects by exploiting similarities with humans rather than differences between the species. By contrast, late-nineteenth-century ethnographic photo portraits of the black female body were a spectacle that exploited differences between humans (Willis and Williams 2000). Under the guise of education, photographs of black women on display at World Fairs and similar exhibitions allowed white "civilized" people to consider the "primitive" and to categorize the "Other" in a diminishing way. Photographed cats became interesting for people to look at not because they were unlike us, but because we could imagine their likeness and make an emotional connection to them. And even if the connections were fleeting and illusory, viewers could still imagine nurturing these cats, could laugh at their antics, or could feel sympathy for their plight.

On the other hand, many portraits in this chapter grounded cats by giving them thoughts and feelings or some social and personal context. Most political and personal portraits depicted cats as more subject- than objectlike by using a deeper anthropomorphism or by capturing cats candidly as they expressed their animal nature and distinct personality. Although anthropomorphizing cats in a comedic way subordinated them as objects by ignoring their individual "catness" and real-life situations, political and personal portraits suggested that cats were sentient creatures who had individual personalities, lived in unique situations, and were ensconced in relationships with particular people. It was not the cat's image that suggested its individuality and tie to humans, but how the image was elaborated with accompanying text, which clarified this relationship and left little room to doubt its existence. Personal portraits hinted at the connections people might have to cat subjects by writing on the photographs about their attachment to and sentiment for them, noting their names, or anthropomorphically speaking about or through them.

It should be no surprise that we found these contrasts. Scholars have noted humans' inconsistent treatment of animals, wherein they accept some as adored members of the family but kill others for sport or food (Arluke 1989; Herzog 2010). This contradictory stance toward all kinds of animals has long historical roots, documented in photographs of them a century ago (Arluke and Bogdan 2010) and, as we saw in this chapter, apparent in portraits made of cats. When all types of cat portraits are considered as a set, they mirror the broader cultural view of animals then: one minute they were objects with whom one had no human connection other than to admire their beauty and then the next minute they were subjects with whom one had some feeling for as sentient beings and perhaps as personal friends.

As subjects rather than objects, the cats depicted in the latter type of portraits set the stage for a more complicated and nuanced visual relationship between humans and cats, inching closer to photographing friendship between the species. Doing so in photographs required, at minimum, the addition of human subjects who could be shown coupled together with cats as a unit. Creating these interspecies tie signs on film was an accomplishment.

3

Two as One

to admire for their beauty or cuteness or to laugh at as silly caricatures of humans. Yet not all portraits, as we saw, rendered cats as mere objects. Some reflected deeper sentiment for imaged cats as friends and respected individuals. Although often humanized, these cats appeared as subjects having thoughts and feelings, their own personalities and life experiences, and relationships with humans.

Because these photographs are stand-alone portraits of cats, we cannot see how people might have behaved toward these animals or what kind of human–animal relationship they would have created and documented on film to remember and share. But we fortunately also found hundreds of images of people interacting with their cats, many depicting what appear to be very close relationships with them, sometimes remarkably so. We see glimpses of what seem to be intimately rewarding moments: people presenting themselves as being familiar with their cats, behaving warmly toward them, and reaping emotional benefits from these personal connections.

How did photographs depict these close relationships between people and their cats? In the arena of public life, individuals who are in each other's presence reveal their mutual attachment for others to see and understand by displaying what Erving Goffman referred to as "with markers" or "tie signs" (1971, 65,). They touch, smile, gaze, and interact with each other (Guerrero and Floyd 2006) to create an impression of being connected and anchored together. These signs are important for the everyday functioning of the social order

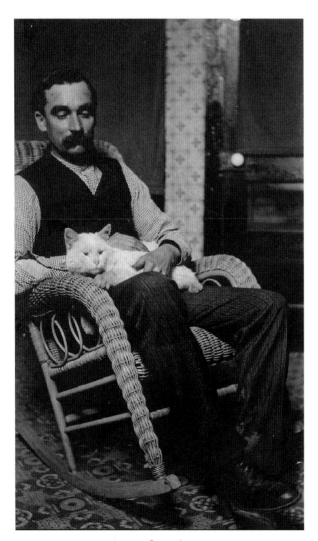

3.1. Serenity.

Photographic portraits of cats entertained people a century ago. Many were light, whimsical images that might have elicited a smile one second and been forgotten the next. These cats were objects

38

because they provide simple tools for strangers to classify others and for intimates to remind one another of how they want to be regarded.

People and their pets also display ties that show onlookers that they have a relationship of some significance. Many pet owners feel their animals are far from being mere objects, seeing them as having distinctive personalities based on unique personal characteristics and whatever else can be attributed to them (Sanders 1990). Owners in turn use this definition of the other to orient themselves toward their animal friends (Bulcroft, Helling, and Albert 1986; Hearne 1987), which affects how they act toward their pets and even how they view themselves. The animals become extensions of their identities (Belk 1996), a unit in their minds. The owner enters public places and situations as a twosome with his or her pet and devises plans of action that require some degree of cooperation for both of them to adjust their behavior according to these shared understandings (Sanders 1999).

This intimate connection and the mutual orientation and control it implies are played out and expected (sometimes even legally required, as in the case of "leash laws") when owners and their pets appear together in public settings. Using leashes, having a mutual gaze, making physical contact (e.g., petting, nuzzling), calling the animal by name, and enacting a variety of other interspecies tie signs publicly demonstrate that the animal and owner constitute a couple.

Human–animal tie signs can also be detected in early-twentieth-century photographs of people with cats. Whether these signs were deliberately posed or unintentionally displayed, cats are clearly pictured as paired with humans rather than as characters incidental to the scenes caught on film and appear to provide comfort and joy to the humans in the photograph. Although these images are static and two dimensional, capturing this friendship and the intimacy it entails was a dynamic process involving those depicted and those viewing them a century ago, a process that can also be seen today. Owners, cats, photographers, and viewers all conspired

unwittingly to create and see an emotional dialogue or communication about close relationships between species in the images. People assumed certain poses with their cats, perhaps coached to do so by their photographers and sometimes aided by cooperating cats, to tell a story about being together. In turn, contemporaries or others decades later viewed these completed images by drawing on personal and cultural knowledge to make sense of the poses.

We take two approaches to these photographic stories. As presentations of self, they display how people wanted to remember their cat relationships and how they wanted others to see them, too. From a dramaturgical perspective, the pictured human and cat appear as a unit tied together by a special emotional bond, a connection that may or may not have existed. We want to expand Goffman's approach to allow for authentic rather than mere theatrical presentations of feelings. Although Goffman dealt with feelings as well as thoughts and behavior, he focused only on embarrassment, shame, and humiliation, and even these feelings are more implied than made explicit in his work (Scheff 2007). As documents, the photographs in this chapter show how people might actually have behaved with their cats, allowing us to infer how they might have felt in their presence. Describing the interactional details of this connection as both a display and a document in photographs sheds light on the behavioral repertoire that built close relationships with pets[1] and the kind of sentiments people perhaps reaped from these ties.

Depicting these close relationships and their possible benefits a century ago likely challenged prevailing ideas about the need to maintain clear-cut boundaries between the species. Home and even studio photography were relatively new on the historical scene. This meant that people could record their

1. Whether looking at human–cat ties from a hundred years ago or today, scholars have not described the microsociology of the human–pet bond, instead focusing on the emotional and physical benefits of this relationship or simply demonstrating its importance to owners.

intimacy with pets for the first time and then easily share these pictures with people living faraway. At least on film and in the imagination of those who viewed these photos, boundaries separating cats from their owners were questioned, lowered, or even broken by relying on visual tropes or cultural clichés familiar to anyone who has ever made a snapshot of themselves paired with a loved one, dependent, or friend. Photographs could suggest that such a bond existed by depicting certain kinds of nonverbal communication between the two beings pictured.

Touching

Adult humans use touch to display interest in and intimate connection to others (Afifi and Johnson 1999). Certain kinds of touch and their placement on the body can imply greater intimacy between people. In photographs, people lean in closer to one another, lay a hand on the other person's shoulder, sit on the other person's lap, or drape their arms around the person next to them to show themselves and others what they purportedly feel for the person with them (Goffman 1976).

We found many photographs of people in physical contact with their cats, although this touch may not have been a sign of togetherness. In some images, the contact's meaning is ambiguous because it seems more practical than affectionate, more controlling than caring. As they posed, human subjects could hold up cats to make them more elevated and prominent, to keep them still enough for a clear photo, or to direct the animals' gaze toward the camera to parallel that of humans in the picture and make for a more uniform image. Of course, these efforts to control the cat's pose might have been done in vernacular photographs to clarify a human–cat bond, but not in those commercially made.

With some commercially made postcards, the apparent connection to cat subjects was more of a theatrical device to create an impression of people coupling with each other rather than with animals. Cats in such photographs could signal love and romance between humans. Kittens, in particular, were favorite photographic props in this regard, perhaps because they stood in for human babies and suggested reproduction. For example, illustration 3.2 visually ties the man and woman

3.2. Romantic cat.

together through the kitten, cementing their affection by ensuring that they look directly at the cat while touching each other as well as the kitten, who sits perched between them on a pedestal, staring back at the camera. It is as though the romantic symbolism of the kitten rubs off on the image's human subjects in their touching of it and each other.

Photographs also probably did not depict genuine friendship between human and cat subjects when the former were infants. Infant–cat photos were commonly made at this time, often for the rest of the family to have a visual record of their precious child and perhaps cat, too. However, even in these staged studio portraits, babies were often portrayed in a dyadic relationship with the family cat by having the child touch the cat's head, paw, tail, or back. The photograph to the right of the title on this book's cover is one example of many we found.

Yet in other photographs touching suggests a more meaningful connection between humans and cats, rife with genuine interest and affection for the latter. Gestures admittedly often arise as a by-product of a practical action (Streeck 2009). Touching cats in photographs might have served to control their pose for a clearer or better-composed image, but it also could communicate the idea that the animal was deeply ensconced in a relationship with people. Photographs resorted to organizing their human and animal subjects by using touch and strategic placement of figures to establish the cat's importance, a visual technique also used in turn-of-the-century portraits of adult couples, where the man is displayed as the central figure while the woman appears to be incidental (Goffman 1976). The woman stands behind or off to the side of the man yet lays her hand on his shoulder to visually confirm their connection to each other. Photographs of cats and their owners used a similar pose to emphasize the picture's main focus on the animal while linking the two. In these images, the cat is centrally placed with the human behind

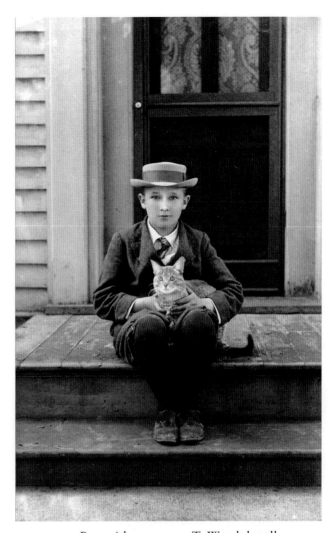

3.3. Boy with cat, 1901. T. Weseloh coll.

and touching it, as with the boy and his Tabby in illustration 3.3.

The touching of cats in photographs can literally depict a closer connection to them and also be used to aim the animal's gaze. The man in illustration 3.4 securely holds his feline friend while directing its eyes toward the camera to make sure the cat is clearly seen as part of the pictured family and an active participant in the image's making. In addition to the holding of this pet in a way that symbolized its importance to these people, the leash, a very unusual accessory for cats then (Grier 2006), is another tie sign in the image. The man's grip on the cat, the uniform direction of everyone's gaze,

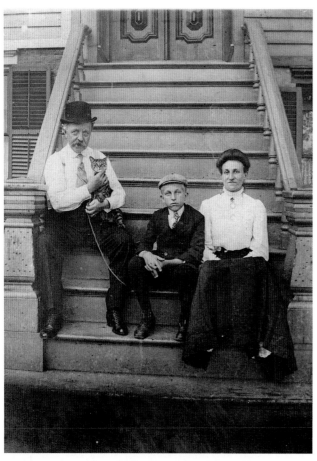

3.4. Leashed cat. R. Bogdan coll.

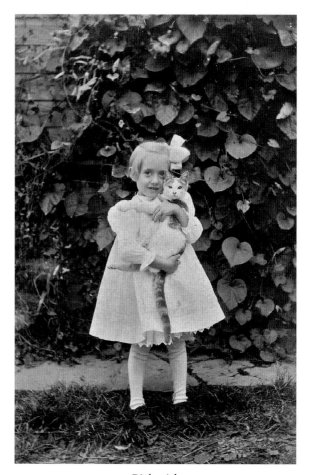

3.5. Girl with cat.

and the attached leash leave no room for misinterpretation by structuring the viewer's perception of these subjects as one unit.

Other ways of depicting touch elaborated the emotional story that photographs told about the connection between people and their cats. Holding up cats to be closer to the level of the human subject's face helped to visually minimize their status differences while connecting the two. Many photographs of kittens and adult cats show them being cuddled and raised high enough so that their heads are close to and about the same height as that of the human in the photograph (illus. 3.5).

In some images, owners' faces were brought close to or actually touched the cats' heads to graphically present the owners as intimately paired with their animals. In illustration 3.6, the woman not only smiles, as if she were a parent cradling her beloved baby, but also tenderly positions her cheek against the cat to make her sentiments visually clear. Through her touch and pose, the image's tie signs indisputably link the two as one.

Instead of lifting the cat to her face, the girl in the cabinet card in illustration 3.7 lowers her face to the cat's level. As she rests herself against the cat in this elaborate studio pose, their heads are almost but not quite level, suggesting a near equality of status and the appearance of close friends. The fact that the cat's head in these photographs is never at or above the same height as the human reflects both a simple disparity of size and a subtle image of subordination taken for granted by the photographer and viewer, akin to the positioning

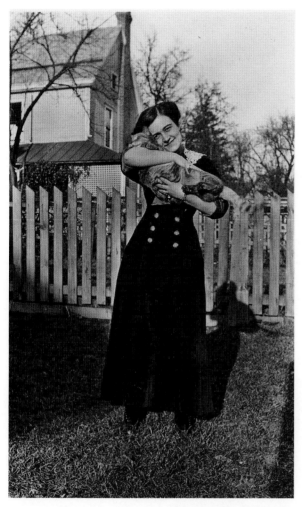

3.6. Cradling cat to face, c. 1909. T. Weseloh coll.

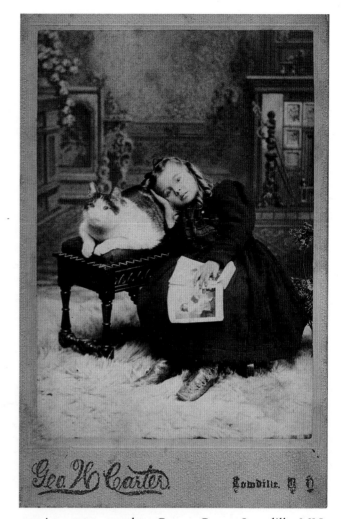

3.7. A moment together. George Carter, Lomdille, MN.

of men and women in advertisements according to Goffman's (1976) study.

Greater intimacy is suggested by depicting people sleeping in bed with cats. The convention in Western societies of two people sharing a bed is symbolic of shared intimacy, a time of vulnerability, and their status as a couple (Hislop 2007). Depictions of this romantic image manipulate position and touch to communicate the idea that the couple feels mutual trust, security, and comfort in each other's presence. The child in the French photo postcard in illustration 3.8 sleeps with her arm gently wrapped around a sleeping cat who is sharing the bed. The image of these close friends, although obviously staged for commercial purposes, reminds those looking at it that such a close moment in real life is one of intimacy, calmness, and contentment.

A different kind of slumber is captured in illustration 3.9, a best-selling souvenir photo postcard from San Francisco Chinatown tours. It shows a man lying down in an opium den with his cat. Opium smokers usually assumed a sleeping position, in part because the pipes were so long and easier to manage lying down, but also because the smokers became relaxed and tired. The man's arm draws the cat close to his chest as they share a few minutes of altered consciousness together. If it is not visually clear that the two are good friends, the card's inscription adds that the cat has also

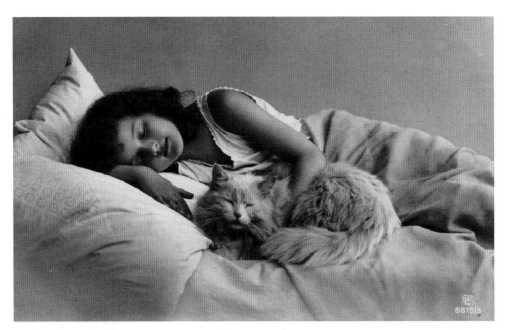

3.8. Sleeping with cat.

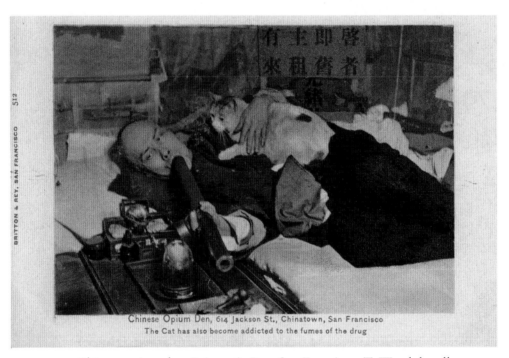

3.9. Chinese opium den. Britton & Rey, San Francisco. T. Weseloh coll.

become "addicted." No doubt, the social marginality of smoking opium, combined with the man's drug-induced mental state, allowed for the cat to be positioned above rather than below his head.

Those looking at these images need not know the subjects to conclude they were together, whether they were actually paired in real life or feigned this relationship for the photo. Touch, above all tie signs, conveys intimacy (Guerrero and Floyd 2006), so that physically connecting or relating these human and animal subjects easily suggests that the two had an emotional communication

with each other and a sense of mutuality. The positions of their hands, heads, and entire bodies point to a close relationship involving warmth and affection, if not more intense feelings.

SMILING

Other photographic tie signs suggested the subjects' pairing but implied different feelings as a result. The two could be linked through facial expressions, such as smiling, that are often interpreted as signs of affection and interest indicating that two people are socially engaged (Kraut 1979) or together in some capacity, perhaps only as passing friends or even as intimates who care deeply for one another (Afifi and Johnson 1999). But smiling implies even more; humans universally read this expression as a sign of joy (Ekman, Friesen, and Ellsworth 1972). In the photographs we looked at, smiling not only showed someone's connection to the pictured cat, but also his or her satisfaction and pleasure when with that cat.

That people smiled to show joy while being photographed hardly sounds unusual by today's expectations for making studio portraits or everyday snapshots; we often expect subjects to smile, whether they are posing with animals or not. However, smiling in front of a camera was rarely done a century ago because it was considered ill-mannered and lower class (Morey 2012). As a consequence, people were usually not prompted to smile for the camera, nor were they prepared to do so on their own. That they sometimes did so is all the more telling for what this expression said.

Despite this prohibition, we found many photographs of people smiling at their cats, a practice also common in dog photographs of this era. The smiling young woman in illustration 3.10 is one example of many. She appears to be quite happy holding the cat in her lap on the front-porch rocker. An image of happiness might well have been the memory that she sought to record permanently on film for her own enjoyment years later or even long after the cat's death.

Gender norms existed that discouraged men from smiling in front of the camera; however, these norms were relaxed when it came to photographing young boys (Wondergem and Friedlmeier 2012). It is not surprising, then, to see photographs like the one of the happy lad and his Calico (illus. 3.11). Lifting chest high his large pet may have been no easy feat for the boy, but the joy accompanying this pose seems unquestionable.

Although adults did not smile as commonly as children in photographs of cats, they sometimes did, but those who did were almost always women or elderly men. Illustration 3.12 is one exception to the rule. Two adult males sit for their portrait, one of them allowing a small cat to perch in his lap.

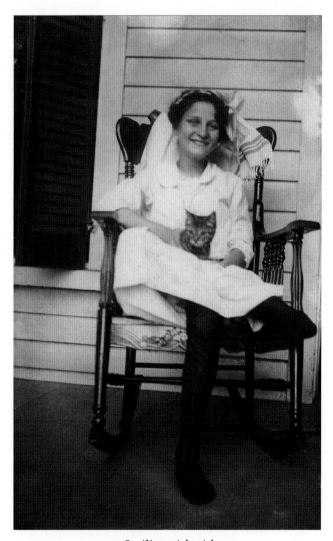

3.10. Smiling girl with cat.

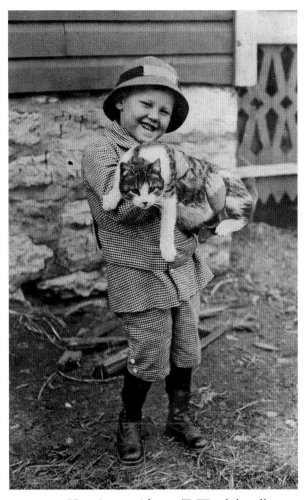

3.11. Happiness with cat. T. Weseloh coll.

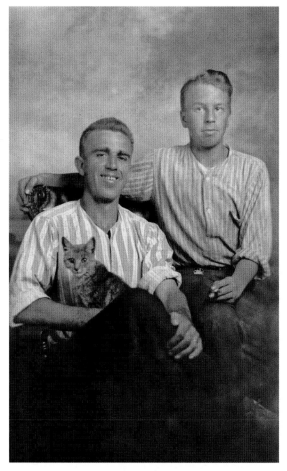

3.12. Two men with cat.

He is unable to keep a stern face when posing with his cat (3.12), although his smile is more restrained than those of the children in the previous two illustrations. The pleasure of holding his cat could not be held back from the camera; his companion's apparent sternness is more typical.

Smiling at a pet obviously cannot be reciprocated in kind, but smiling in photographs can tell us something about the human subject's connection to his or her cat. In addition to being a tie sign that depicts affiliation and friendship, smiling as a presentation of self entails positive feelings as well as theatrical behaviors. We attribute happiness, contentment, joy, humor, and wryness to a smile in everyday life, and the same interpretations can be made of smiles in photographs of people with cats.

ACTIVE PLAY

Other photographic tie signs in early-twentieth-century pictures suggested that subjects were paired and experienced positive feelings as a consequence of that pairing, but they also implied that another and equally important feature characterized the human–cat relationship: a joint mental state or collaboration. Images of cats being played with provide a tie sign easily grasped by those who have had a pet and even by many who have not. They understand that people can "lose themselves" in the moment when playing with animals because the activity is so focused and engaging. But they also probably know that play entails some degree of knowledge about one's pet and communication with the animal (Sanders 1999).

Playing with cats can involve a range of behaviors, including but not limited to performing tricks, chasing objects, petting and stroking, teasing, and fooling with small objects such as cloth tied to a string or a toy. Commercially produced catnip was available early in the postcard era (Grier 2006) and probably served as an aid to encouraging such play. Yet capturing these antics on film, especially if owners were part of the image, was no easy feat. Cats are usually outperformed by most dogs when it comes to learning tricks and doing them on command for a photographer. In this regard, illustration 3.13 is a stark and perhaps humorous reminder of this common difference between these two domestic species. Cat fanciers might point out that the cat in this photo is looking at the dog with disdain or irony for its obseqious behavior, instead choosing to sit aloofly on its pedestal, putting itself, literally and figuratively, above such prosaic performances.

The girl in illustration 3.14, too, was unable to get her cat to respond for the photographer, but even in the cat's failure to perform the picture tells a story about human–animal friendship. The girl seems to be gesturing to one of her cats to jump into her lap or even sit up for a treat. Yet even such failed attempts to get the desired response from a cat are still a form of play that depicts a special closeness between human and cat.

Some attempted tricks could be elaborate and staged, involving multiple cats and props. Despite

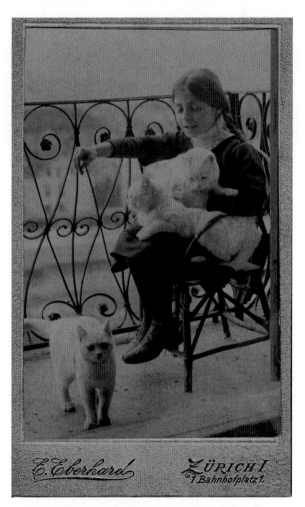

3.13. Boy with cat and dog. T. Weseloh coll.

3.14. Uncooperative cat. T. Weseloh coll.

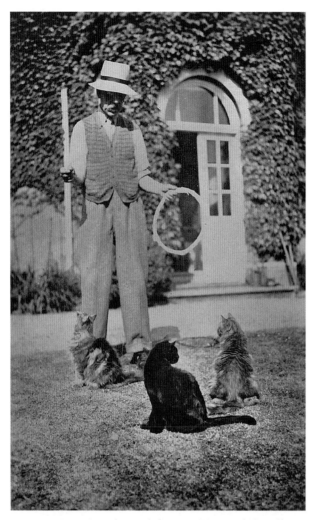

3.15. Jumping through hoops. T. Weseloh coll.

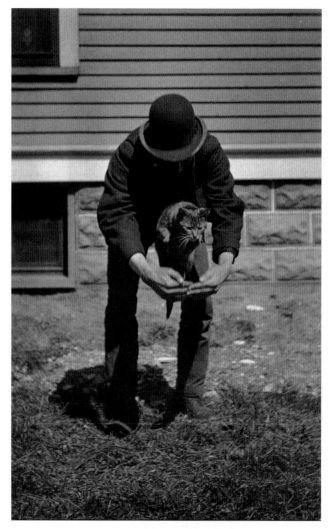

3.16. Playing with cat. T. Weseloh coll.

his intent to photograph such a complex trick, the man in illustration 3.15 could not get the cats to perform for the picture. Although this scene might have been merely staged, it seems likely that the cats were capable of running through the hoops. Either way, the photograph communicated the idea that the man and his cats had "known" each other long and well enough to have learned this trick. They were a team.

Although photographs of cats failing to perform tricks were common, they nevertheless depicted a human–animal relationship. That such ties existed was even more apparent in the few images we found of cats actually carrying out a trick. Dogs could easily be taught to perform simple

tricks such as sitting or giving a paw, but some cats could, too. The owner in illustration 3.16 created a hoop with his extended arms for the cat to jump through dutifully. He apparently enjoyed the trick and cared for his cat so much that having his own face in the photograph was unimportant. It is unlikely that this jump was a fluke; more likely, the man and his cat had worked at this stunt over a long time as part of their playtime together. It is apparent that the two are a well-coordinated duo.

Not all photographs of active play—or its attempt—with cats involved tricks. Even if cats were unable to perform a trick on cue, owners could still play with them in other ways and photograph these

moments together with their pets. For example, people could pick up and hold their cats in humorous poses, although we found only images of men doing this. These light moments convey the idea that the two are "only playing" or just "roughhousing" together, but not in a mean-spirited or harmful manner. By depicting this sort of play, the "holdup" in the photo postcard of illustration 3.17 lets the viewer know in no uncertain terms that man and cat are old friends.

Simply teasing cats, perhaps with a stick or small toy, qualified as a form of play, at least when their pictures were getting taken. That was apparently the technique used by the woman in illustration 3.18, who provoked the couple's cat to react for this image. Waving something in front of the cat makes it respond to and be active with these people. Hardly just an ornament here, the cat is shown interacting with them, a sign of their connection.

Another kind of play with cats was to dress them up and then take their picture. Photographs caught some young female pet owners posing their cats this way as a gender-appropriate form of play. This anthropomorphizing of one's pet mirrored and mocked the closeness of animals to humans while visually cementing the ties between them. The girl in illustration 3.19 is having fun playing dress-up with her cat, Petunia. Either Pam or the photographer has deliberately positioned Petunia, who is wearing a dress and hat, to look at the camera and strike a pose as if she were a baby.

Depicting active play between people and cats demonstrates a particular kind of human–animal

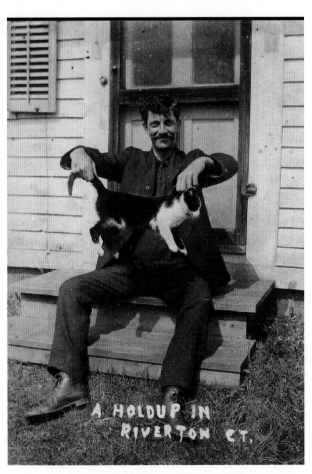

3.17. A holdup in Riverton, CT.

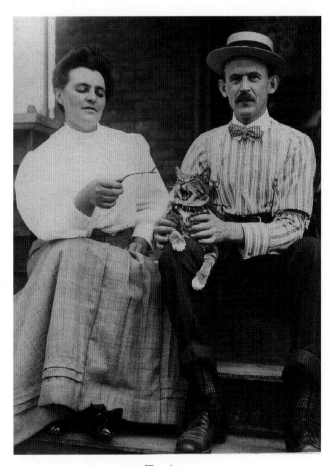

3.18. Teasing a cat.

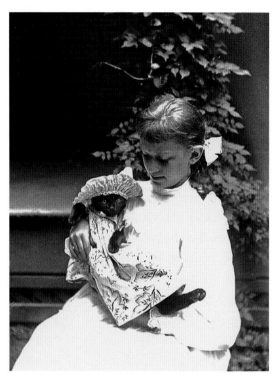

3.19. Pam and Petunia. C. Mastrovito coll.

communication, one that in everyday life requires those playing together to have a mutual understanding or awareness of each other, so cues can be made, interpreted, and responded to appropriately (Sanders 2003). As a form of interaction, human–animal play grants that the latter is an agent in this context rather than a mechanism only reacting on cue (Lynch 2006). Those who play with their pets routinely grant such reciprocity and agency to them (Alger and Alger 1997; Sanders 1993) and are reminded of this collaboration in the photographs they take of them. Whether familiar with the pets at play or not, both intimates and strangers alike can recognize the apparent friendship suggested by these images.

IDLE PLAY

Other human–animal tie signs in photographs suggest not only the presence of joy and collaboration in human–cat relationships, but a sense of calmness, if not well-being, where communication

is easy and words are not required. Aaron Katcher and Alan Beck (1983) call this distinct kind of interaction between humans and animals "idle play," where one's pet becomes an extension of one's identity instead of just being part of a dyad. Although the term *play* is somewhat misleading because it suggests active physical engagement with an animal, Katcher and Beck are correct in noting that the sheer company of animals can create a sense of oneness between humans and animals that has a powerful calming effect on people (Allen 2003).

Our search for early-twentieth-century cat photographs revealed many examples of idle play in which the human subjects appear tranquil and "still," presumably because they were sharing an intimate moment with their close animal friends. In these images, the human subject's gaze need not be fixed on the cat. Their eyes might be unfocused, as if in reverie. They might even be asleep, looking safe, comfortable, and secure. Exactly this sort of peacefulness seems evident in this chapter's lead photograph (illus. 3.1) and in the backyard scene caught on film in illustration 3.20.

Just photographing someone sitting with a cat can define the two as engaged in idle play, where singleness and harmony between human and animal are inferred. One example is the British real photo postcard of a girl contentedly sitting on a bench staring at the photographer while stretching her arm above her sleeping kitten (illus. 3.21). Both girl and kitten share a tranquil moment together.

People are also shown staring randomly into the distance without an apparent focus, perhaps mentally drifting from the scene, while touching or in close physical proximity to their cats. Pictures of pet owners adrift were usually only of adult women, reminiscent of the portrayal of women as mentally absent in modern advertisements (Goffman 1979). The difference is that the women in the advertisements appear vacant or not present, whereas the women in the photographs we found appear to be in a state of deep comfort, calmness, even bliss, in part if not entirely due to

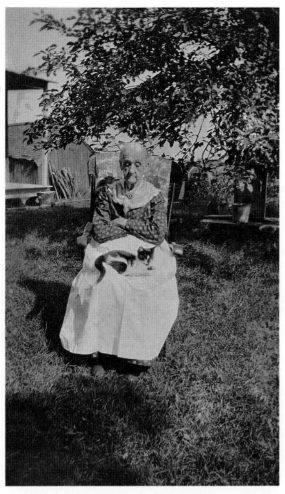

3.20. Napping with cat. T. Weseloh coll.

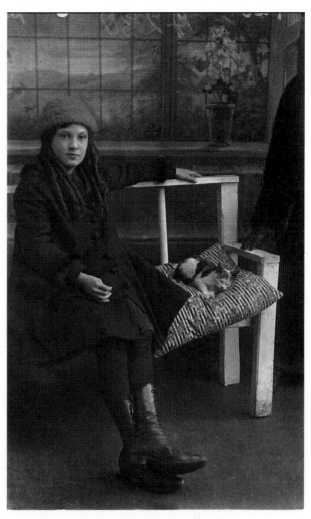

3.21. At peace on a bench.

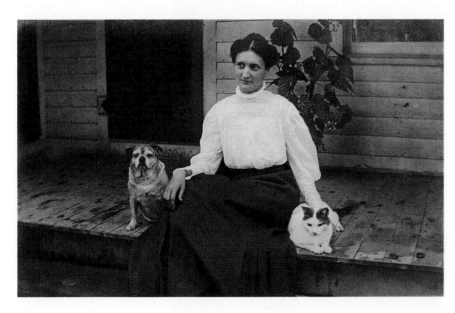

3.22. Together on the porch.
T. Weseloh coll.

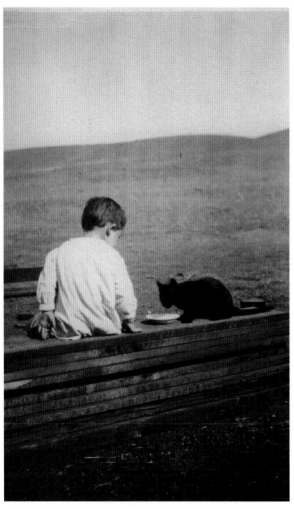

3.23. Watching the cat eat.

the company of their cats. The woman in illustration 3.22 appears to be occupying just such a private, still moment with her cat and dog on the front porch of her house.

Gaze can be used to portray idle play. Human subjects in these photographs can be looking in the direction of their animal friend, perhaps noticing its activity or admiring its appearance. In the photo postcard that captures a boy and the family pet, for example, the boy quietly sits watching his black cat eat, seeming to enjoy nothing more than spending this leisurely time together (illus. 3.23).

Portrayals of idle play suggest that people are "lost in the moment" when near their cats. Some photographs simply show the human subjects alone with and staring at their cats. The woman and two cats in image 3.24 appear to be experiencing one of these special moments. The photograph catches their body language in a way that suggests this mutuality. The woman seems to be leaning forward to face and be closer to her cats. Although we cannot see her eyes, she seems to be making eye contact with her cats, a display often perceived as conveying more affection than when people have broken or no eye contact with others (Burgoon, Coker, and Coker 1986).

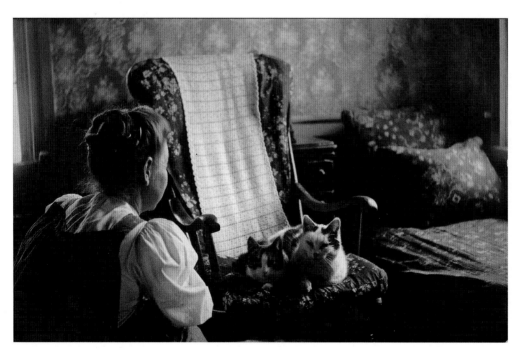

3.24. Staring at cats.
T. Weseloh coll.

Other images suggest idle play through physical contact with cats as human and cat share a peaceful moment together in an incidental rather than deliberate way. Such idle play appears in the photograph of a man quietly reading next to a wood-burning stove as his cat sleeps atop his shoulder (illus. 3.25). Neither the cat nor the man focuses attention on the other, yet both are probably aware of being together at a less than fully conscious state. Their identities almost merge into one.

If there is more intentional contact during the pictured idle play, a cat might sit quietly on someone's lap as its owner mindlessly strokes its fur. We saw many photographs depicting just this sort of

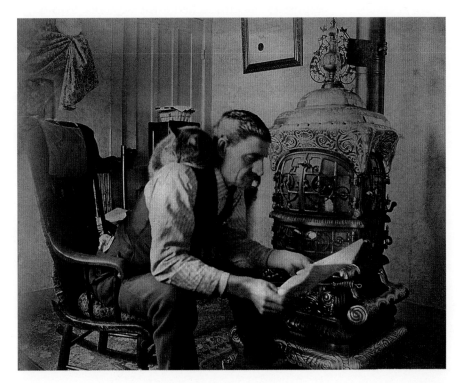

3.25. Man reading with cat. T. Weseloh coll.

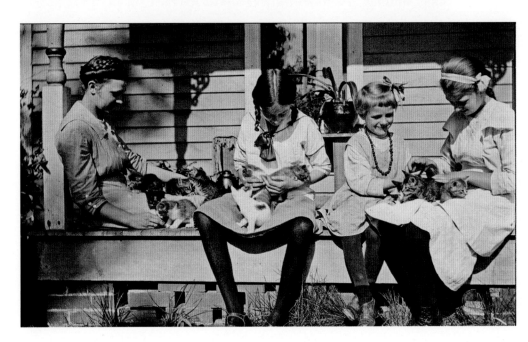

3.26. Idle moment with kittens, c. 1913.

interaction. In one photo postcard, a mother and her three daughters look at, hold, and pet their eleven kittens while on their porch (illus. 3.26). Inscribed on the back of the card is the simple but heart-felt message, "The happy family—11 cats, find them."

Depictions of idle play captured serene moments between people and their cats. Although these moments were not special events such as holidays, birthdays, or other times considered to be major symbols of friendship when shared with significant others (Baxter 1987), they were probably almost as important to the humans in these images. Indeed, these photographs, more than just a visual reminder that the people in them had a close friend, add some meaning to this intimacy by hinting that idle play existed between the humans and animals pictured in them.

Bliss

Tie signs in photographs can visually couple humans with animals, linking the two as a unit or pair. The symbolism of these signs resembles that in contemporary photographs of people paired with one another. These symbols suggest that humans and cats are emotionally connected and coupled by showing them to be touching, smiling, playing, and sharing moments together. But, as we noted earlier, Goffman's approach to tie signs does not deal with feelings associated with these gestures and expressions because he was concerned only with the structure of interaction rather than what these forms might mean to actors displaying them. Our approach has been not only to study the impressions people give in photographs, along Goffman's lines, but also to consider how such role play might be experienced.

People in these photographs appear to display a state of mind, whether felt or contrived, that can develop when humans are in the company of cherished pets. This animal-inspired mental state is a sociological phenomenon influenced by the presence of another being and expressed in the tie signs between them, as happens in human intimate relationships (Anderson, Guerrero, and Jones 2006) when the presence of a partner produces affection, serenity, safety, and trust (Beck and Katcher 1996; Turner, Rieger, and Gygax 2003).

This intimate state of mind has been linked to possible health benefits for humans. Although this link is far from proven (Herzog 2011), some evidence suggests that pet ownership enhances the owners' psychological and physical health. The idea that animal companionship might have this positive impact on humans is a modern discovery, or so we like to think. Yet pet owners long ago may also have reaped this benefit. The images of cat owners in this chapter demonstrate some of the same beneficial mental and emotional states, or at least these states were contrived for photographers to record many decades before scientists hypothesized this connection. Humans in these images appear all the better because of their intimate ties with cats, just as modern snapshots of pets show their guardians to be happy and serene when pictured with them (Katcher and Beck 1983). They look happy, secure, contented, and even blissful with their cats, at least for the time it took to strike a pose for the camera, if not longer, assuming these sentiments were authentic.

Of course, these visual depictions hardly prove that cats provided an intimate experience for the humans in their lives. These pictured emotions should still be regarded as photographic impression management—a sentimental layer of tie signs that not only show the viewer that humans and cats are coupled but show this coupling in a richer, more complex way. From this perspective, the two are not only a Goffmanian "with," but also an emotionally ensconced couple whose close ties enable the animal to shape human affect for the camera to capture and for owners and their friends and family to understand and share for many years to come. However, human–cat ties in

early-twentieth-century photographs did depict more than a union between person and pet. They pictured cats as firmly embedded in hearth and home, thus opening the visual door, literally, to membership in our everyday human world.

4

Domestic Privileges

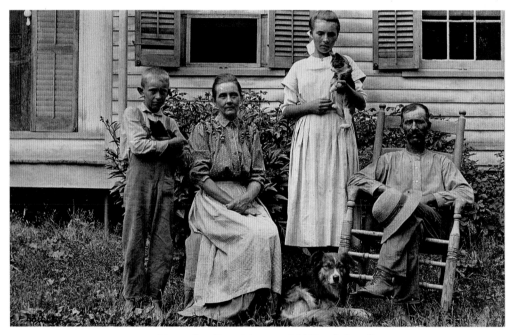

4.1. Farm family with pets. T. Weseloh coll.

Humans have long recognized that animals have thoughts and feelings, but beginning in the late nineteenth century people started to take animals more seriously. Pet owners became freer to express their experiences with their animals and attribute agency and awareness to them (Grier 2006). Those who developed these close relations with companion animals were forced to consider them as individuals. This new form of thinking and feeling about one's pets opened the door, both literally and figuratively, for them to become part of human families.

Although the American middle class kept pets long before the postcard era, the idea that ideal families included pets was gaining traction (Phineas 1974). Pets were becoming a more meaningful part of human family life, not merely as workers or show pieces, but as significant others and "members of the family." Although pets at this time were usually kept outside, closer relations brought them into household routines and rituals, whether they were everyday occasions such as gathering in front of the woodstove after dinner or special ones such as the celebration of Christmas.

However, we should not assume that most families at this time viewed their pets as kin in the way that many people now do. Historical studies

56

suggest otherwise. For example, pet gravestones before the 1980s almost never had monument inscriptions indicating the belief that pets were equivalent to kin, although there were occasional references on tombstones to the deceased animal as a friend (Brandes 2009). Regarding the pet as a real or metaphorical relative or family member was most likely the exception than the rule.

Nevertheless, the pet's family role was changing, and photographers documented the growing cultural ideal of including pets within the circle of kin. This documentation was part of the growing popularity of making a photographic record of family life in general (Chalfen 1998). People consider their collection of photographs to be a document of significant events and people as well as a testimony of strong family ties, values, and feelings. Creating such a visual family record and tribute relies on a number of conventions that remind family members or show relatives or friends what the family unit meant to those who created the photographs and what they endured and experienced as a group. Inferences can be drawn both from the manifest content of these conventions because they can provide some information about family dynamics and from their latent content because they tell us how the family wants to be regarded and remembered (Cronin 1998). Thus, these conventions are both a matter of myth because people have been shown to regularly represent families as stable, happy, unified, intimate, and enduring despite a grimmer reality (Hirsch 1999) and a matter of evidence because some degree of authentic emotion and intimacy can be captured on film.

One convention is photographing pets, a practice that today is a regular and even ritual part of family life. Pictures are taken of pets as part of the symbolic code that family members use to organize their experiences and world into meaningful categories (Ruby 1983) and to reinforce their identity as a family, just as members do when they speak about and with their pets (Tannen 2004). They are "producing" or "doing family" by presenting a certain image of themselves and who belongs to their group for others to see and understand (DeVault 2000).

That families include pets in photographs to better define themselves as a family unit does not tell us how they accomplish this visual task. Erving Goffman's (1974) notion of framing social life is a powerful tool to understand how photographs include pets as kin. Frames are interpretations, representations, and simplifications of reality that can be communicated among people. They are tools to tell others "what is going on here," and they accomplish this meaning by packaging rhetoric or imagery in a way to encourage or discourage certain interpretations of the frame. In general, these interpretations are positive because people put forward their most desirable image for others to see.

By looking carefully at this chapter's photographs, we can see how people a century ago framed family life to include cats as members. What these images show us is both an ideal notion of family life (Olson and Hulser 2003) and a realistic glimpse of the everyday dynamics of family members who were embracing the growing popularity of pet keeping by allowing animals to become part of the domestic fold and then documenting that inclusion for all to see, enjoy, and learn from as long as the photographs lasted and as far as they were shared. As we see, these images extended kinship to cats as companions and friends by drawing, however deliberately or not, on theatrical conventions that, according to Goffman, guide everyday human interaction and impression management.

FRONTSTAGE

Goffman (1959) divided social life into front- and backstages, likening these regions to their theatrical equivalents. Frontstage performances are visible to the audience, whereas backstage, away from the audience, people can let their facade down, become more expressive, and reveal more authentic identity. Family members, for example, can usually count on having a bedroom or bath as their private

domain, shut off from the rest of the household activities and certainly from the social world outside the home. It is a place for them to find composure or to let themselves be unkempt, to break from the impressions they convey when outside the home (Collett and Childs 2009). But when family members are on frontstage, they must carry out their performances and maintain control of themselves and how they appear.

Making a deliberate and formal family portrait puts everyone present on a photographic frontstage where they are more careful, contrived, and selective as to what they reveal about themselves and their family. This cooperative effort produces a visual record of the entire group that can be framed and hung on walls, placed on mantels, or glued into albums for family and friends to rekindle memories and feelings for years to come of what and who were family to them. In the period we studied, professional or itinerant photographers made studio-quality portraits of cats with family members that put their best visual foot forward. People often dressed for these special pictures and made sure to include many if not all the humans and animals that defined for them the meaning of family. We found these frontstage images of families from all social classes, as suggested by the clothing worn by the human subjects in the images and by the settings where they posed. However, the bulk of family portraits that included cats appear to have been taken on farms or in rural locations, perhaps because cats were so commonly kept as "barn animals," as shown in this chapter's lead image (illus. 4.1).

It was common in these family portraits to have children rather than their parents or grandparents clutching the cats.[1] When adults were shown hold-

ing cats in formal family portraits, it was usually the grandmother who did so. This pattern might have resulted from cats being identified within the family circle as the "children's pet" in addition to whatever social custom discouraged adult men from posing with them, a matter examined more closely in the next chapter. The photo postcard in illustration 4.2 is a typical feline–family portrait because next to the adults, along with other siblings, are two female children holding their pet cats.

Parents made sure to have their children photographed with special relatives and favorite pets when not getting a picture of the entire family. In illustration 4.3, the family's son is standing next to his cat and grandmother, one hand on his grandmother's shoulder as she sits with the cat on her lap. All three look directly at the photographer and viewer to depict their unity and bond with one another. This picture might have been framed and placed on the home mantel, hung on the wall with other family pictures, or glued in the family album next to photos of grandparents, children, and other relatives.

If not depicting all family members living in one household, some group portraits depicted just the women of the household along with their prized cat companion, often showing them as part of a multigenerational family. Illustration 4.4, for example, shows three generations of women who apparently wanted a photograph to remember significant family ties, both human and animal. When they went outside to pose for the portrait, they made sure to include their pet cat, who is resting comfortably in the grandmother's lap at the center of the image.

Including cats in these group portraits makes a personal statement about the cats' importance to the people in the photographs. But including them also makes a sociological statement about what was considered to constitute a complete, cohesive, if not ideal family unit and home. These photographs do not depict just a place where children are reared, belongings are kept, or people return to (Bowlby, Gregory, and McKie 1997), but a site

1. Dogs in family portraits were usually not held and controlled to this extent because of their larger size and willingness to cooperate in front of the camera. They were often posed at the feet of the male head of household, who perhaps also had his hand on the dog's back (Arluke and Bogdan 2010).

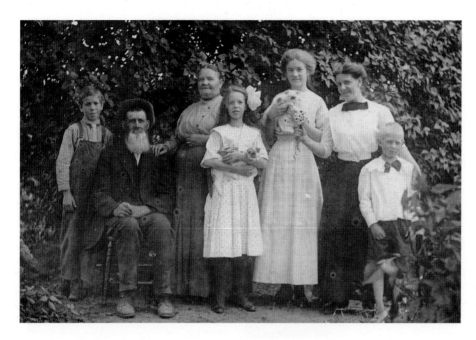

4.2. Family with cats. R. Bogdan coll.

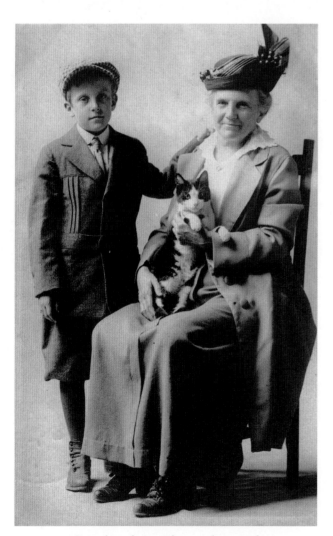

4.3. Grandmother with grandson and cat.

where there is warmth, security, and a safe haven for all, including the pictured cats.

PERSONAL CEREMONIES

Family identities are established and maintained by engaging in social practices that highlight the family's symbolic place in the world (Hermanowicz and Morgan 1999) and announce who its members are to themselves and others (Goffman 1959). One such identity-conferring practice occurs during holidays, reunions, birthdays, and celebrations when families use customary rituals to show themselves to insiders and outsiders. These perfunctory rituals are a way family members express their character, convey their appreciation of others in the situation, and remind people of their family's boundaries and social structure (Goffman 1967).

Photographs of ceremonial rituals can establish the status of cats as kin by documenting their inclusion during these special family events. Favorite cats were not just photographed with humans at any time or during prosaic routines; they were also paired with their owners at the most important family moments and celebrations. Through these images, the events and those present would be recalled and talked about over the years. One

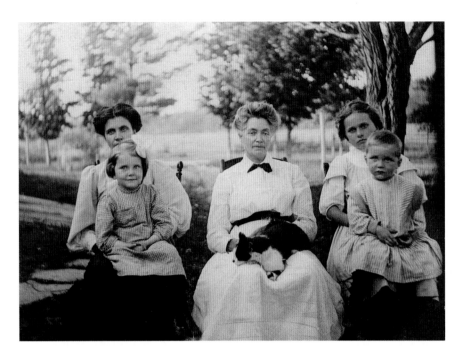

4.4. Three generations with cat. T. Weseloh coll.

such important occasion was a birthday. To celebrate and remember this day, a boy or girl might hold their favorite cat to have their picture taken together, as was done in illustration 4.5 for this child's sixth birthday.

Cats were also present at July 4 festivities, Memorial Day parades, school graduations, and Christmases. Photo postcards were sometimes taken of individual family cats posed on a chair or stool and then mailed as Christmas cards, perhaps with an inscription reading: "Blackie comes with Holiday Greetings to you all." The older couple in illustration 4.6 chose to include their pet cat in a photo postcard celebrating Christmas, showing the three sitting next to the family's Christmas tree. The man's hands rest gently on the back of his lap cat. Perhaps this card was sent to distant friends and family to celebrate the holiday or kept as a reminder of the cat's importance to the couple's experience of close family bonds at this time of the year.

Holiday cards more commonly featured family members with all their animal companions, including but certainly not limited to their cats. The result was a memorable group image for friends and relatives to enjoy and likely keep in the family

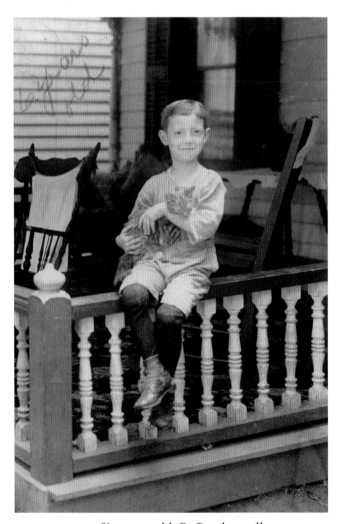

4.5. Six years old. R. Bogdan coll.

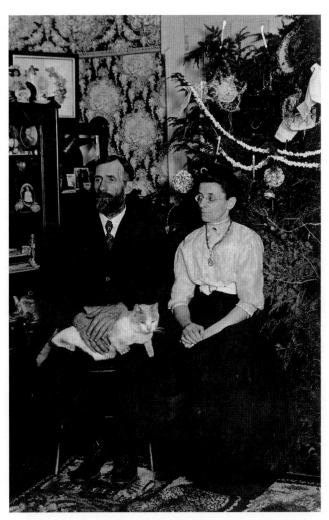

4.6. Couple with cat at Christmas. R. Bogdan coll.

album for future viewing. Although the scratched "Merry Xmas" message on the photo postcard in illustration 4.7 is difficult to see in the reproduction, it is part of a Christmas greeting in which the family made sure to include their cat and dog. The dog is perched on the hood of the family's proud new possession, an automobile, and their cat, in order to be seen, is held up in the window. The picture captures the family's pride in both their automobile and their pets.

Other kinds of family celebrations were photographed with cats. Important news or events were happy times shared among friends and family, creating an intimate moment worth remembering. Purchases of new homes, announcements of babies or marriages, promotions at work, or graduation from school were occasions to celebrate with those close to the photographed individuals. We found pictures of cats being enlisted as participants in such revelries. The three women in illustration 4.8 made sure to include their cat prominently by placing him on a plant stand in the middle of the group as they raised their glasses high to toast an unnamed event, perhaps a reunion or birth announcement. To properly depict this ceremony as a ritual of inclusion, the photographer or the persons in the

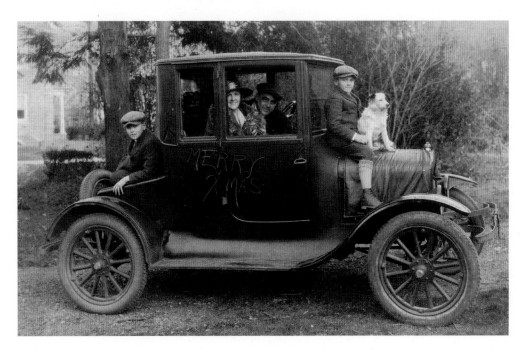

4.7. Family with car and pets, c. 1920. B. Nelson coll.

picture did not place the cat on the sidelines of the image, but rather in the middle of the social action, elevated to a position firmly within the celebrating group. Such strategic placement of the cat during the pictured ceremony was a way to say that each of those present, whether human or animal, was oriented to the gathering as a whole and devoted to the spirit of the occasion (Goffman 1963a).

Cats were not just included in special holidays and celebrations at home; they also were part of transitions or changes in family life. One significant transition was the recognition of a child as ready and capable of having and taking care of his or her own pet. Parents strongly embraced the importance of children associating with animals during the nineteenth century, a trend that has continued to the present (Melson 2001), because it was believed that children could learn social skills such as responsibility and duty through pet keeping. This association was considered important and memorable enough to document by making studio-quality portraits of children and their cats at the photographer's store or at home. In illustration 4.9, the boy's family dressed him in his Sunday best and posed him next to his cat. Elevating the

cat on a plant stand increased the animal's prominence in the image and reduced the status difference between the species, a pictorial reminder for the viewer to regard both cat and boy as members of the family.

Relocating to another home, perhaps in another town or state, was one such big event in the lives of American families. Important pets were probably taken from one home to the next, and, if not, they were around the house during preparations for the move. The father and daughter in illustration 4.10 posed with their family cat next to some boxed possessions, soon to be en route to the new family residence.

Including cats in photographs of family ceremonial activities tied them unambiguously to the interior life of the home. Although these images might have served primarily to remind those present of a significant event or holiday, which incidentally included the family pet, they might also have served secondarily to feature the cat as a principal player in the scene and by extension in the family as a whole. According to Goffman (1971), the latter visual device is a ritual of ratification that marks an alteration in the cat's status, showing a

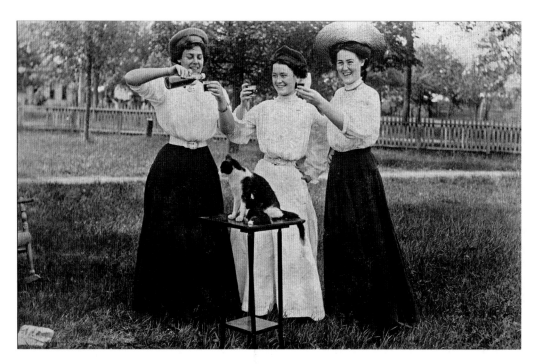

4.8. Celebrating with cat.

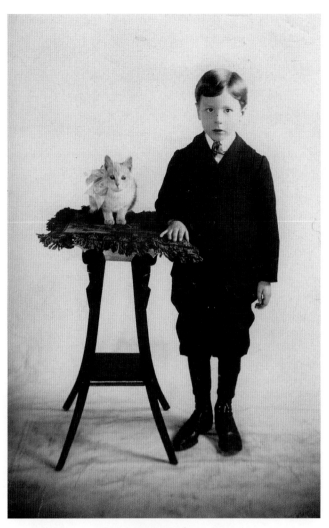

4.9. Boy and cat.

4.10. Moving to a new home. C. Mastrovito coll.

change in its relationships, prospects, and direction in life compared to other animals not so clearly ensconced in family life. The pictured cat can then be thought of as a surrogate family member, obscuring the distinction, even if just temporarily and romantically, between humans and other animals (Shell 1986).

Surrogate Roles

The photographic depiction of cats as family members frequently pictured them in humanlike roles, which is easy to do because pets are frequently experienced as surrogate infants, children, or mothers (Greenebaum 2004; Margolies 1999). This symbolic flexibility meant that cats could be cast as babies, children, juvenile friends, or parents with their own offspring. These proxy roles ask viewers to playfully extend to the pictured cat the same attributes and behaviors associated with and expected of people occupying particular social positions. Once the cat is likened to a human, its visual role becomes an interactional shorthand that allows even those viewers unfamiliar with the pictured cat and human to easily classify and humanize the cat on the basis of whatever cues appear in the image. For those people personally connected to the photographed cat, these associations are already internalized. Indeed, for some owners, these cats are not merely surrogate babies, children, parents, or grandparents. They are family members (Shell 1986) whose photographs become a visual document of their transformation into human beings.

The most direct cues that pet cats were playing these roles are captions or written messages explicitly referring to the cats as family members, saying things such as "our baby King Charles" or "one of our many kids," as can be seen in illustration 4.11. Such writing indicated that cats were sometimes given the honorary status of child if not treated as surrogate sons or daughters. Indeed, to use human family referents for a cat is very different from representing the animal as a "friend" or "beloved one." Kinship terms such as *kids* describe a degree of emotional and social proximity between animal and human beyond devotion or friendship (Brandes 2009).

Other less direct but nevertheless suggestive photographic cues point to potential childlike roles.

Simple pairing of cats with family members could visually liken them to their human domestic counterparts. Photographs could, for example, pose cats with babies to strongly suggest the similarity of the two in terms of their place in the family (illus. 4.12).

Another device to suggest childlike roles for cats was to capture an adult couple tending to the needs of kittens. Like puppies, kittens easily accommodated the image of parents posed with their "babies." Illustration 4.13 shows one of many photographs we found apparently depicting husbands and wives cradling, nurturing, or otherwise tending to their animal dependents at home. Here, the three kittens are nestled in a wicker basket on what might have been the human subjects' front steps.

4.11. One of our many kids, 1907.

4.12. Infant and cat. T. Weseloh coll.

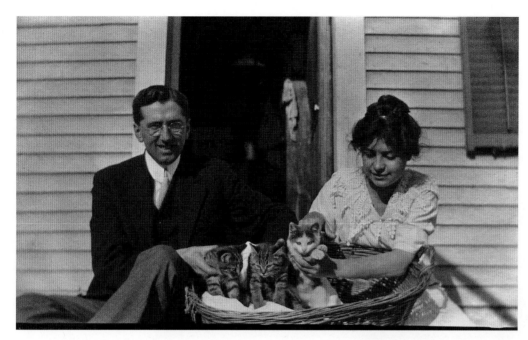

4.13. The kittens' parents. T. Weseloh coll.

Pet cats were also depicted as babies by showing children learning parental skills such as nurturing. Photographing children as they fed, groomed, or otherwise cared for their pets provided parents with a teaching opportunity to encourage and reward these skills, thereby promoting their child's transition to parenthood (Titus 1976). Parents could coach or simply acknowledge certain poses when making these photographs and then talk with their children about these images after they were made and put in family albums. Making and reflecting on images of children practicing parenting skills with family cats documented the importance of assuming certain highly valued roles, while making a permanent record for children to learn from and emulate in the future. One such example is the girl in illustration 4.14. She proudly holds her blanket-shrouded kitten close to her chest as the two sit for their portrait. Her cradling of the kitten in the photograph suggests tenderness with and fondness for the pet; she holds it the way people hold human babies, as she would perhaps do one day with her own child. People who made such photographs and those who viewed them readily understood the pose because it so closely resembles the way parents tend to babies

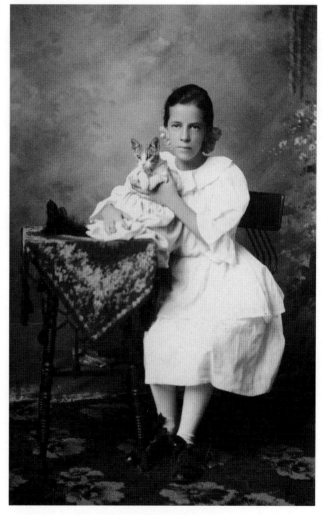

4.14. Girl with cat.

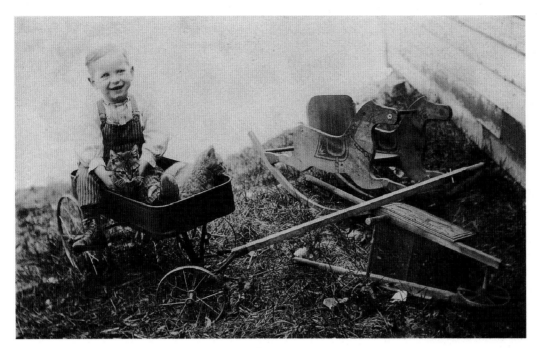

4.15. Playmates.

and the flow of mutual participation and intimacy between them (Manning 1997). Perhaps the girl's family wanted to reinforce this role when they made this photo postcard, whose use of touch, subject positioning, and gestures unmistakably portray a parent with child.

In the early part of the twentieth century, cats and dogs were considered ideal playmates, so children were encouraged to include them in their playgroups and leisure pursuits. This association was firmly embedded in both European and American thinking, so it is not surprising that many commercially made as well as vernacular photo postcards from this era captured pets' playmate role. The boy in illustration 4.15 appears to be having a great time outside with his two cats as they all sit in his favorite wagon.

During the postcard era, children were free to roam their neighborhoods as well as the countryside with minimal adult supervision. It was typical for children to take their pets with them on such adventures—especially dogs, but cats sometimes, too. Having pets provided children with a close "buddy," perhaps to play the role of a sibling or close friend. Family cats could easily share the

many carefree moments when children had little to do other than to "spend time" in the moment with their friends, human or animal. We came across many photo postcards of children and their cats playing together outdoors. Illustration 4.16 captures a boy dressed in his cowboy suit and holding his gun, ready to play with his black cat.

Some children did not have any siblings. Cats, along with other kinds of pets, could sometimes stand in for the missing brother or sister. Louise posed first as a six-year-old with her kitten and grandparents (illus. 4.17) and then as a teenager with her grown-up cat (illus. 4.18). Louise was an only child who, according to annotations in the two family photo albums of her childhood, treasured this cat as her best, and perhaps only, friend during her formative years.

Photographs also depicted cats as good parents. Parents then, as now, realized that there were important lessons to be learned from observing the behavior of certain animals. For example, one reason for caged birds' immense popularity at the beginning of the twentieth century was that they were thought to serve as moral models of middle-class life for children because they

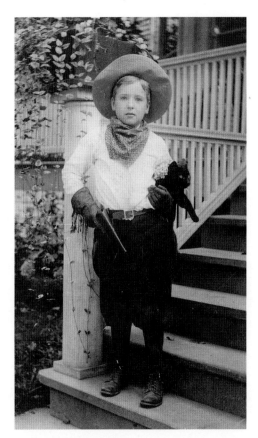

4.16. Little cowboy with black cat.
R. Bogdan coll.

possessed virtues such as monogamy and devoted parenting skills (Grier 2006). Cats, too, could provide these teaching opportunities because with kittens they were often devoted, forgiving, affectionate, uncritical, and available (Margolies 1999). Pointing out cats' strong maternal instinct was a favorite theme for photo postcard photographers. Images of cats feeding, raising, and "fostering" the young of other species, including chipmunks, squirrels, and fox, modeled such exemplary kindness for children to learn from and adults to enjoy. Tabby was one such good mother, according to the caption on illustration 4.19, because she "adopted" two baby skunks after losing her own "children." Use of these anthropmorphic terms makes the cat's parental nurturing and responsibility for the young a highly teachable story with a clear moral.

Picturing cats in familial roles enabled photographers and their human and animal subjects to establish and viewers to appreciate and learn from the cat's inclusion in domestic life. These imaged roles, as intermediary boundary objects, took physical form in the photograph (Simpson and Carroll 2008) and bridged different worlds or, in this case, species to negotiate a new identity for cats. These boundary roles functioned in a symbolic if not real sense as further "evidence" of the cat's attractiveness to and intimacy with family members, cementing their pictorial place in the perfect family.

EXPRESSIVE EQUIPMENT

We arrive at particular impressions of people based in part on their connections to objects around them. Furniture, décor, physical layout, scenery, and stage props are part of what Goffman (1959) called "expressive equipment." These background items have meanings that generalize to the people with whom they are paired, enabling them to claim certain identities with greater credibility (Casselman-Dickson and Damhorst 1993). For example, a person's furniture and home are considered extensions of their identities (Collett and Childs 2009), as are their children, whose appearance and behavior are seen as a direct reflection of them (Collett 2005).

Expressive equipment can be used in the visual arts to influence how viewers see the people who appear in paintings or photographs. Gwendolyn Shaw (2006) studied how props were used to imply that African Americans in nineteenth-century portraits shared the viewers' values and could obtain life, liberty, and happiness as might any citizen. Certainly, the people in these pictures existed and their accomplishments in life were real, but with the help of what else was in the portrait, more was being said about their place in society. As examples Shaw cites one portrait that features the American flag prominently in its composition, suggesting that the pictured African Americans subscribed to the same national and patriotic values that other

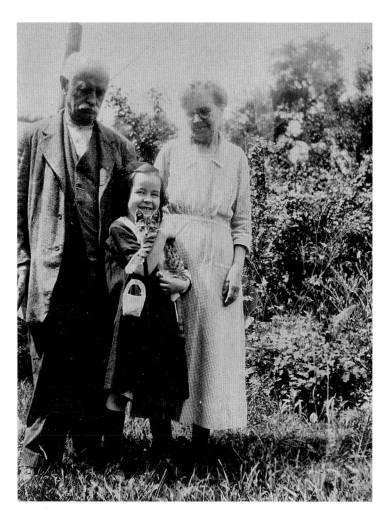

4.17. Little Louise at age six. N. Perin coll.

Americans subscribed to, and another portrait that depicts each of the African American subjects holding a book, recalling the purpose behind a project that raised money for schools in Louisiana.

Expressive equipment in early-twentieth-century photographs of cats could function the same way. To depict a cat as part of an interspecies family, photographs could associate pets with key symbolic physical props understood to represent domestic culture. For example, the two cats in illustration 4.20 make this association by being pictured not just with the household's husband and wife, but on their front porch. A century ago the front porch as an expressive prop symbolized the ideal American family (Pickering 1951). Considered to be an outdoor living room, weather permitting, the porch was the place families retired to after dinner to enjoy the cool air, relax after a long day, and come together with neighbors and nature. It is as if the porch represents the cats' transition from outside to inside the house, from the harsh and unprotected life outdoors to the warmth and safety provided by the humans who grant them access to their home.

Photographs visually established cats' membership in families by showing them sitting or napping on top of furniture and occupying rooms normally reserved for human rather than animal traffic. Their family membership was sometimes depicted more emphatically by capturing them lying or sitting, sometimes on folded blankets to provide extra warmth and comfort, on what appears to be the head of household's favorite rocker or lounger. Illustration 4.21 is a case in point, capturing the family's

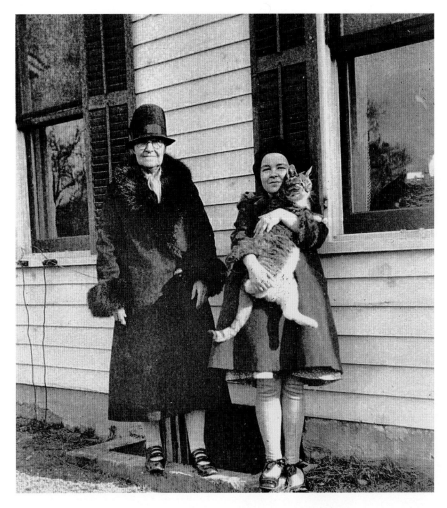

4.18. Little Louise at age thirteen. N. Perin coll.

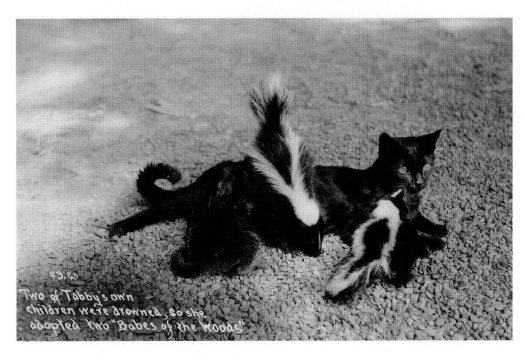

Two of Tabby's own children were drowned, so she adopted two "Babes of the Woods"

4.19. Tabby, the good mother cat.

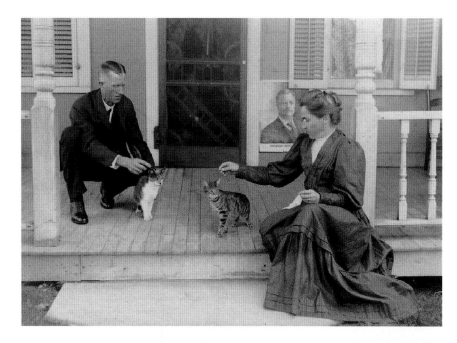

4.20. Sitting on porch with cats.

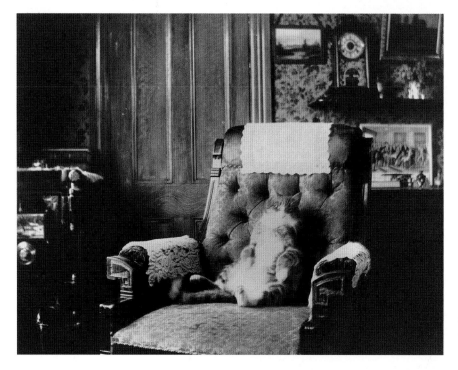

4.21. Cat in easy chair. C. Mastro-
vito coll.

pet lounging on an easy chair in the living room. The humorous pose suggests that the cat probably was indulged and permitted substantial freedom in the house to make itself as comfortable as possible.

The handwritten message and image in illustration 4.22 further the notion of the cat as an integral member of the household by placing the cat not only in the sender's library, but on a centrally placed chair that might well have served as the sender's favorite place to sit. Because the recipient is "not feeling quite so well," she is provided a glimpse into the sender's library—which is filled with treasured pictures and trinkets, numerous books, and, not least, her sleeping cat, who occupies a prominent place in the interior landscape—"even if you cannot come in person."

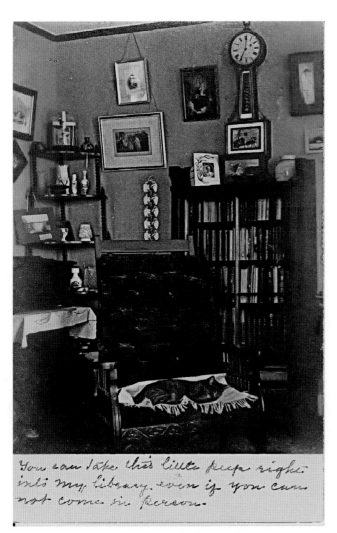

You can take this little peep right into my library even if you can not come in person.

4.22. Asleep in the library.

Linking cats to the most interior and private parts of homes required catching the right moment and location or deliberately staging an event to make the visual point. Viewers unfamiliar with the pictured cat needed to know from the image's props that the cat had family privileges. Simply photographing a cat sitting on a plant stand, an oriental rug, or porch swing, for example, did not communicate the same impression as a cat that was perched on a prop associated with deep human emotion or thought, a place of solitude where important matters were transacted. Just such a situation is shown in illustration 4.23. The family cat sits directly in the middle of an open rolltop desk filled with personal letters, bills, and other records that were certainly off limits to strangers and perhaps even to some family members who might read or disturb important papers. Although this pictured cat could not read these documents, it could certainly move or dirty some.

The act of bringing a cat into the home could be spelled out on a photo postcard. Writing across an image could make it perfectly clear that a cat belonged inside the family circle's most private spaces. Bedrooms were one such domestic area normally off limits to strangers or even houseguests,

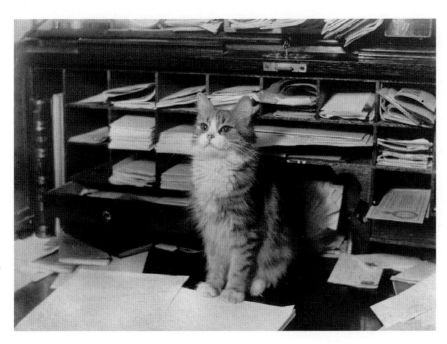

4.23. Cat on a rolltop desk.

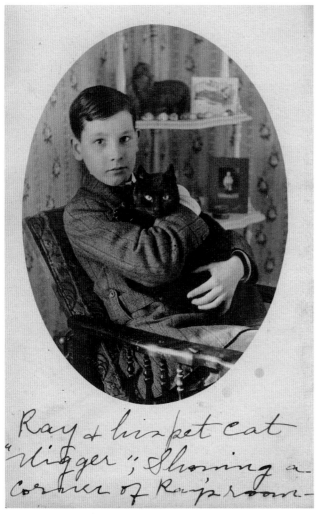

4.24. Ray and his pet cat. T. Weseloh coll.

unless given special permission to enter. In one photo postcard, Ray's parents made sure to note that their son's cat shared a corner of his bedroom (illus. 4.24). Although the name of Ray's cat offends us now and may even have implied some social distance between the boy and his cat, the norms of white society a century ago showed no such sensitivity to the use of this language.

Within bedrooms, the most intimate household space is the bed itself. Cats and dogs are far more likely now to sleep with their owners than they were a century ago. More than two-thirds of those responding to surveys about their pets say they sleep together on the same bed at night (APPA 2011–12). Although commercially produced photo postcards sometimes captured this bedroom intimacy between people and their cats, few individually made postcards did so, like the one of the contented woman in repose, with her cat resting comfortably nearby (illus. 4.25).

Cats can be visually associated with kin by capturing them with the things family members used outside the home. In illustration 4.26, the girl is posed with probably her most important possessions, the family cat and a velocipede, an early form of tricycle propelled by pushing it along the ground. Whether a photographer's prop or her

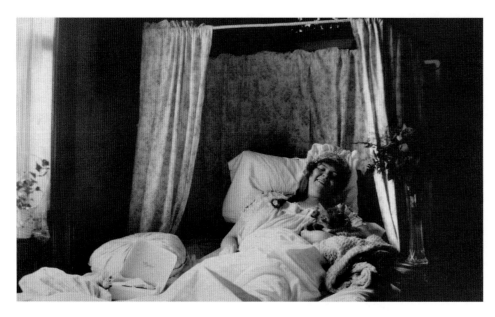

4.25. Woman in bed with cat. T. Weseloh coll.

own, the velocipede was an important symbol of middle-class leisure. During the late nineteenth and early twentieth centuries, the velocipede and comic books were considered appropriate gifts for both girls and boys (Jensen 2001), as may have been the cat in this postcard.

Other family-related props outside the home also served as handy visual devices to identify cats as kin. One such device was the family buggy, as important to most people a century ago as cars are today. The two white cats in illustration 4.27 were deliberately placed on the buggy's seat to give them prominence in the image and to allow them to share the spot where their owners sat.

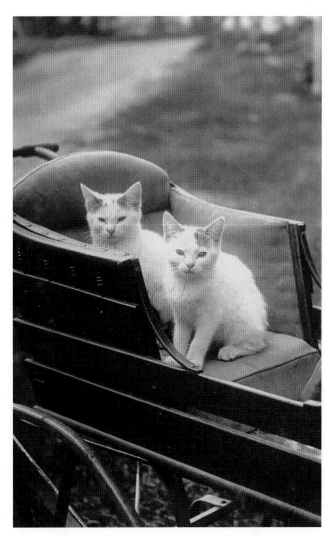

4.27. Cats in the buggy seat. T. Weseloh coll.

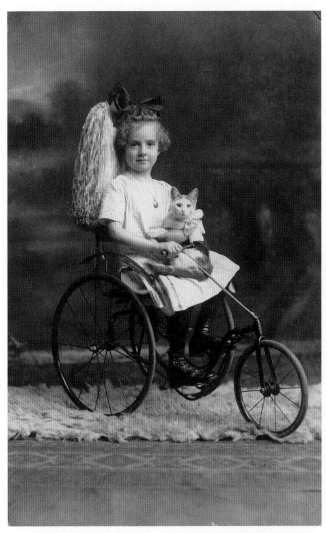

4.26. Girl with cat and velocipede. R. Bogdan coll.

Iconic props signaled a family's interior life and its definition of home. Indeed, merely photographing cats inside homes constituted the largest prop by communicating the idea that these animals were permitted if not welcomed in a space traditionally reserved only for human routines and rituals. By contrast, now it is common practice to have pet cats in the house, although some are confined to particular rooms or are otherwise prevented from entering certain places such as master bedrooms or from walking on spots such as dining-room tables. A century ago, however, these domestic privileges were more the exception than the rule for pet cats.

COURTESY HONOR

Goffman (1963b) observed that people who are related or close to a stigmatized person can themselves be viewed negatively because of their association, even if they have none of the personal characteristics deemed socially undesirable by others. Although not described by Goffman, the converse effect should exist as well—namely, that people or, in the present case, animals who are associated with a higher-status being should then be viewed positively because of their connection. From this perspective, pictured cats might ride the higher-status coattails, a courtesy honor, of other kinds of animals more clearly regarded as family members or essential to family life.

For example, photographs could visually include cats as kin by pairing them with dogs. At the start of the twentieth century, dogs were generally thought of as more "legitimate" family pets than were cats. The former were far more likely than cats to be allowed indoors, given special privileges, and lavished with attention (Grier 2006). By photographing dogs and cats together in the same picture, cats visually shared dogs' more acceptable status as kin. One pictured scene shows all family members, including their cat firmly held front and center, obediently mugging for the camera (illus. 4.28).

Despite the current popularity of dogs and cats as favorite pets in America, birds were the pet of choice a century ago (Grier 2006). Caged birds were much more popular than they are now and were the favorite indoor family pet. The canary was most popular, but native birds were also often trapped, caged, and kept. The popularity of caged birds was a function of their singing. Prior to the phonograph and the radio and aside from live music, there were no melodious sounds in the home without birds. Parrots were exotic favorites but less common than small birds because they were expensive to purchase, cage, and feed. They also were more demanding: they chewed their cages, needed wing clipping, tossed their food around, and screamed rather than sang. Then, as now, their owners enjoyed their intelligence and ability to mimic the human voice and other sounds. Those who viewed the photo postcard in illustration 4.29 were reminded by the card's title, "the happy family," of the close ties that probably existed between the boy and his cat and parrot.

And cats could also be visually brought into the kin's inner circle by photographing them with

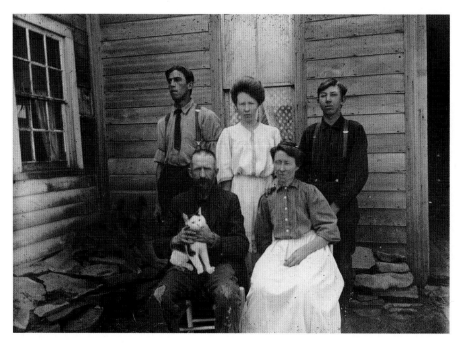

4.28. Family with cat and dog. T. Weseloh coll.

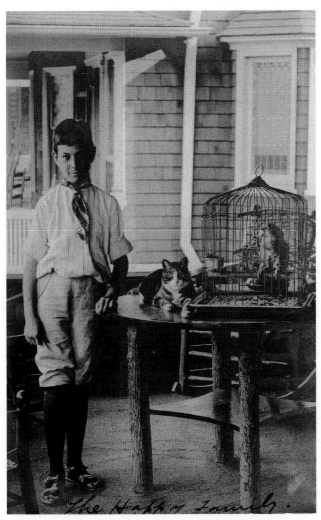

4.29. The happy family. T. Weseloh coll.

animals that were very important to family members but were not quite full-fledged pets. Horses were vital to many people at the beginning of the twentieth century, even after the introduction of the internal combustion engine (McShane and Tarr 2007). Horses were needed for all sorts of transportation; they enabled people to go to work, to town for food, to school, and to visit friends and family. The husband and wife in illustration 4.30 assembled their most important animals for the family portrait, including the family horses, dog, and cat—the latter cradled in the woman's arms.

Photographic images of the perfect family often showed off household members' most important possessions, whether they were living creatures or physical objects. The pictorial significance of any one possession in these collective displays depended on the company it kept. Because cats were often not the only animal possession that helped to constitute a home, they could be pictured with other pets or work animals that had higher status or value. Visually pairing cats in this manner meant that they had assumed a new and more elevated social identity as family members and that the symbolism of what constituted hearth and home had expanded to include cats.

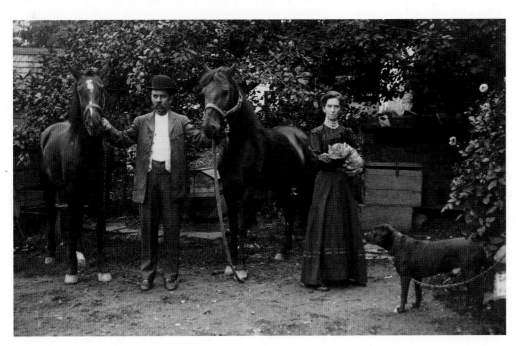

4.30. Family with horses, dog, and cat.

BOUNDARY BLURRING

Laypeople frequently refer to their pets as members of the family and regard them as a meaningful part of domestic life. Nowadays many pet owners do not think twice about letting their cats come inside their homes rather than confining them to a barn or allowing them to roam the neighborhood. Some are never let outside or, if permitted, only on a leash or in a restricted backyard space. Other cat owners go a step further and let their pets sit on living room furniture, sleep with them at night, celebrate their birthdays, and go with them on family vacations. Although not every pet owner engages in or approves of these practices, doing so is no longer considered very odd, if strange at all, by many of the forty-four million households with eighty-two million cats in the United States (American Veterinary Medical Association 2007). These practices were becoming a family norm by mid-century, a trend reflected in the growing number of advertisements in women's magazines that depicted animals, including cats, as members of the family (Kennedy and McGarvey 2008). However, they were not commonplace at the beginning of the twentieth century, and that is what is so intriguing about this chapter's images. They document what must have been at the time a relatively new if not unorthodox way of thinking and feeling not only about one's cats, but also about one's home.

A home is made up of people's lives, as reflected in the built environment, its furnishings and other materials, as well as its collective memories, histories, habits, and household members' desires (Bowlby, Gregory, and McKie 1997). Photographs enable the collective memory of a household by recording what was important to and jointly experienced by its members, who was included in their routines and rituals, and how they wanted to be remembered. This chapter's photographs show the kinds of everyday practices that reflected or were a means to constitute a more-than-human family. The everyday practices by which more-than-human families are constructed have received little

attention, although recent research has raised this possibility with dogs (Power 2008). But the photographs in this chapter suggest that such a domestic process existed long ago with cats, too.

Photographs, much like paintings of humans, helped accomplish this definition of family by creating visual stories about the cats they depict and their private family lives. These stories can be dramaturgically told through front- and backstage portraits, domestic props, surrogate roles, and the granting of courtesy honor to household cats that shape how viewers read the images. Understanding the cultural meaning of these photographic devices helps to unpack the picture's story about what went into having and imaging a more-than-human family.

Photographs taken a century ago of cats relied on all of these devices and more to visually establish the cats' status as kin, provide a glimpse into the meaning of the expression "member of the family," and constitute family through visual representations of home. The resulting depictions of human–cat families represent a boundary crossing that was emotionally important for the people and cats seen in this chapter and symbolically important in the broader cultural scene because it visually marked the beginning of the notion now taken for granted that pets are proverbial members of the family. The photographs we have seen not only documented this modern thinking about cats as friends and family members but promoted and cemented this idea in our society because they were a long-lasting visual record and "proof" of human–animal intimacy that could be easily shared with distant family, friends, peers, and strangers. In other words, these photographs helped to make the now beleaguered notion of pets as family members a visual social fact.

Of course, as visual documents of what it truly meant for cats to be family members a century ago, the photographs in this chapter should also be viewed with some skepticism. Family photographs of these cats suffer from the same interpretive limitations posed by contemporary family photographs that include only people; they are selectively

made to represent "real life" (Chalfen 1998), or, as Goffman observed, they frame how people want to depict the working world. Following Goffman's thinking, many scholars of family photographs point out that these representations are idealized depictions of social relationships rather than evidence of lived family realities (Hirsch 1997; Rose 2010). As Laura Wexler writes, domestic images "work by staging affect" (1997, 166). Pictures of family occasions, birthdays, holidays, and the like show kinfolk as happy, carefree, and cohesive, but snapshots of parents and children fail to capture their everyday routines, labors, displeasures, unruliness, or dissension. In this regard, family photographs are only a partial and biased view of what family relations are really like to the people imaged.

The photographic conventions for constructing family relationships are the same whether human or animal members are depicted in the image. They permit false impressions and misreading, not only of our human selves and relationships, but of our pets as well. We cannot know what cat and human expressions, poses, and behaviors were left out of this chapter's photographs, but the omissions made in photographs of human families are no doubt a good lead. Like photographs of their human family counterparts, feline–human family images do not capture much of the cat's everyday behavior or moments when humans show indifference, disregard, or even cruelty to their pets.

There is yet another omission that makes these family photographs only a partial record of how cats were regarded at the time. Photographic evidence suggests that not all family members befriended cats in quite the same way or at least that some were not comfortable being portrayed this way on film. Our review of hundreds of early-twentieth-century cat photos found that adult men were for the most part conspicuously out of the picture, literally and figuratively. Photographing close ties with cats was a gendered practice. As we see next, men with cats behaved differently in front of the camera and perhaps in everyday life.

5
Gender Displays

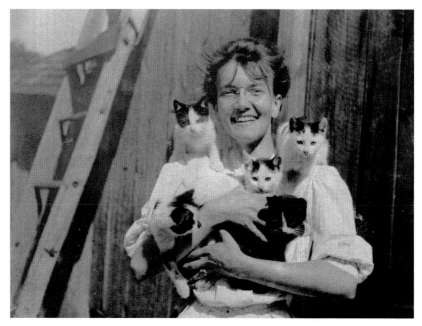

5.1. Woman with five cats. R. Bogdan coll.

Cultural norms influence our interpersonal ties, establishing what other people and animals we connect with and how. Part of our modern thinking about pet keeping is the association of certain pets with men and others with women. People have historically identified dogs as masculine and cats as feminine (Serpell 1988). This connection is now normative, built into our culture as a taken-for-granted preference, with sanctions to ensure widespread conformity. To wit, one study of greeting cards aimed at children (Murphy 1994) found that these cards reinforced the idea that boys like dogs and girls like cats. Popularly written books also convey this theme. Titles such as *Cat Women:*

Female Writers and Their Feline Friends (McMorris 2007), *The Feline Mystique: On the Mysterious Connection of Women and Cats* (Simon 2003), and *Women and Cats: A History of a Love Affair* (Lorvic 2003) are reminders of how deeply woven the gendering of cats is into our history and everyday thinking, but there are no books with similar titles for men. Dog and cat products are also gendered. The Blue Buffalo Trading Company, a pet food company, makes it possible for dog and cat owners to create virtual trading cards of their pets; dog cards are colored blue, but cat cards are pink; in the sample trading cards, the dog is described as liking to play tug of war, whereas the cat likes

snuggling. And in pet stores, items such as brushes will often be blue for dogs and pink for cats.

Because cats are women's pets in modern Western societies, men can find their masculinity being questioned if they own cats and show them special affection (Perrine and Osbourne 1998). Such gendering of pets has not been missed by popular television series; in one show, a male character is teased for having a cat because it suggests he is homosexual or effeminate. To defend themselves from doubt, some men will explain their cat preference by letting others know that they "always had owned dogs" or that they were "also dog people."

Our modern sentiment about domestic cat keeping also sees women, but not men, as having special relationships with cats, sometimes involving multiple animals at once. The appeal of cats to women is so strong, the assumption goes, that many cannot control the urge to have more and are driven to collect scores of them. The "crazy cat lady," the pejorative stereotype of an eccentric old spinster who lives in a decrepit house with dozens of untamed cats, became a fixture in American popular culture and mythology at some point in the twentieth century. *The Simpsons* features a Crazy Cat Lady character; *Wikipedia* has an entry titled "Cat Ladies"; there is even a "Crazy Cat Lady" action figure, who has a "wild look in her eye" and comes with lots of plastic cats; and for a few dollars more you can buy the *Crazy Cat Lady Game*, which features on its cover a woman with a crazed look and a description of the goal of this "insane game" as the collection of the most cats. By the 1990s, scholars started to study more seriously people who hoard animals, finding that about two-thirds of them are women who come close to this stereotype (Patronek 1999) and that many live in conditions not fit for humans or other animals and are totally preoccupied with their animals' lives, often to the point of severely neglecting themselves, their human family and friends, and their obligations (Arluke and Killeen 2009).

Modern thinking takes women's intense involvement with cats one step further when it blurs interspecies boundaries. It is not just that their cat connections are more intense, but that their thinking, feeling, acting, even appearance become cat-like. A completely fictional woman–cat hybrid, the cat woman, started in a 1950 Batman comic book and was followed by decades of comic iterations and full-length movies, most recently starring Halle Berry (*Cat Woman*, 2005) and Anne Hathaway in *The Dark Knight Rises* (2011). There are cat woman costumes or simply masks for women to buy. These mass-media icons and pop-culture fashions draw on and exaggerate the image of cats as sensual and sexual beings, making for a hypersexualized "frisky feline." Human traits of cunning, seductiveness, sleekness, and sexuality anthropomorphize cats; conversely, women are sexualized when called "cat," "sex kitten," or "pussy."

How modern is the contemporary association of women and cats? Although this gendering is firmly in place today (Mitchell and Ellis 2013), traces of it appeared as early as the late Middle Ages (Rogers 2006). We know that Renaissance paintings sometimes included cats, usually with women subjects. Literature of the times also supported this early gendering. However, we know even less when it comes to the connection of women with cats in nineteenth- and early-twentieth-century America and Europe. The most thorough historical work on pet keeping in America devotes just two pages to this matter (Grier 2006), and the most complete photographic history of human–animal relations provides only a couple of examples of women and men with cats (Arluke and Bogdan 2010), without diving deeper into this matter.

However, there is some evidence that cat photographers a century ago were aware of this connection and tried to use it to further business. Some photographers assumed that their images of cats would have more appeal to women than to men, so they tried to create particular poses that women might enjoy, poses that today might be seen as "cute" if not maudlin. The portraitist Charles Bullard, for one, considered how women would view his cat models, saying: "The post cards made an

especial appeal to women, and I was always experimenting to get the cats in cunning poses that would make a hit with the feminine trade" (Ranck 1915, 57).

More than merely exploiting the alleged feminine appeal of cat photographs, the images in this chapter suggest that gender expectations for having or not having close relationships with cats already had a foothold in popular thinking at the start of the previous century. Close relationships with cats were not depicted equally for everyone; adult males appeared far less often than did women with cats, and when men *were* photographed with cats, their poses suggested less connection to cats than in images of women or children with these animals.

What does it mean that these decades-old cat photographs portrayed men and women so differently? Goffman (1976) used the term *gender display* to refer to formalized, ritualized behaviors characteristically performed by men and women to announce their alignment and intent in a social situation. These behaviors become stereotypical simplifications or exaggerations that can be expressed briefly and understood immediately in lieu of playing out an entire act. These displays affirm what the basic social arrangement should be about people and social order, teaching the young and reminding the public how to be feminine and masculine.

Goffman's insights have been applied to study gender displays and their differentiation of the sexes in a variety of photographic genres, such as human portraiture (Ragan 1982), but not to study such displays in images of pets. Scholars, though, have shown that dogs can be used to display gender in everyday interaction (Ramirez 2006). If people remind themselves and others that they are meeting traditional gendered expectations by using animals, then we should assume that photography is one more social field upon which people can "do gender" with pets (West and Zimmerman 1987), just as hunters use trophy shots as proof of their masculinity and sportsmanship (Brower 2005). Given our interest in the depiction of cats, the

narrative about one's gender is played out and then documented and shared every time someone declined to be photographed with a cat or struck a certain pose to be pictured with their cat.

Of course, this is not to say that men and women interacted with or felt differently toward cats in everyday life than they let on in their photographs. We do not know whether these images were documents of very real gender differences in human–cat relationships or staged gender performances that hid backstage interactions where men showed greater interest in and affection for cats. Either way, however, photographs served as a medium through which people could tell a story not just about their sentiment for cats and the importance cats had to them, but also about the kind of people they sought to be and what place they aspired to in society. How these stories were told, rather than their veracity, is our concern here.

OUT OF THE PICTURE

Narratives shape what we should think and feel by what is said and not said in them (Clandinin and Connelly 2000; Ramanathan 2007). The story told in photographs about cats' relationships with men and women begins by conspicuously leaving men literally out of the picture. We found relatively few photographs of adult males with cats in any pose. Men might have been preoccupied taking the photographs, they might have been unwilling to have their photo taken with cats, or they might have felt they were not in significant enough relationships with cats to merit having a picture taken with them.

However, the absence of photographs of adult men with cats is not because men were reluctant to have their pictures taken with pets in general. By the time photography became a popular medium in America, men were just as likely to be photographed with pets as were women, and their poses with these animals could be just as tender and caring. There are scores of photos of adult men with dogs, birds, iguanas, and special, petlike farm

animals (Arluke and Bogdan 2010) that suggest genuine affection between man and animal. The exception seemed to be pictures of adult men with cats.

When pictured with pets, men were most likely to be photographed with dogs in particular. Dogs were safe for men to be paired with in a photograph, even to the point of showing some emotion for these animals. Of course, many photographs of men with dogs cast the animals in the role of companions or hunting buddies rather than coddled infants. Cats' relatively smaller size meant they could be more easily regarded as infants, alluding to a maternal connection inappropriate for most men to consent to for a photograph.

Early-twentieth-century gendering of dogs and cats, at least according to photographs of the era, seemed to be a familiar part of the human–animal terrain, just as it is today. For example, the couple in illustration 5.2 stiffly sits for their front-porch portrait, each holding their gender-appropriate pet. Dressed in shirt and bowtie, the gentleman looks directly into the camera as he balances the dog tucked into his arm, while his wife looks down at her cat as if she expects it to move or jump off her lap and spoil the picture-taking moment.

And when photographed with pets other than cats, men could display apparent affection for the animals with whom they were intimately paired. There are photographs of men hugging alligators, clutching bear cubs to their chest, looking fondly at parrots, stroking elephant trunks, cradling pigeons in their palms, holding rabbits or chickens near their faces, and of course unabashedly showing warm sentiment for dogs. In one example of the latter, the kneeling man on the photo postcard in illustration 5.3 stares intently at his canine companion as he embraces his friend. Although it is possible that his touch was merely to control and quiet the dog for the photograph, it is equally likely that the image reflects regard and warmth for the animal experienced and deliberately posed by the man.

Even when men were paired with cats, something else was left out of the picture. Although photographs, whether they are Victorian or contemporary images, can capture the photographer and subject's sentiment (Alexander 2006; Palmer 2010), when pictured with cats men rarely displayed the kind of emotion that is apparent when they were photographed with other animals. They instead appear estranged.

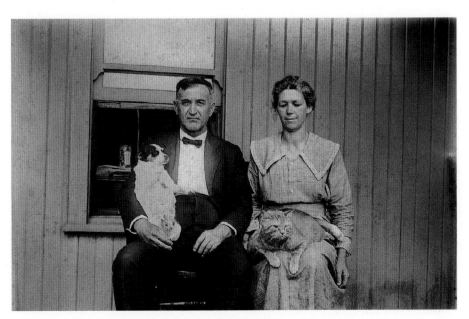

5.2. Man with dog, woman with cat.

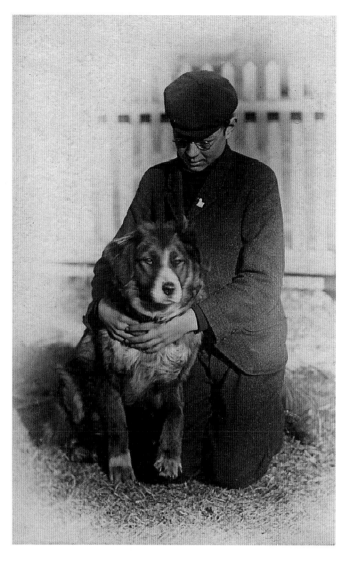

5.3. Man with dog.

DISTANCE

Goffman (1959) observed that people sometimes separate themselves from the roles they play while they are playing them because they are uneasy, embarrassed, or ashamed to be seen in certain social positions. They may feel stigmatized by or simply awkward in the role of pet owner, and the assumed caretaking, affection, and nurturing that accompany this position might be managed by appearing to keep an arm's length away from this role. When pictured with cats, men a century ago appeared to carefully avoid poses that might suggest intimacy, whether this distance was genuine or done as a performance for the photographer and those seeing the photograph in the future.

The most common way that photographs captured male displays of role distance was by directing their gaze toward the viewer rather than toward the cat subject and by not using their hands to touch or hold the cat, unless the touch was to impose control rather than express affection. We found few pictures of men cradling, stroking, or even touching cats with their hands, but we found many with cats casually sitting on their arms, for example. Such poses underscore the sometimes subtle visual distancing not present in similar pictures of adult women with cats. For instance, the man in illustration 5.4 has placed one hand on his leg and the other at his side, letting his cat perch on his right forearm, a far cry from the visual intentionality and mutuality depicted between women and cats.

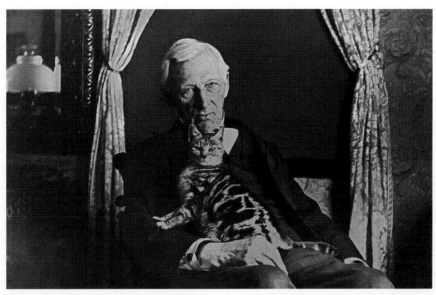

5.4. Elderly man and cat.

We found many photographs of adult men in a similar vein of guarded intimacy, with cats sitting on their shoulders; again, the male subjects do not use their hands to touch the pictured cats. The photo postcard in illustration 5.5 captures an affectionate moment between man and cat, but one more in accord with gendered expectations, a far cry from having the male subject caught on film cradling the cat like a baby. By cocking his head to one side, the man affords this ample-size cat plenty of room on his shoulder, while also more subtly avoiding facial contact with his friend.

And in the very few photographs of adult men touching cats with their hands, the pose is usually one of control rather than nurturance. Heightening this visual detachment, many cats in these images appear to be little more than ornaments. The photo postcard in illustration 5.6 depicts the man as the photograph's center of attention—he, not the cat, is in focus. His hand rests on the cat's back presumably more for control and dominance than to display affection and intimacy.

In illustration 5.7, the man merely lifts his right hand for the cat to sniff. He might have considered this cat to be his close companion, but the cat appears to be little more than an object in the

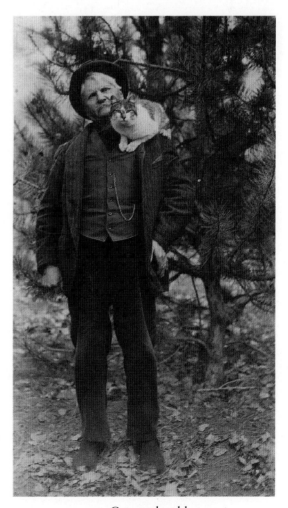

5.5. Cat on shoulder.

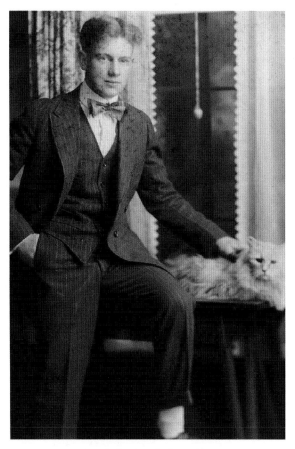

5.6. An arm's length.

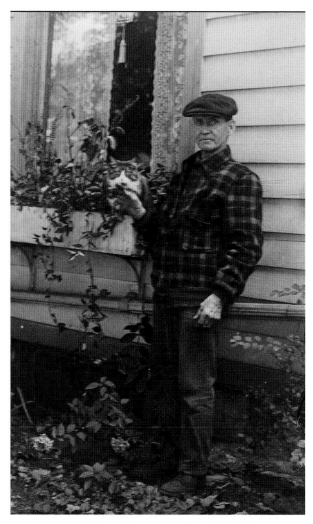

5.7. Man with cat. T. Weseloh coll.

flower box. The man's gesture toward the cat is almost dismissive, although it is not clear whether he holds his hand up for the cat to sniff or to keep the cat away.

The gender code was generally relaxed for boys and young men, but it would be wrong to think that children then had not already absorbed the gendering of cats along with general prohibitions against public displays of tenderness in favor of male-appropriate toughness or aggression. The boy in illustration 5.8 points his gun at the cat, presumably as a joke that acknowledged his male toughness and masked whatever softer feelings he might have had for the animal. Although his gaze here is directed toward the cat, it is arguably done for better aim than out of affection or caring.

The gendered work in illustration 5.9 is complete: men and women are physically separated from each other, with the seated women in white and the men dressed in darker suits standing or sitting above them. As the women tend to their cats, one of the men seems intent on upsetting the tenderness of the moment by pretending to throw a cat at one of the women, with the family dog looking on.

It was visually possible, however, for adult men to show some tenderness toward and nurturing of photographed cats while maintaining distance from the role of intimate pet owner and caretaker. Placing oneself in the right context can help to ensure that certain behaviors are not misinterpreted, allowing the individual to maintain his desired role

distance. Although cultural restrictions on men's feminine behavior were and still are real (Twenge 1997), the looseness of social roles provides some room for people to step out of traditional gender expectations if the role deviance is done in a way that avoids having one's identity questioned. Photographs can accomplish this effect if the subject is pictured in the context of a standardized social occasion that provides a stage to evoke maleness (Goffman 1976), especially if the arrangement is gender marked (West and Zimmerman 1987), leaving little question about the photographed human subject's masculinity.

Men were shown in tender poses closely holding cats only when safely ensconced in a setting and activity clearly anchored to a masculine identity. Such images are conditional tie signs because they show that men and cats are paired, but with emotional restrictions. We found a number of photographs of men posed with cats in this manner taken in work settings where the male subject's role is indisputably linked to their jobs rather than to pet keeping or domestic life at home. The train

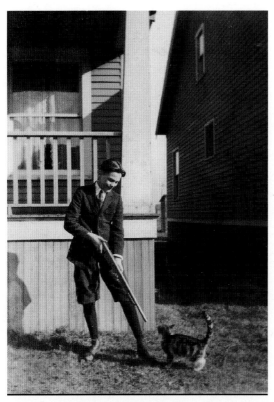

5.8. Pretending to shoot a cat.

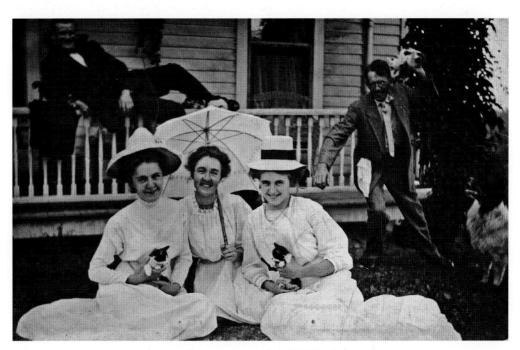

5.9. In their proper roles. T. Weseloh coll.

crew in illustration 5.10, for example, made sure to include their black cat mascot with them when photographed as a group. The man in the middle who clutches the cat probably had no qualms about showing this affection, in part because the image so clearly defines the moment caught on film as one of "men at work."

It was also permissible for men to be photographed clutching cats when they were depicted in a productive activity that was not a formal job. In illustration 5.11, for example, the human subject is captured as a hunter, a sporting or subsistence role closely identified with men. The cat is also doing what the human does. This photo is one of the few we found of an adult male tenderly holding and stroking a cat. Given that the proud hunter sits with his rabbit trophies and gun displayed behind him, this image may be less ironic than it is predictable; only when the male subject's masculinity was indisputably pictured in the image would he feel safe exhibiting some tenderness toward his cat.

It was also acceptable for an adult male to cradle a cat in a photograph when the human subject was a powerful social or political figure. No doubt

their high status gave them some visual license to appear in uncharacteristically gendered ways, plus the suggestion of nurturance may have been a good vote getter. Calvin Coolidge could be photographed in a tender pose with his cat (illus. 5.12), but everyone viewing the picture knew he was both president and a well-known animal lover. During the postcard era, Calvin Coolidge had many presidential pets. Despite his reticence to interact with humans, Coolidge was at ease with animals (Booraem 1995). He and his wife, Grace, kept a menagerie around the White House, including canaries, mockingbirds, wombats, raccoons, an antelope, a hippopotamus, a bobcat, a goose, a donkey, a wallaby, two lion cubs, and, of course, cats and dogs. Their gathering rivaled small zoos. Although the couple were particularly fond of dogs and had many photographs taken with them, they also treasured their cats.

Photographs of adult male intimacy with cats, when they were made, severely curtailed how close the two could appear on film. Men could only be guarded friends with cats, either not touching and avoiding eye contact with them or restricting their

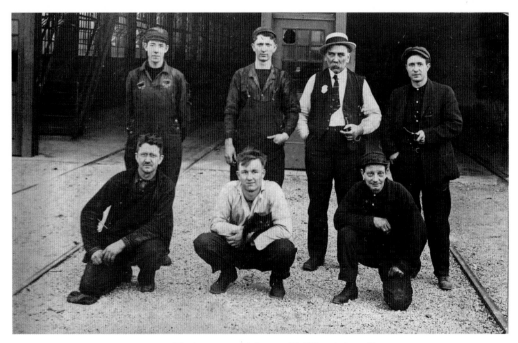

5.10. Train crew with cat. T. Weseloh coll.

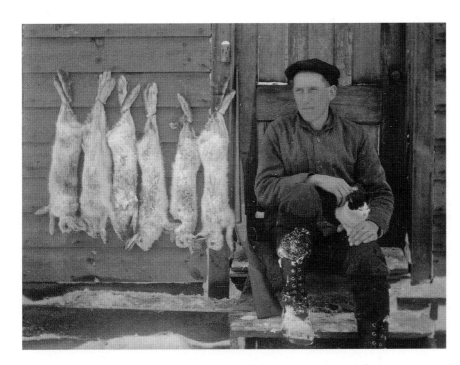

5.11. Hunter with cat.

human–cat appearances to outdoor work scenes or to characteristically male activities. The cats were the pictured men's peers more than their dependents or children, unlike photographs of men with other pets that show demonstrable affection without needing to ground the apparent emotion in masculine-identified situations or roles.

EMBRACEMENT

By contrast, women were not only photographed more often with cats than were men, but more often intimately depicted with them as mothers. Victorian proscriptions for women to serve as parents and nurturers were well embedded in American cultural norms at the beginning of the twentieth century (Green 1983). These proscriptions combined with expectations for mothers to shoulder responsibility for most household labor meant that they often became the family pet's caretaker and emotional nurturer. Photographs of women embracing this ideal role of motherhood showed that they had the capacity to perform it and were actively engaged in appropriate activities (Goffman

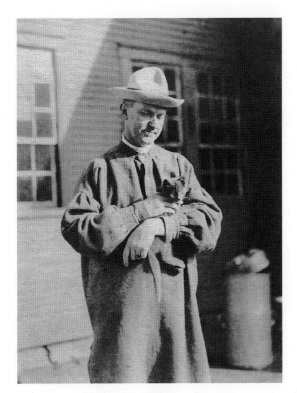

5.12. Calvin Coolidge with pet cat.

1961). Indeed, to some degree, cats in these photographs serve as mere props to better create images of the good mother because cats, like children (Goffman 1963a), are incomplete and open beings that are particularly suitable for use as visual tools to create certain impressions (Collett 2005).

However, photographs cannot easily portray some ways that cats symbolically function as children. For example, it is difficult to depict the helplessness of pets that elicits the kind of sentiment felt for children or to show that pets as perpetual children remain dependent on people for their entire lives (Margolies 1999). But their size and ability to be held lend themselves to depictions of being parented. Women were pictured in nurturing poses with cats in the same way that photographs showed parents holding infants or small children.

Images of women supporting their cats with both hands, holding the animals as gently as one would an infant, were common. The woman in illustration 5.13, like a proud mother, seems quite happy to have a photograph taken with her beloved cat held so dearly.

Women were also more likely to be shown touching and looking at cats or making eye contact with them. This body language depicts intentionality in the photograph and can reinforce the human–cat tie signs discussed in chapter 3. In illustration 5.14, the women's gaze is not directed at the camera, but at the tiger cat sitting on both of their laps; their touch as well seems to reassure the cat.

Photographs also linked the feeding of cats mainly to adult women and less so to children. That images made this link is unsurprising given the clear expectation at the time for women to be in charge of feeding the household, a norm that continued throughout the twentieth century (DeVault 1991). If family members defined "household" to

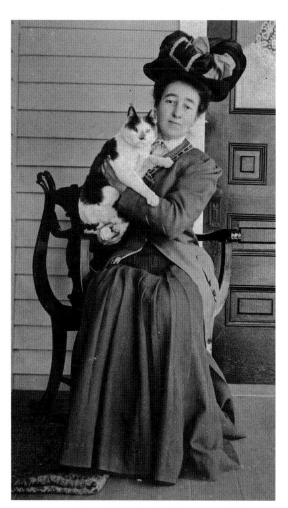

5.13. Cradling cat. T. Weseloh coll.

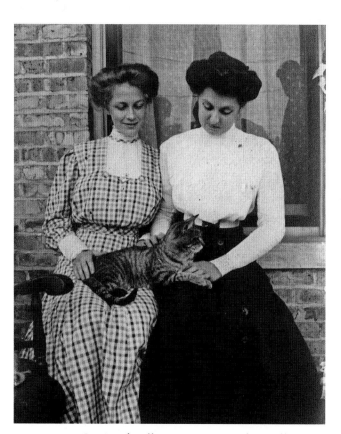

5.14. Gazing fondly at cat. R. Bogdan coll.

include their pets, then the responsibility of feeding them—with the exception of hunting dogs and special farm animals viewed as quasi-pets—fell on the shoulders of women and occasionally children. Showing women and children as pet caretakers further distinguished the kind of friendship they had with family cats, while tying these images into traditional gender and age expectations for domestic labor. In illustration 5.15, the female head of household feeds the family's pet cat as her young daughter looks on.

Victorian prohibitions against feminine traits in men, such as caring for infants and expressing emotions (Kestner 1995), were part of America's gender code by the nineteenth century. However, these prohibitions were relaxed in childhood and adolescence. We found many photographs of boys in nurturing poses with cats, such as the young man in illustration 5.16, who clearly demonstrates

his affection for this cat by gently cradling and gazing fondly at it.

At least in front of the camera, prohibitions against adult men showing tenderness and caring toward cats were relaxed for elderly men, just as they were for children and adolescents. Social comfort with such portrayals stemmed in part from the cultural view that saw aging as inversely related to masculinity, an attitude still pervasive today (Spector-Mersel 2006). Freed from rigid masculine expectations, older men could easily nurture or parent the cat as though it were an infant or child. Seated on his front porch with his favorite cat, William Richardson probably did not object to having his picture taken in this pose (illus. 5.17); in fact, he seems almost proud to be photographed with his animal friend.

People make clear their earnestness in assuming a role by expressing attachment to the role,

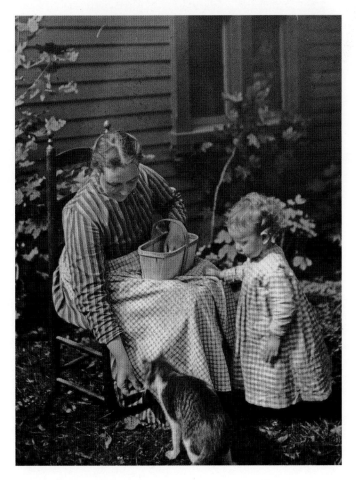

5.15. Feeding cat. C. Mastrovito coll.

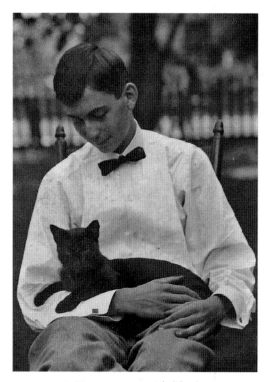

5.16. Young man with black cat.

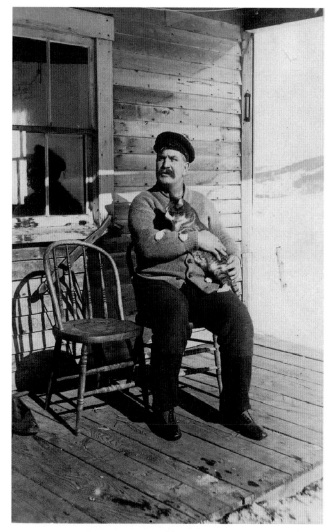

5.17. Will Richardson with pet.

demonstrating a capacity to perform it, and showing visible investment of attention and effort. Photography enabled cat owners to record or at least to display these attitudes and abilities so they could tell themselves and others that they sincerely embraced being their cat's caretakers and nurturers. Girls and adult women could use such displays as further evidence of their gender; young boys and elderly men were given a visual pass that made it possible to be safely photographed in intimate and tender moments with cats. Not so with adult men, who, as we noted, either did not behave this way in everyday life with cats or were uncomfortable being photographed. Either way, this distinction suggests that gender norms for interacting warmly with one's cats existed when these photographs were made. Although it was socially acceptable for some people to be photographed embracing the role of cat nurturer, the amount of interest in cats called for by this role had its cultural limits. As we see next, a thin visual line separated the embrace of a socially acceptable role in photographs from relationships with cats that some people then, and

perhaps now, might have viewed as inappropriate if not excessive for women.

ENGULFMENT

By becoming engulfed in or apparently overwhelmed by their relationships with cats in front of the camera, women stepped out of the traditional roles available to them at this time and into what were probably more socially marginal roles in the eyes of some, if we keep in mind that many of these photographs were not just made for private use. These women might have been proud to display their strong attachment to and interest in cats, but such role engulfment (Goffman 1959) could

suggest that they had become overly involved with their pets, carried away, much like contemporary photographs of women that depict them as overly engaged and out of control, laughing uncontrollably or being overwhelmed by emotion (Goffman 1976). Even worse, they might be seen as losing some of their humanity in the process.

Images of people holding and caring for many cats suggest intense involvement with and very strong affection for these animals. We did not find photographs of adult men holding or playing with two or more kittens or cats, but we found many images of women doing so. These images were mailed throughout the country and over the years became highly desired by photo collectors. Women, as in the first illustration for this chapter or in illustration 5.18, appear in photographs holding several

fully grown cats at once. The cats seem to be spilling out of the woman's arms in this studio-made photo postcard. That a professional photographer was hired to make an image of this woman and her three cats suggests how important they all were to her. Although there is no way to know, she may have very well have had others at home.

Most photographs of multiple cat ownership had two prominent features: the women were by themselves, without extended family or friends, and they were usually older. The next image of a woman holding two kittens and a large adult cat is typical (illus. 5.19). Such photographs reinforce the gendered ideas not only that cats are women's pets, but that some women cannot get enough of them.

Victorian culture through literature and art went beyond merely associating women and cats;

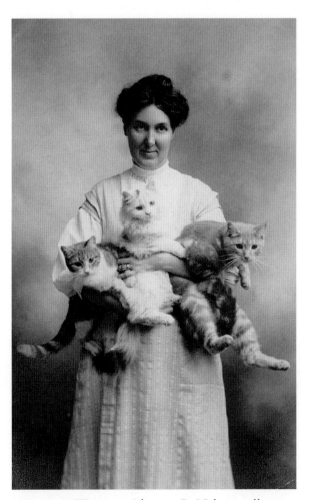

5.18. Woman with cats. B. Nelson coll.

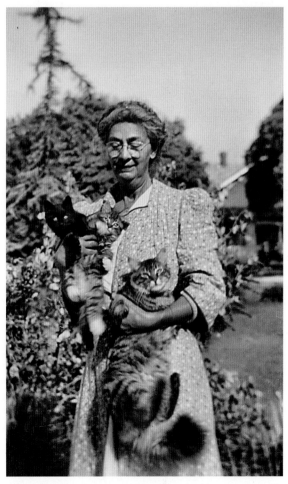

5.19. Older woman with cats. C. Mastrovito coll.

the two became paired and inseparable in a romantic and sexual way. Commercial photographers took advantage of this erotic connection, further complicating the photographic depiction of women's relationships with cats and the nature of their friendship. Makers of photo postcards borrowed heavily from cultural stereotypes of cats that portrayed them as "sleek," "crafty," and "promiscuous" animals. These images enabled cats to become a visual tool to convey romance and sensuality as well as to imbue the female subject with an element of wildness or passion that would otherwise be ignored or controlled. Using a cat as a sexual prop, one commercial photo postcard (illus. 5.20) portrays the model as a "sex kitten"; she suggestively points her cat toward the camera lens while showing off her bare legs.

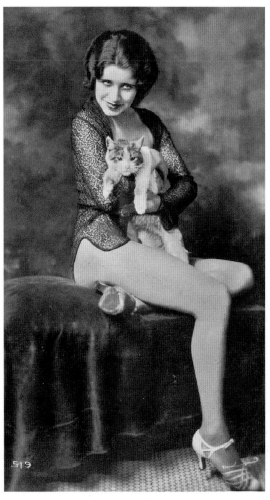

5.20. Sex kitten.

Photographs also captured women's catlike sexuality and feline affinity by pairing them with both domestic cats and bigger, wilder cats. Inferences of women's passion and sexuality have long been made by imagining them not as domestic cats, but as wildcats (Lawrence 2003) because of the latter's independence and aggressiveness in the passionate wilderness. One classic example of this sexual pairing is the feline imagery in the controversial personal and public life of the late-nineteenth- and early-twentieth-century French novelist and performer Colette (Spencer 1981), who kept a wildcat as her household pet; posed between lion, ocelot, and leopard pelts; impersonated cats onstage; and had one of her novel's protagonists dream of returning to the jungle to marry a big cat. As in the feline images that often eroticized Colette and the characters in her novels, the woman in illustration 5.21 is lying on top of a stuffed tiger, perhaps capturing some of the meaning associated with it when alive.

A tongue-in-cheek French photo postcard (illus. 5.22), one of more than eight similar poses by this model, completes the transformation of woman to cat. The image both eroticizes and animalizes the model. The word *chatte* is French slang for "pussy," a term that in this period referred to anything soft and furry. As a double entendre, the prurient meaning of this word has been in use for more than a century. A sexual suggestiveness beyond the card's title is communicated through the woman's coy glance and exposed teeth. Adorned with whiskers and cat ears, she is depicted as part cat, part human. Although such zoomorphism in retrospect seems light and daring, humor often masks deeper sentiment about a group. Animal qualities have been used historically to represent the character or behavior of groups of people when they are seen as straying from their culturally determined place (Arluke and Sanders 1996). By connecting specific animals (and their presumed "natural" characteristics) with human groups, these groups can be problematized as threats that need to be eliminated or at least controlled. It is

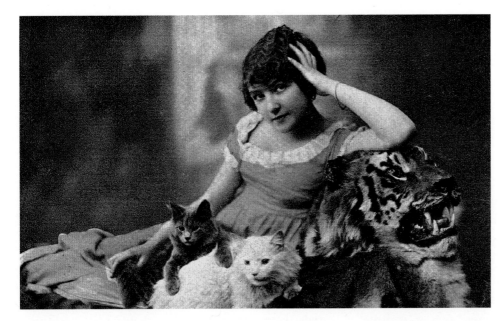

5.21. Woman with domestic and wild cats.

no coincidence that the women's movement was gaining traction around the same time these photo postcards were being made, sent, and enjoyed by millions of people. Many who bought the "Chatte" postcard probably saw this depiction of a sexy cat as more of a putdown of women seeking to break free from conventionality than a welcome sign of their liberation.

Photographs that erotically or sexually linked women and cats subtly separated them from the world in some essential way. Going beyond an affinity for cats, these women, by implication, seem to have become a little more animal and a little less human in the process. That such a visual pairing can make this connection and separation shows the power of the perception of role engulfment to marginalize women and to some degree cats as well, as this association does today (Simon 2003).

THE PERSONAL PHOTO AS POLITICAL

It is a misnomer to think that the photographs in this chapter are but a simple record of friendship, sometimes intimately portrayed, with cats. Nor are they only handy visual tools used to conjure up fond memories years after a cat's passing. When we consider all these photographs as a set, we can

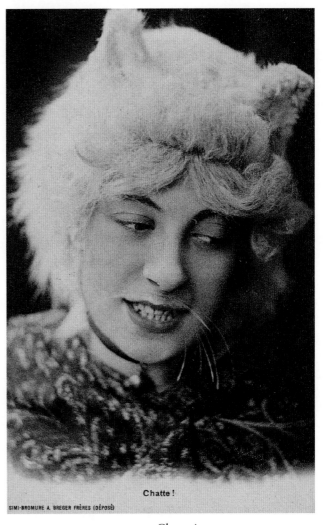

Chatte!

SIMI-BROMURE A. BREGER FRÈRES (DÉPOSÉ)

5.22. Chatte!

see their political as well as personal meaning; they depicted individual experiences while also reflecting and perpetuating widely accepted stereotypical views about gender. These depictions of women and men suggest that this gendering was culturally entrenched long before the modern era. The personal photo was political.

The gestures and poses in these images were micropolitical expressions (Henley 1977) that reinforced cultural expectations for being masculine or feminine. Because photographers and their subjects could not escape these expectations, we found a mixed picture of who did or did not have close relationships with these animals or at least who was or was not comfortable depicting intimate ties to animals on film. Women were not only more often paired with cats but paired in emotional and feminine poses, sometimes with multiple cats and sometimes in ways that animalized them, even to the point of appearing to be cats themselves. For women in cat photographs, interspecies ties appear very close, if not intense. By comparison, as noted, adult males were less often photographed with cats, and when they were, the interaction often appears more distant. For men in human–cat photographs, interspecies ties look loose and guarded.

The political nature of these images gave men and women little or no wiggle room to depart from their conventional roles. For men, the gendered expectations apparent in human–cat photographs were very narrow and limited. Having cat bonds or at least documenting them on film was so socially costly, perhaps stigmatizing, that men distanced themselves from cats or were too embarrassed to be photographed with them despite whatever bond may have existed. Either way, the absence of men in such photographs and their emotional reservation when they were in them suggest that having a close visual tie to cats was a risky connection for men of the era because doing so questioned their masculinity. For women, gendered expectations for interacting with cats were mixed and confusing. Having or simply documenting relationships with cats reinforced traditional maternal and domestic

behavior, fed into a cultural trope of the crazy cat lady, or cast them as sexualized animals. The pictured choices for women, then, were either to follow existing gender norms and keep their emotions in check as nurturers or not to play by these rules and lose self-control and a bit of their humanity.

These depictions not only reinforced gender differences but also perpetuated them. The political nature of human–cat photographs picturing either men or women hinged on their transformation from private records into more public ones. These pictures were not only and always for the enjoyment of one person, family, or even generation. Although they portrayed the private behavioral repertoire of men and women with cats, the postcards were widely shared with friends and family and in some cases sold to the general public across the country. For decades to come, many were preserved in family albums for future generations to see and learn from or kept by postcard collectors to admire or sell to others. Of course, the conversion of these photographs from private to public use pales in scope to the ability of contemporary snapshots to enter the public sphere and mass culture through print media, film, television, and the Internet (Zuromskis 2006), but their circulation nevertheless allowed the messages behind the images to be seen, reflected upon, and absorbed far and wide.

Yet men could be anchored to cats, sometimes quite intimately, when the cats were not pictured as individual pets paired with particular owners or families. Visual tie signs could tightly link cats to men displaying affection, nurturance, and joy when the cats assumed a more public role—for instance, as naval mascots, as we see next. Here the animals were not mere pets; they had an unofficial role as ratters and morale builders, serving a large group of sailors at sea far from home for long periods of time in what sometimes were wartime conditions.

6

Citizen Cat

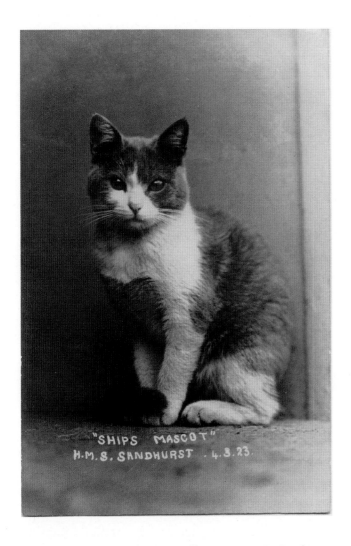

6.1. Ship's mascot, HMS *Sandhurst*, 1923. B. Buckberry coll.

Although men appeared wary to be photographed with cats, much less be depicted in sentimental ways with them, in a different context these gendered reservations were relaxed in front of the camera. Photographs posing naval crewmen with their ship's cat mascots frequently and prominently pictured close relationships with these animals. In this unique situation, the cat's social role and relationship to men appear to differ from those existing in everyday life.

A combination of historical conditions and reality at sea gave rise to this situation. Early in the twentieth century, America finished its engagement in the Spanish-American War, mobilized during the Mexican Border War, embarked on World War I, and experienced a military lull before World War II. To demonstrate its position as a world power, the country enlarged and modernized its navy and sent ships to far-off places. A large navy became part of America's military profile, as it did to a lesser extent for England. Although animals served as mascots in all branches of the military in both countries, they were particularly common aboard navy ships during this period, where they were a pervasive part of life at sea.[1]

Animals aboard ships were neither officially allowed nor actively prohibited. Only the British Royal Navy had an official place for mascots by encouraging the presence of cats, in particular on ships, but in 1975 it became the first military service

1. Parallel accounts of keeping mascots can be given for other branches of the US military during this era. Army units, for example, were known for their mascots. During World War I, these animals hunkered down in the trenches, endured long marches, and occupied cramped tank turrets alongside soldiers.

95

in the world to officially prohibit mascots. United States Navy regulations did not address the issue, so commanding officers made their own rules. Some encouraged mascots; others just overlooked their presence; and a very few banned them altogether.[2] Even where animals were outlawed, they appeared in secluded places and at opportune times.

Cats and other animals were drafted into mascot service through a number of routes. Some officers brought animals on board knowing that the crew would adopt them. Others were smuggled or openly brought on board by individuals or small cadres of crew members either at their homeport or in ports of call. Also, it was fairly common for cities and states that had navy bases to present animals to ship crews as gifts to support the military's efforts and to wish them good luck. Some foreign governments did the same. These acts of generosity were often accompanied by community presentation ceremonies where the mascot made the transition from land to sea, from civilian to navy life.

Cats, though, were probably the most common naval mascot on American and British ships. Smaller and quieter than most other mascots, they were relatively easy to control and care for compared to most wildlife and farm animals onboard. Despite their lower profile and more unobtrusive demeanor, cats packed a powerful symbolic punch when it came to photographing the many roles they served for the American and British navies during the first decades of the twentieth century.

Cat mascots are prominent in informal group photographs taken onboard American and British ships. Some of these images were the work of local commercial photographers who boarded ships when they were in port, but amateurs also produced many of them. Amateurs took candid images of daily life, but because of their inferior equipment and lack of skill, their postcards were typically not up to professional standards. Onboard photographers, whether amateur or professional, produced images of cat mascots as good citizens, friends, and more to many of the sailors.

Although these photographs depict the cat mascots' valiant efforts and at times legendary experiences, they raise but obviously do not address the moral question of subjecting animals to the cruelty of war. In addition to battle mortality and injuries inflicted on humans and animals, conditions at sea could become quite harsh. Supplies could dwindle, and weather conditions could become brutal for all onboard. Tension and stress could mount from long tours at sea far from home and in the face of dangerous enemies, causing crew members to bicker and team spirit to flag. These features of shipboard life and culture were also not photographed.

Instead, shipboard photographers and their subjects captured a more idyllic world among crew members by depicting a happy and cohesive life onboard. The frame (Goffman 1974) created on film certainly had some basis in reality. Mascots no doubt played a very real role in bolstering morale and solidarity at sea, but they also were unique symbolic props that had personal and propaganda value. As frames, mascot photographs rendered pictured events meaningful by visually organizing their content to guide how viewers should think and feel about them. Mascot photographs conveyed a certain version of life at sea that sailors would want to recall in years to come; reassured distant friends and family that their sons, friends, lovers, and husbands were safe and among friends; and presented a united front, showing individual ships and their crews as a single national fighting spirit.

What aided in the creation of this collective frame was the photographers' ability to provide glimpses of ritualized and intense social interaction, sometimes involving several people focusing their attention on the same cat-oriented event,

2. Jack Green, public affairs officer, Naval Historical Center, personal communication with the authors, Mar. 2008.

while simultaneously convincing the viewer that the cats were willing coparticipants. Images signal that a collective mood has swept up the pictured ship's crew, its culture, and its animal life, first by suggesting that mascots can be leaders, albeit nominal, of men.

FIGUREHEADS

Although Goffman (1959) did not explicitly talk about the social role of mascots, he discussed a similar character in courtly human interaction. Here, people form around a dominant figure that remains the center of attention. This figure can hold dramatic or directive dominance. The former person, like the mascot, has a position of visible leadership as a mere figurehead, whose subordinates really direct the show. Photographs of cat mascots could be posed, captioned, or otherwise created to suggest that the mascots were the ship's heart and soul, the focus of the crew's interest and affection, and a symbol of military might and destiny.

Of course, photo postcards sometimes show other animals competing for the role of ship's figurehead. Along with cats and dogs, many other species served as naval mascots, including pigs, bears, snakes, lizards, kangaroos, anteaters, deer, ferrets, turtles, parrots, and crows. Ships could have different species of mascots at the same time, with cats being just one kind. For example, the sailor shown in illustration 6.2 is posed with his crew's mascot kitten and goat.

However, some onboard cats were singled out as the ship's figurehead. One way that photographs created this frame was through portraits of mascot cats that linked their identity with an entire ship and crew. Formal portraits done in photography studios on shore, such as the one beginning this chapter (illus. 6.1), feature the cat by itself, front and center. The cat has no name in the photograph, although it certainly had one onboard the HMS *Sandhurst*. Because this cat represented

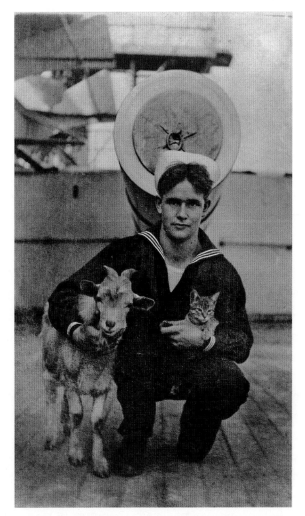

6.2. Sailor with cat and goat. B. Buckberry coll.

the entire ship, simply labeling it the "ship's mascot" cemented its collective identity. Another possibility is that the cat had many different names onboard because in everyday life people often have several names for their pets; the *Sandhurst*'s crew of hundreds might have given their mascot cat dozens of names.

There were other explicit ways to connect mascots to a ship's name and crew. Major holidays or events were important events to celebrate onboard by creating special photo postcards to send to family and friends. These holiday cards became opportunities to feature the ship's figurehead. Cats were so openly a part of military life at sea that mass-produced Christmas cards from

Royal Navy vessels featured these mascots. The card mailed back home in 1926 by crewmen on the HMS *Curlew* is but one example of many (illus. 6.3).

Some photographs personalized the pictured mascot by inscribing its name on the image, while still clearly linking it to the ship's identity. Tom, one of the USS *Virginia*'s mascots, had his picture mailed to civilians all over the world (illus. 6.4).

Whether the mascot is named or not, an important element in such a photograph was to capture the cat's status as the pet of many sailors, if not the entire ship. To be clear about this status, one image posed the cat mascot on the ship's deck fittings, around which rope was secured for docking (illus. 6.5). Only one sailor's shoulder and another's hand are in clear view, but the crew made sure to inscribe "our pet" on the photo postcard.

To establish the mascot's status as a figurehead representing the entire ship, physically and socially, shipboard photographers were careful to pair the mascot with iconic props representing the ship, its crew, and the larger ideology of state military power. Cats, for example, could be posed next to or on top of the ship's brass nameplates affixed throughout the craft or on portals or vents. The tiger cat in illustration 6.6 was proudly photographed on a nameplate for the crew of the USS *Don Juan de Austria*, an American gunboat that served with the Atlantic fleet as a troop transport during World War I.

Cat mascots were more commonly photographed on top of or inside the large cannon barrels that distinguished American and British destroyers and battleships. The irony of pairing a small, fragile, and gentle creature with a powerful metal object and symbol of destructive force was not lost on those viewing the postcards. As part of cats' symbolic value as figureheads for the navy, photographs could imbue aggressiveness in them to parallel the fighting spirit of troops during wartime. The cat mascot in illustration 6.7 peeks out from inside the barrel of a thirteen-inch gun on

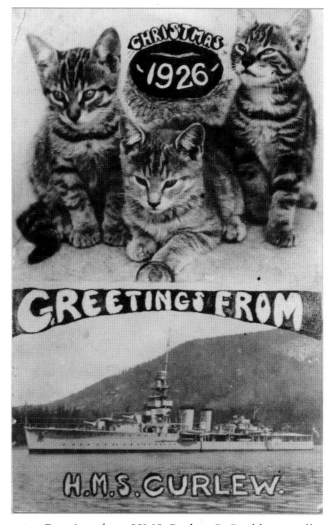

6.3. Greetings from HMS *Curlew*. B. Buckberry coll.

the USS *Colossus*, which patrolled the North Sea during World War I.

The fact that many mascots had the run of the ship contributed to their popularity and ability to serve as figureheads. They could visit shipmates everywhere, from below to the observation deck (All Hands n.d., 78). All ranks of crewmen onboard were photographed with cats to visually link mascots to the entire ship and its crew. Unlike most pets living on shore that belonged to a person or family, military mascots were communally owned and regarded as companions by many—even hundreds or thousands—of sailors. Enjoying mascots was not limited to the working sailor; crew members of all

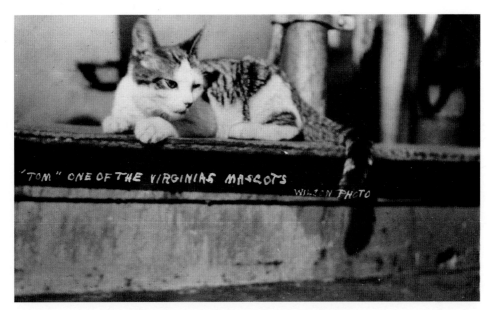

6.4. Tom, one of the *Virginia*'s mascots.

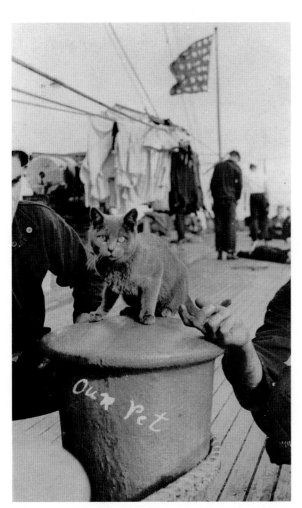

6.5. Our pet. B. Buckberry coll.

ranks enjoyed the companionship. In illustration 6.8, a naval officer proudly holds two kitten mascots for the camera.

Photographs extended mascots' collective identity as a form of propaganda. Of course, mascots were not the only animals in World War I that had propaganda value as symbols of national power (Baker 1993), but they were among the most effective devices to make an identification with the state and associated values. One way to accomplish this link was to include cats in photographs of higher-ranked servicemen posing next to or in front of the American flag. A mascot perched on the sailor's shoulder in illustration 6.9 shows that no attempt was made to hide the presence and importance of cats to a crew's identity and allegiance to American and military beliefs and ideals.

Of course, not all mascots served such a large constituency in reality. On a larger ship, a single unit might have had its own mascot. For example, the kitchen crew might keep its own cat, while the boiler room had a dog. Whether the mascot belonged to the whole ship or just a segment of the crew, specific individuals looked after the animal's welfare, feeding it and providing a place

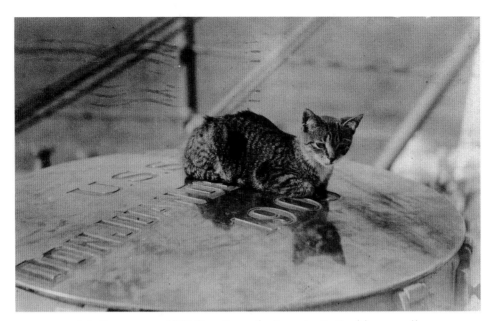

6.6. Cat mascot. USS *Don Juan de Austria*. B. Buckberry coll.

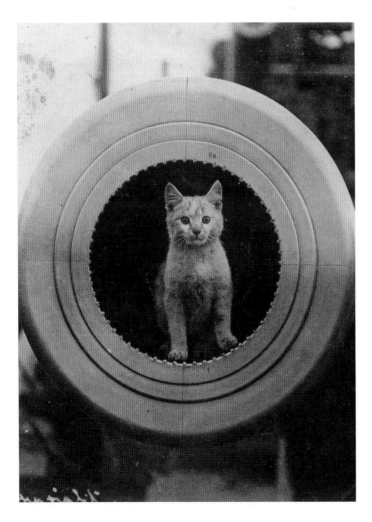

6.7. Cat mascot in gun. B. Buckberry coll.

for it to sleep, often in a sailor's bunk or officer's quarters when the mascot was small. Illustrating the cooperative nature of animal care, a particular crew member would collect money for a fund to buy special food that a mascot might require. These caretakers were typically not considered the animal's owners; mascots belonged to everyone. When caretaker sailors were discharged, they did not take the mascots with them.

However, photographs suggest a different version of reality in which crew members came together into a cohesive team around mascots regardless of rank. Photographs capture cat mascots participating in group rituals and displays of social solidarity that symbolically celebrate the shipboard cat as a friend to all and fellow crewmate. Indeed, the mascot photograph itself—its gathering, planning, posing, taking, and sharing—is a ritual of social integration where crew members who might not routinely mix had a reason to come together and share a common emotion and memory, such as moments of playing with mascots.

PLAYMATES

Mascot photographs depicted an idyllic image of shipboard life and culture; one gets the impression that most if not all the sailors are happy, relaxed,

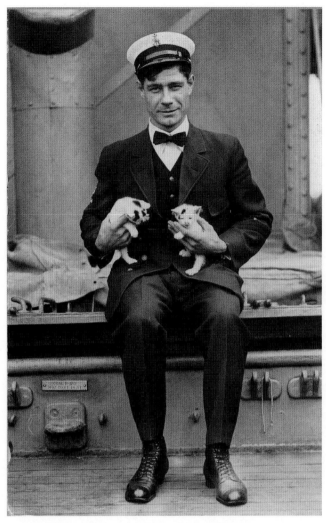

6.8. Officer with kittens, c. 1908. B. Buckberry coll.

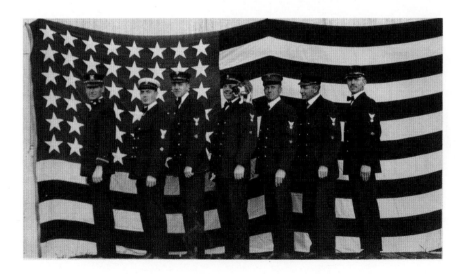

6.9. Patriotic cat. B. Buckberry coll.

and at play with the mascots. Photographs captured the cat mascots' ability to serve as pleasant diversions from the crew's daily toil. Sailors are shown sitting idly by, perhaps just watching their mascots. Regularly sending these photo postcards to friends and relatives at home indicated that mascots were an important part of their lives, an aspect they wanted to share with loved ones. It is also possible that these postcards, although not an official form of naval propaganda, were sent because the images softened the war experience, reassuring loved ones at home that the men were safe or occasionally had playful moments. Images show sailors lounging with cats as if they all are passing idle time. A shot of several kittens and cats shows them as the center of attention on one ship (illus. 6.10).

Mascots provided intangible benefits that the crew often valued more than rodent control; the cats had an uncanny ability to bolster the morale of servicemen just through watching their antics. This was particularly important because of the stressful conditions servicemen endured. Stays at sea were long, the living conditions were cramped, ships lacked amenities, and communication with sailors' loved ones left behind was limited. Crews in war zones suffered the sounds of large guns and the fear of being wounded or killed. The environment challenged the spirits of even seasoned, battle-hardened servicemen. Simply being in the presence of mascots, watching them at play, was a relief and distraction from the tedium of long journeys, the loneliness at sea, and the tension of battle. Sailors might have a difficult time not smiling when seeing two of their shipboard "shipmates," a cat and a dog, sparring with one another on deck, as happened on the deck of the USS *New York* (illus. 6.11).

Of course, mascots could serve as welcome diversions in more direct and active ways than by merely watching them. People enjoy teaching "tricks" to pets and getting them to perform for an audience. Photo postcards were the perfect media to share a mascot's accomplishments with friends and family in distant places. Pickles, "our mascot" shown jumping through this sailor's outstretched arms in illustration 6.12, amused many a crewman and served as a good buddy to some. It is doubtful that most cat mascots could learn sophisticated tricks to perform on cue for the onboard photographer. But to create a frame for them as good playmates, photographers made sure to catch the exceptions that made the point—the cleverer the

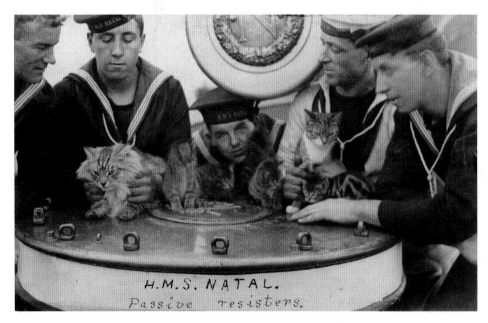

6.10. Passive resisters, HMS *Natal*, c. 1918. B. Buckberry coll.

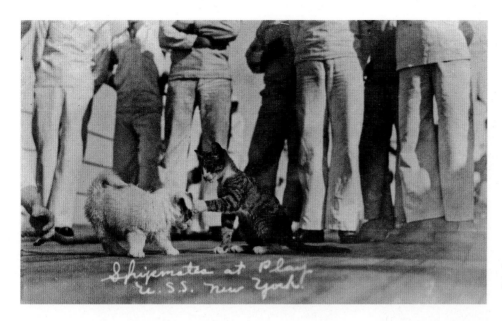

6.11. Shipmates at play. B. Buckberry coll.

better. By performing such tricks, the navy mascot in illustration 6.13 no doubt provided ample entertainment for the crew of the USS *Chicago*. More to the point, if this mascot could be trained to perform on cue for the photographer onboard, it strongly suggests that one or more crewmen on the *Chicago* had close enough ties to the cat to want to train it, perfect the training, and then capture the final trick on film for others to see and for the sailors to remember years after serving at sea.

One form of activity aboard ships involved the intense competition between various vessels in fleets over everything from the running of the engines and the firing of the big guns to the quality of the food and ship cleanliness. There were interfleet boxing and wrestling matches as well as swimming and shooting meets. This sense of competition extended to mascots: Who had the largest, smallest, strangest, most exotic, or most dangerous animals?[3] Most of these comparisons were limited to bragging fests that were carried out in the spirit of jest. This spirit of competition can be seen in a

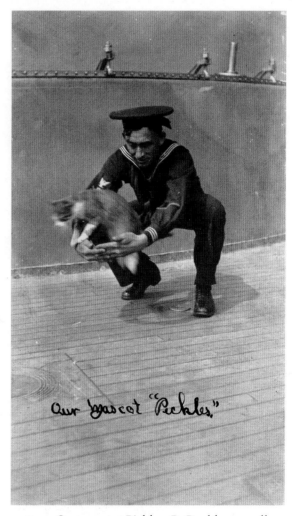

3. Brian Buckberry, lieutenant, U.S. Navy, ret., personal communication with the authors, Apr. 2008.

6.12. Our mascot Pickles. B. Buckberry coll.

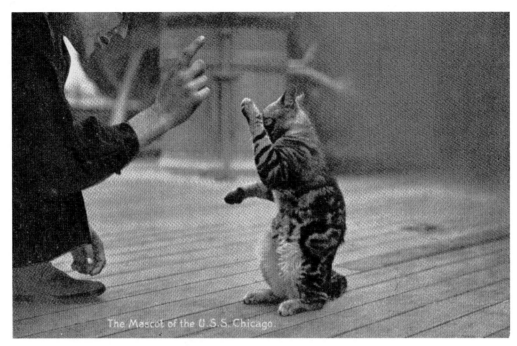

6.13. The mascot of the USS *Chicago*.

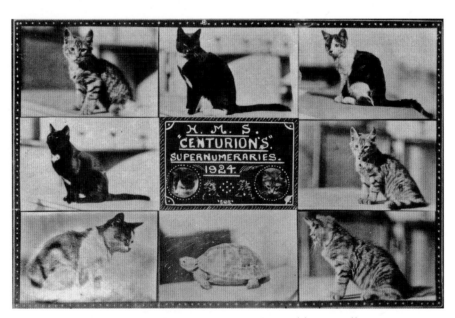

6.14. HMS *Centurion*, 1924. B. Buckberry coll.

1924 photo postcard created by the HMS *Centurion* that flaunted the largest number of cat "supernumeraries" in Her Majesty's fleet (illus. 6.14), using another term for "mascot" that suggested that these animals had no apparent function, in the spirit of our everyday use of the word *pet*.

Whoever made the *Centurion* postcard must have only halfheartedly used the term *supernumeraries* to describe their cat mascots because it minimizes their importance to sailors. Cats provided recreation for all the crewmen, who vied for their attention, and were friends to anyone who

took the time to relate to them as playmates. But they served other functions onboard that were as vital, if not more, to the crew's mental health and esprit de corps.

NURTURED CHILDREN

Mascots did more than merely distract servicemen from the duties and demands they faced. Cats provided them with opportunities for attention, affection, intimacy, and companionship. Crewmen are commonly seen in photo postcards tenderly holding, touching, and caressing their animal friends, who could easily pass in these images as infants or young children being tended to by their parents. One such image shows a sailor warmly clutching a mascot while seated on the ship's deck (illus. 6.15). Such poses strikingly contrast with photographs of men with cats in civilian life, as we saw in chapter 5.

With an all-male crew of up to fifteen hundred onboard a ship, a tough-guy culture developed that left little room for tenderness. With animals, servicemen could openly show their softer side, express feelings, and demonstrate their affection without ridicule. In illustration 6.16, a Royal Navy marine carefully cradles his unit's cat mascot as crewmates look on approvingly.

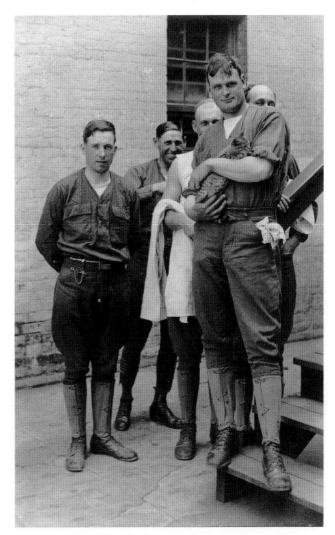

6.16. Royal Navy marines with mascot.

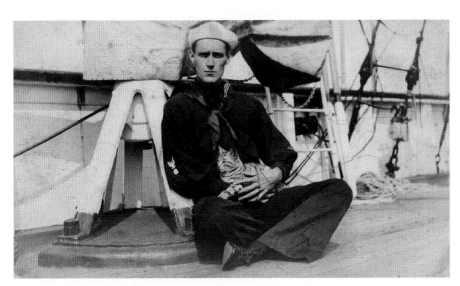

6.15. Nurturing a mascot.

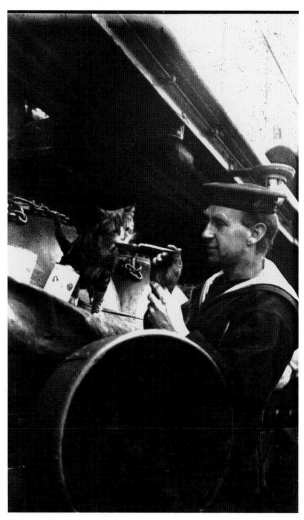

6.17. Feeding a ship's cat. B. Buckberry coll.

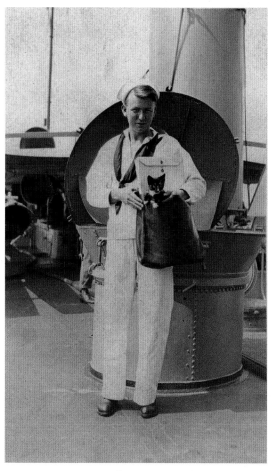

6.18. Cat in mailbag. B. Buckberry coll.

Beloved mascots could engender tremendous pampering and respect from servicemen. Sailors would go to extremes to take good care of mascots. Although an individual crewman or unit on board often took primary responsibility for feeding and cleaning up after their mascots, the fact that so many others onboard also felt affection for these animals ensured that they were regularly fed quite well. Some animals were hand fed by concerned crewmen, as in the photograph of a sailor spoon-feeding the ship's kitten (illus. 6.17).

Nurturing could extend to not letting cat mascots fend for themselves on large ships. Rather than leaving them alone, sailors are shown taking cats with them on daily duties and making them part of their daily work. These pictures remind viewers that these animals are not regarded as mere playthings or as simple diversions. They are important enough companions to keep close at all times. The sailor in illustration 6.18, for instance, carries a tuxedo cat mascot in the mailbag as the two carry out their onboard duties together.

Thoughtfulness and affection for cat mascots often went beyond giving them frequent bowls of fresh milk and scraps of fish, especially for those deemed favorites. Special sleeping quarters were erected for favorite mascots. Hammocks for cats were one example of this kind of treatment. Illustration 6.19 shows a kitten resting comfortably in his hammock, thoughtfully erected by the crew of

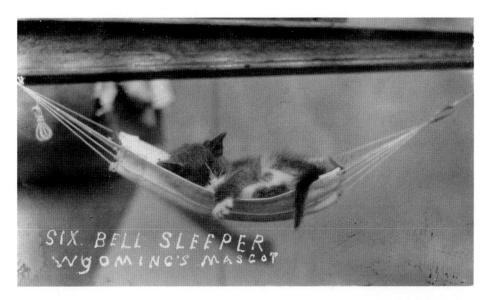

6.19. Six bell sleeper, USS *Wyoming*'s mascot. B. Buckberry coll.

the battleship *Wyoming* during World War I. "Six bell sleeper" was probably both an endearing and humorous reference to the good if not indulged life provided mascots onboard: bells were used to help mark the time during the various watch periods on a ship, and the inference is that this kitten slept through the first three hours (six bells) of its watch.[4]

More to the point, photographs were made of cat mascots lounging in comfortable and well-decorated private quarters. Dardanellus, the mascot in illustration 6.20, even has a small ladder, which it certainly did not need, to climb into the specially made hammock with a small pillow. Its wall is even decorated with a drawing of cats and an envelope meant to be from an admirer or loved one from afar. Deliberately crafted by adoring crewmen with a sense of humor, images like this one were surely entertaining to set up and capture on film but also strongly suggested that Dardanellus was well tended to and nurtured by crew members on this ship. The caption clearly spoofed the life of leisure this cat had, compared to the ship's crew and their many arduous duties.

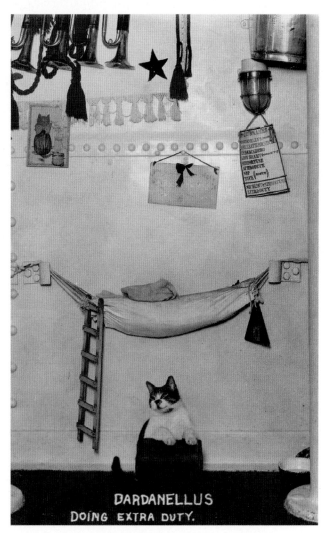

6.20. Dardanellus, doing extra duty.

4. Brian Buckberry, personal communication with the authors, Nov. 2012.

Depicting mascots as dependent infants or human children made it easy for photographs to imply that crew members "knew" these individual animals and experienced a relationship with them. We cannot say for sure that crew members actually had this sentiment, but the images strongly suggest they did. Other photographs expand this frame to depict cats as much more than conventional pets to the crew members with whom they are portrayed.

TEAM PLAYERS

More than just good-luck charms, token figureheads, playmates, or pseudo-children to nurture, mascots were part of the team, providing service to the ship in their own way. As shipmates, cat mascots carried out certain practical duties.[5] Cats as well as ferrets and some dogs were valued as predators of mice and rats. They were called "ratters." Certain cats were particularly good ratters and earned special pampering as a reward for this service (V. Lewis 2002). In illustration 6.21, the two large cats held by the sailors were likely the ship's ratters.

Photographs suggest that sailors also treated their cat mascots as fellow shipmates and team members because the mascots experienced wartime service right along with the crewmen, thus elevating their stature from pet to peer. A bond develops between creatures living together for long periods of time, especially when they share cramped quarters and a common mission as well as face hardships and dangers together. They become part of each other's history. This was especially true when mascots had to endure rough seas and battle conditions along with their human counterparts; they, too, displayed courage, honor, and readiness to

help fellow crewmen. The result was that some sailors developed deep and lasting emotional connections to mascots greater than anything they subsequently felt with other animals.

This extraordinarily close bond between crewmen and their mascots must have existed on the HMS *Royal Princess*. Stowaway Jim, the ship's much-endeared mascot, was no "ordinary cat" in the crew's eyes. The postcard picturing him (illus. 6.22) proudly notes that he "is an old wardog and bears his battle honours." Because of his companionship through battles at sea, the crew went out of its way to honor Jim for exceptional duty. In lieu of formal rank or medals,[6] he was informally recognized as the chief of all onboard cats, or "OC."

Mascots were in danger when at sea. They could be wounded or killed in battle. Even though they were often the first to be rescued, they also might go down with their ships. (It was considered bad luck and poor seamanship to abandon a mascot on a sinking ship, and mascots had secure places on the lifeboats.) They also were prone to accidents, such as falling down steep staircases or being washed overboard during storms. Although mascots were pampered, the confines of a ship were not always conducive to an animal's good health. Some mascots died from poor diet and disease, and others were injured or killed during combat. One photo postcard notes that the HMS *Renown*'s mascot, Jimmy, was wounded during the battle of Jutland (illus. 6.23). When killed in action, some highly regarded mascots were accorded full military honors and buried at sea in a flag-draped coffin as the band played taps.

As co-combatants, mascots were also considered to be veterans of war, and crewmen were proud to have served with them. Personifying such a contribution is the case of Tom Whiskers. As

5. Of course, the nature of a mascot's military service influenced the functions it could provide. Dogs, for instance, served as army mascots on land and helped to sniff out dead soldiers, track scents, and detect explosives.

6. Although we found no cases of mascot cats receiving formal military rank and honors, this did happen with mascot dogs at sea.

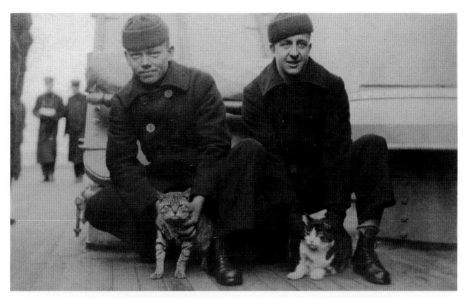

6.21. Sailors holding ratters, c. 1915. B. Buckberry coll.

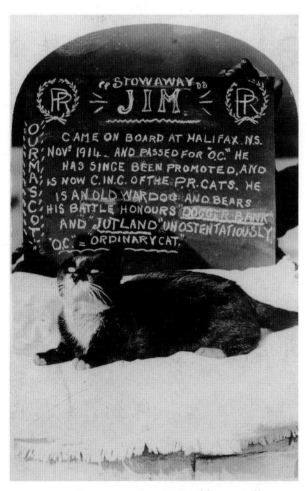

6.22. Stowaway Jim. B. Buckberry coll.

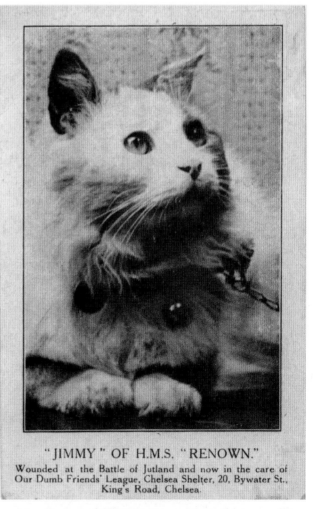

"JIMMY" OF H.M.S. "RENOWN."
Wounded at the Battle of Jutland and now in the care of
Our Dumb Friends' League, Chelsea Shelter, 20, Bywater St.,
King's Road, Chelsea.

6.23. Jimmy of HMS *Renown*. B. Buckberry coll.

shown in illustration 6.24 with its accompanying caption, this cat was considered a "veteran" of World War I, where he was a mascot on the hospital ship USS *Solace* and then a ship's cat on another hospital ship, the USS *Relief*. Referring to Tom Whiskers as a veteran highlights the fact that this animal was considered equal to sailors. He was on that vessel when this widely circulated postcard portrait was taken.

The value of cat mascots and the pleasure of their company could continue long after sailors were out of harm's way. Some mascots that survived their tours of duty went on to lead prosaic civilian lives. When they could no longer be kept onboard, animals such as bears or kangaroos were given to zoos (Schulte-Peevers et al. 2006, 500), and cats

and dogs were retired to farms and private homes. Long after the official end of war, some cats were still treated as members of the team when on land with veterans. Tiger, the mascot of the Veterans of Foreign Wars (VFW) at the Long Beach, California, post, agreed, perhaps reluctantly, to being dressed in veteran's garb for a special shot (illus. 6.25).

That this VFW mascot is dressed in a fitting outfit is not an exception. We found many photographs of mascots of all kinds, including cats, wearing sailor's caps, naval T-shirts, and other garb that clearly linked them to the crew or ship as well as to the larger idea of military service and patriotic duty. By creating this frame of mascot as team player, photographs helped to cement the symbol of cat mascots as faithful shipmates

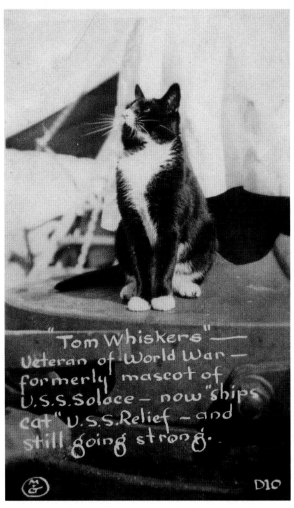

6.24. Tom Whiskers. B. Buckberry coll.

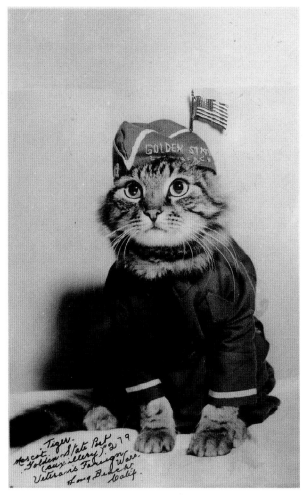

6.25. Tiger, mascot, Golden State Post No. 279, VFW. Long Beach, CA.

through thick and thin, a core value espoused if not expected among crewmen themselves.

CITIZEN CAT

In his essay "Citizen Canine" (1998), cultural historian Edward Tenner minimizes the importance of mascot dogs, saying that they play a small symbolic role in human social and work life. He claims that as "pure theater" (75), mascots were symbolically unqualified to serve as little more than greeters of people and representations of nations. Images in this chapter suggest otherwise, however. Mascots—at least the naval cats of the first half of the twentieth century—have played more varied and symbolically valuable roles.

Photographs of cat mascots signal a whole realm of relationships between crew members and animals not adequately covered by such terms as *working animal*, *pet*, and *companion*. The term *mascot* is convenient shorthand to describe these relationships, but perhaps a more precise term is *civic friend*.[7] Photographs framed cats' relationships with crew members as a civic friendship (Schwarzenbach 1996), much like the kind of bond that can form in human communities when individuals demonstrate interest in and caring for other people's welfare.

Photographs depict cats as good citizens who hold the crew together. These mascots appear to be available and responsive to everyone onboard, regardless of number or rank, who come upon them to befriend, care for, or play with as well

as to identify with and consider part of the team or unit. Whereas certain crewmen may have felt closer to and more responsible for a mascot, others may have taken only a passing interest in a cat while still enjoying the pleasures of its company. By comparison, pets confined within homes or fenced property do not have free reign to entreat new human friendships beyond the immediate family and perhaps a friendly neighbor or two. Cat mascots truly had a social nature.

Part of the mascot's civic contribution as depicted in photographs was to serve as the center of attention, distracting crew members, even if momentarily, from the stress and strain of months at sea and combat, or its possibility. The moment caught on film focuses on the cat as much as or more than it does on the sailors. Postcards show many people onboard sharing a common interest in a cat whose friendship is being collectively cultivated, its companionship collectively enjoyed, its care collectively nurtured. Further visual reminders of mascot cats' ability to distract crew members from the tedium and demands of military service are photographs of the mascots by themselves, without sailors in the picture. Humans are literally taken out of these pictures to focus completely on the mascots.

Photographs create the impression that cats, as good citizens, could in their own way contribute as much as any sailor to the ship's operation and the quality of life at sea. Images depict cats as a synthesis of worker and pet whose presence benefitted the ship as a whole. At the most prosaic level, these animals performed tasks—such as killing rats on ships—that made life easier, safer, or cleaner for many people. But postcards also suggest that mascots, as civic friends, bettered the sailors' emotional lives. Images of cats appear to show them positively affecting crew members' morale by combating loneliness, instilling pride, and providing solace, comfort, entertainment, and companionship to many people. In return, cats provided sailors with an opportunity to display their softer side

7. Strictly speaking, mascots were "mates," a type of friend (Allan 1989). Although both mateships and friendships are sociable relationships entered into voluntarily by people treating each other as equal, they differ according to the social context that frames them. Context is relatively unimportant when it comes to friendships, but in mateships it defines the relationship and sets its boundaries. With the latter, relationships happen primarily because people happen to be together within some narrowly defined social sphere, as is the case with naval mascots.

and transcend gender prohibitions on film, if not in real life, by showing affection toward mascots.[8]

Images also suggest that cats strengthened bonds and forged a stronger onboard community. Mascot photographs depict the crew as a unit or team, making it appear to be cohesive and, in some images, part of a broader spirit of patriotism and national identity. What is interesting about these displays of solidarity is that they create a perception of mascots as bringing together people of very diverse backgrounds into a single fighting force; this was certainly the case for sailors leaving port for the first time as novice crew members. Photographs, then, depict not only human–animal bonds at sea, but also bonds among those who find themselves sharing a common interest in the mascots. Their interpersonal ties were perhaps strengthened in the process, as suggested by photographs showing several sailors pictured together, all focusing their attention, at least for the shipboard photographer, on the featured cat.

Social solidarity and group identity are not givens. At certain times, there can be a greater need to deliberately cultivate an image of unity. When at sea on long journeys with relative strangers who might be facing battle conditions, individuals need to be cemented, at least symbolically, into a greater whole to help forge an identity as a unified team, reassure those far away that loved ones are safe and sound with friends, and mobilize public support for the military and its war efforts. At this level, the images in this chapter show an ideal world onboard, but there is also reason to consider these pictures as documents of life at sea. Photographs detail the everyday activities of a ship's crew and how it sees itself (Dubin 1990), so these symbolic images are likely to have more

than a kernel of truth in them. In the end, visual portrayals of the citizen cat become an objective display of solidarity, a powerful, group-sustaining, metaphoric device vitally important for continued individual participation and the survival of crews serving on naval ships.

8. That mascots might have actually provided these mental health benefits to sailors presages the contemporary interest in therapy animals as providers of companionship, nurturance, and stimulation to nursing home residents, prison inmates, and others (Wood, Giles-Corti, and Bulsara 2005), whose situations differ markedly from that of sailors.

7

Peaceable Kingdom

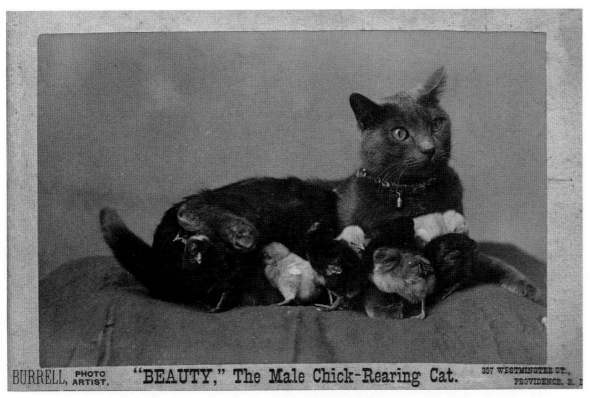

BURRELL, PHOTO ARTIST. "BEAUTY," The Male Chick-Rearing Cat. 357 WESTMINSTER ST., PROVIDENCE. R. I

7.1. Beauty, the male chick-rearing cat, 1889. T. Weseloh coll.

To better understand the importance and meaning of the images in this book, we need to step back and consider them as a group. To write them off as mere snapshots in the narrowest of ways suggests that the photographs were casually made with little forethought and carried little or no emotional value to the people who appeared in them, owned the animals, or received the photographs from afar as postcards. No doubt some early-twentieth-century cat photographs do fall into this category. But many of the images we have shared suggest that more went on emotionally and symbolically behind the scenes of these printed images. We can use a famous American oil painting, predating these photographs by only a few decades, to consider this intentional and meaningful take on these pictures and help give them a deeper, personal context.

Peaceable Kingdom is an eighteenth-century painting by Edward Hicks showing a large mix of wild and domestic animals as well as people at

113

peace with one another. Hicks created this work, in fact an entire series of such paintings, in the early to mid-1800s as a visual sermon based on a passage from the Book of Isaiah that describes a calm and safe world among different species. The painting is widely recognized, understood, and enjoyed today as the fulfillment of Isaiah's prophecy, starting with "The wolf shall dwell with the lamb." Benign animals are lying down with trusting infants in a world of equanimity, and in the background William Penn signs a peace treaty with the local Indians.

It was not just Hicks who hoped for a world where predators lie down with prey and where all creatures live in harmony with each other. The popularity of *Peaceable Kingdom* only increased during the nineteenth and twentieth centuries. Even today, people of all walks of life take comfort in the idea expressed in *Peaceable Kingdom* that human–animal friendship can exist and produce a jointly experienced state of calmness, security, and mutual understanding.

Although the photographers and subjects behind the images in our book did not have in mind Hicks's *Peaceable Kingdom* or the words from Isaiah when they made these pictures, their creations nonetheless speak to a similar sentiment and suggest similar benefits of friendship among the species. These photographic conceptions of cats, what they meant to some people, and what kind of life they possibly had in our human world depict a peaceable kingdom, too—a visual interspecies paradise.

Photographs abound of people in serene settings enjoying the company of their cats and other animals. As in Hicks's paintings, the subjects of these images, both human and animal, are lying down with each other in nature. In the photo postcard of illustration 7.2, the dog and cat rest calmly in the presence of their protectors, whose smiles hint at the contentment they likely felt while savoring the moment.

Photographs also drew from the peaceable kingdom theme when they depicted cats caring for other animals, extending themselves to help other kinds of animals in need. Stories about cats doing unusual or folksy things were very popular at the close of the nineteenth century and beginning of the twentieth. An 1883 *New York Times* article entitled "Strange Companionship" described an unusual relationship that developed between a

7.2. Picnic with dog and cat. T. Weseloh coll.

large Maltese cat and a goldfish in one Philadelphia home; the cat allegedly would gently paw the fish's back, while purring, and occasionally catch a fly, which it would drop into the aquarium for its friend the goldfish to eat (*New York Times* 1883).

Taking advantage of such popular curiosities, local photographers would hear about a cat that nursed rats or squirrels and make a portrait of the mother cat in the act of nurturing. The earliest altruistic portrait, of "Beauty, the male chick-rearing cat," captured the public's interest in 1889. A photo portrait was widely circulated with his "remarkable" story on the reverse side (see illus. 7.1). The story claimed that at three months old Beauty saw some chicks, immediately adopted them, and began brooding, playing, and caring for them, just like a hen. Although Beauty had sharp teeth and claws and was known as a great mouser, he never showed any hostility to his chicks. As a traveling exhibition in museums, the thirteen-pound Maltese adult Beauty continued to rear chicks and win the adoration of at least a million people who visited his exhibit, according to the card's estimate.

Such interspecies altruism was occasionally reported in newspapers as a type of human–animal interest story. The *Deseret News* in Bloomington,

Illinois, reported on March 14, 1922, that Suzie the cat nursed five baby rats along with her own kittens, breaking her former record of nursing two rats. The article, praising her "unique motherhood," pointed out that Suzie could have made a meal of the rats but instead purred and played with them. A similar case of cat altruism occurred in Lake Placid, New York. The caption in illustration 7.3 documents the virtuous behavior of a cat that was "the greatest foster mother in the world" because she raised fox pups. As an ironic take on the peaceable kingdom theme, this postcard was produced by a farm that raised and killed tens of thousands of foxes for commercial profit.

Photographs also keyed into the peaceable kingdom theme when cats were pictured being nurtured by other animals. Best illustrating the idea that cats could benefit from the kindness of other species was an immensely popular image of a cat drinking cow's milk with the help of a farmer. We came across many photo postcards showing different poses of farmers squirting cows' milk directly from udders into cats' mouths (e.g., illus. 7.4). The "down-home" and wholesome appeal of these images made them popular to collect or mail to friends and today symbolize a bygone era

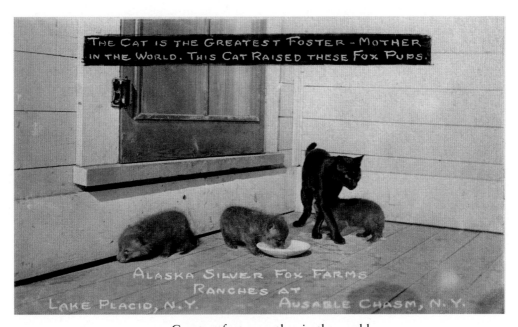

7.3. Greatest foster mother in the world.

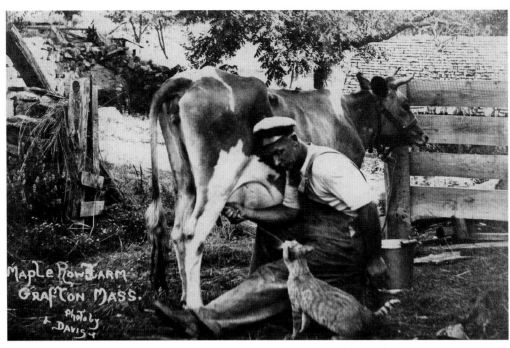

7.4. Getting a squirt, c. 1908. Photo by Davis.

of the small, unmechanized family farm. But these photographs also spoke to the idea that kindness could extend between animals, whatever their species. Although the cows in these images are sharing their milk because the farmer chooses to, the cat, cow, and human appear to coexist peacefully in a way that clearly benefits the cat.

At the heart of a peaceable kingdom is the notion that humans and other animals can reciprocate friendship and mutually experience the comfort and security that comes with having close ties, or what Aaron Katcher and Alan Beck (1983) call an "intimate dialogue." We believe that photographs trying to capture such a peaceable kingdom can be understood in two ways: they can hint at what the actual lived experience might have been for the depicted subjects, and they can present an ideal version of that experience, thus functioning as both documents and stories of human–animal relationships.

INTIMATE DIALOGUE

The photographs we have seen can be read for evidence of an intimate dialogue in signs that the subjects cared for each other and benefitted from their apparent friendship. They can do this because photographs, especially vernacular or casual snapshots of traditional folk activities such as interacting with household pets, provide insight into humans' emotional world (Mechling 2004) and perhaps animals, too.

The images in this book suggest that both humans and animals reciprocated friendship and probably experienced many of its benefits firsthand.[1] Of course, it is easier to interpret the displays of humans as opposed to those of animals in these photographs and to conclude that the former likely reaped emotional benefits from their peaceable kingdom with cats. But in theory, cats, too, should have extracted benefits from their contacts with the humans in these pictures if the photographs truly captured an interspecies state of tranquility

1. While experiencing the mental health benefits of an intimate dialogue with pets is not new, what is new, of course, is that more people today reap these benefits because pet ownership is more common and the benefits of such ownership are headlined in the news and heralded by many.

and caring. We can only infer, apart from their superficial appearance and pose, what these cats felt as recipients of human friendship and as potential reciprocators of this kindly attention. Although research on pet attachment has focused largely on its benefits to humans, a few studies suggest that animals also can gain from such attachment. Greater pet attachment, for example, leads to increased enrichment (Shore, Douglas, and Riley 2005) that gives animals more attention, stimulation, and varied experience. If photographs captured this attachment, then all subjects benefitted from it.

Even when the *ornamental cat* was photographed alone as a decorative object without humans in the picture, people still might have felt some of the positive feelings associated with the notion of a peaceable kingdom. At minimum, we know that someone cared enough about these particular cats to photograph them, whether for commercial purposes or for strictly vernacular and personal reasons. As we saw, portraits of cats, including those commercially made, often included written comments by the postcard's sender indicating that the charm or beauty of the image moved them, if not the cat's similarity to their own cats at home. Certainly, with vernacular cat portraits we feel more comfortable assuming that warmth and endearment existed in these apparently close human–cat ties; indeed, the sheer making of these images, including getting the treasured cat to pose for its picture and then obtaining the finished image, were joyous moments themselves.

Of course, when people are paired with the *coupled cat* in the same image, it is far easier to see how photographers and their subjects depicted a human–animal connection and its benefits. Peace of mind, calmness, serenity, and bliss can come from having close social relationships with animals (Sanders 2003) and can be outwardly displayed when people smile, gaze at, or lean toward the focus of their intimacy (Anderson, Guerrero, and Jones 2006). Many images we reviewed depict tie signs between humans and cats that intimately link them and include nonverbal gestures associated with contentment and "being in the moment" (Katcher and Beck 1983). People appear to enjoy being with their cats, whether they are smiling with apparent joy and contentment, gazing into the pet's eyes, holding it close to their bodies, or looking distantly into the horizon in a state of reverie. The cat subjects appear to reciprocate by sitting still enough to render an acceptable image and even responding to someone in the image by performing a trick or appearing content in the person's home or presence. People who defined their interactions with cats as close and coupled targeted these animals for attention, affection, and other emotions. In turn, it seems very possible that these cats understood, in some manner, that they were protected and safe and perhaps enjoyed as friends. In other words, they felt comfortable and secure, much like the animals in Hicks's *Peaceable Kingdom*.

We can also see an intimate dialogue in photos of the *kindred cat* giving apparent pleasure to people who included them in their domestic lives. We know now that many pet owners find solace in their animal friends during times of stress, talk to them about personal matters, and believe their animals understand them. It is not unreasonable to think that many of the domestically photographed adults and children with cats in the early twentieth century found similar comfort, well-being, and support from their cats. These images picture successful and prosperous cats, so to speak, surrounded by all the visual cues viewers might associate with a good life for cats, including the requisite attention and affection from humans in the household. Cats are shown ensconced in families' private spaces, whether sleeping on beds, sitting on easy chairs, or peeking out of car windows. Some were even important enough to their human friends to include as kin or close friends when pictures were being made of major holidays, birthdays, and other celebrations, an act suggesting that these beloved pets received extra care and nurturing.

Photographs of the *gendered cat* capture some of the emotional benefits that women in particular

and perhaps men, too, experienced in their cat relationships. Studies have shown, for example, that women report somewhat greater attachment to pets than do men (Herzog 2007) and that women talk more to their pets, initiate this talk sooner, and talk to them more often in infant-directed speech or "motherese" (Prato-Previde, Fallani, and Valsecchi 2006). The nature and strength of this attachment and the behavior it entails likely provide the kind of intimate and intense satisfaction that results from nurturing. Images we saw of women and some men cradling kittens, clutching cats on their chests, and pressing cats against their faces are nonverbal behaviors that indicate parenting of cats and suggest attendant feelings of being immersed in time, safety, control, and focused attention—all positive emotional states observed in our relationships with humans as well as animals (Katcher and Beck 1987). Cats pictured getting this attention likely received extra kindness, care, and stimulation as well as an immediate experience of contentment.

A wider intimate dialogue between humans and animals is suggested in photographs of the *citizen cat*, where the emotional benefits of their ties appear to extend to many people. Researchers have found that animals can help to build a sense of community by increasing contacts among neighbors, enhancing social support, and bolstering friendliness (e.g., Wood, Giles-Corti, and Bulsara 2005). We saw many images of cat mascots on naval vessels with sailors posed in ways suggesting that the cats, too, reaped some of the benefits of a peaceable kingdom, at least while at sea. By serving as pseudo–crew members, these cats seemed to build the ship's morale and group identity by bringing sailors together, providing companionship or at least a welcome distraction to many, and offering symbolic leadership to sailors of all ranks. In exchange, photographs show dozens of sailors often scrupulously caring for and looking after these cats, tending to their basic needs, and sometimes lavishing attention and affection on them.

IDEAL DIALOGUE

Although the photographs in this book suggest that an intimate dialogue existed between people and cats, they can also be read as depicting an ideal dialogue between the two. Seen from this perspective, these images are not unlike wedding photographs, which portray people looking their very best at a special event (C. Lewis 1997). According to Goffman (1976), "private pictures," whether of someone's wedding or special cat, have meaning and value because they were made for the sake of creating a perfect memory. As the center of their ideal moment and flawless day, the couple about to be married, dressed in their finest clothing, surrounded by flowers, exude joy and contentment with each other. Most of the photographs of cats we have seen were not taken at such important, once-in-a-lifetime events, but the cat pictures were hardly spontaneous and candid; the people behind them also attempted to create a perfect memory of a special moment, albeit more prosaic than a formal wedding.

Seeing these photographs of cats as idealizations rather than documents of friendships with cats does not lessen their appeal to us today. Even if cats were mere photographic props, the mystery shrouding the meaning of these images makes them inviting to view, ponder, or be charmed by. We can imaginatively interact with these images and with the humans and animals who appear in them. We can envision how important these cats were to the people who paid photographers to make the prints, took their cats into town to have a formal studio portrait made, or waited until just the right second to capture their cherished pet sitting in exactly the right position on the windowsill.

Nor does seeing these photographs as idealized friendships lessen their value as social science data. Scholars can use photographs as data in different but equally valuable ways. They can discover interpersonal or, in this case, interspecies relationships that may otherwise be overlooked because these

ties are not directly observable due to the passage of time or the privacy of the interaction. And they can inspect photographs to understand the nuances of interaction, the presentations of self and other, and relations among people and animals that might escape the watchful eye of even the most experienced social researcher, as photographs in general allow us to do (Harper 1988).

Whether the goal is to discover social relationships or subtleties of interaction, some would say that these photographs, like other qualitative materials, provide biased and less than factual data about human behavior and social life (Prosser and Schwartz 1998). The images are hardly a representative sample of all cat relationships in the period covered: they are highly selective of only certain cats, certain people who apparently were very attached to their pets, and certain carefully posed moments that showed a snippet of positive sentiment toward these animals. However, the "bias" inherent in photographs is what itself becomes important to study for what the images tell us about ourselves.

Even if only a partial reality, the photographs in *The Photographed Cat* reveal how some people regarded the social role and personal importance of cats and pets in general by modeling the behaviors and activities that constituted friendship to them. With their subjects posed to manage impressions that others might have of them, the images contain information connecting the kinds of relationships that were achieved with the kinds aspired to. In other words, the images become microsociological documents that link how people expected idealized relationships to look with how people actually conducted their lives (Grady 2006). In the end, we learn as much or more about the people behind the cat subjects than we do about the pictured cats, and this is the strength of our images rather than their weakness as data.

Although these depictions are useful as data about desired ways of relating to animals, some might criticize them for what they say about the nature and place of animals in human society. Idealized portrayals of the human–animal relationship, in this case with cats, can be seen as evidence, if not a tool, of our transformation of animals' natural state into something thoroughly humanized. Of course, their very status as domestic pets has already rendered their animality almost invisible (Berger 1980), but photographing them as our perfect friends completes their re-creation into cultural fetishes. What is truly animal about the cats we see sitting for their portraits, sleeping on someone's lap, lying on the bed next to their owners, playing outside with the neighborhood kids, or serving honorably at sea during war?

We can no longer see the animal's authentic nature because it has slipped out of our everyday view and out of the pictures we make of them. Photographs document this transformation by incorporating cats into the center of modern social life and showing their importance as friends many decades ago. They complete the transformation by creating a permanent record that can be easily and widely shared, allowing us today to reimagine these human–animal friendships and compare them to our own.

Perhaps the issue, though, is not about denying what is natural about nonhuman animals, but about eliminating what is animal in humans. Highly stylized and selective photographs of cats, whether commercial or vernacular, are perfect instruments to present this kinder, simpler version of being human. Far from exhibiting cruelty or other violence toward animals, the photographs we have seen ignore, if not deny, the existence of such untoward sentiment and behavior in favor of picturing a more compassionate and gentle way of being with creatures included in our lives and on whom we have become as dependent as they have on us.

The fact that photographers sought to capture this interspecies friendship is in the spirit of Norbert Elias's (2000) notion of the civilizing process. Elias claims that increasingly complex networks of social connections since the sixteenth century

have led to the replacement of physical and violent conflict with political and economic struggle. This process has permeated individual consciousness such that, over time, people now display more self-restraint and impulse control, enabling greater interpersonal and intersocietal cooperation. Many of Elias's students have extended his work to explore how this process of domesticating human impulses, in particular those toward violence, has progressed similarly.

Although Elias's theory relates to the changing dynamics between people, the images in this book are graphic reminders that the civilizing process extends to human–animal relationships as well. In the first half of the twentieth century, images of ideal friendship allowed people to show others and perhaps remind themselves, too, that they had let animals into the human circle as neither object nor tool, but as the best of friends. That we can look at these old photographs and see a familiar sentiment in the poses of human and cat subjects is a testament to the gradual gentling of our attitudes toward animals. That photographs framed cats this way a century ago shows that the peaceable kingdom is an historical work in progress.

References

Index

References

Afifi, Walid, and Michelle Johnson. 1999. "The Use and Interpretation of Tie Signs in a Public Setting: Relationship and Sex Differences." *Social and Personal Relationships* 16:9–38.

Alexander, James. 2006. "Sentiment and Aesthetics in Victorian Photography: The Child Portraits of C. L. Dodgson." *The Carrollian*, Spring:2–67.

Alger, Janet, and Steven Alger. 1997. "Beyond Mead: Symbolic Interaction Between Humans and Felines." *Society and Animals* 5:65–81.

Allan, Graham. 1989. *Friendship: A Sociological Perspective.* Boulder, CO: Westview Press.

Allen, Karen. 2003. "Are Pets a Healthy Pleasure? The Influence of Pets on Blood Pressure." *Current Directions in Psychological Science* 12:236–39.

All Hands, ed. n.d. *U.S.S. Seattle: During the War.* Brooklyn, NY: Brooklyn Daily Eagle.

American Pet Products Association (APPA). 2009–10. *APPA National Pet Owners Survey, 2009–2010.* Greenwich, CT: APPA.

———. 2011–12. *APPA National Pet Owners Survey, 2011–2012.* Greenwich, CT: APPA.

American Veterinary Medical Association. 2007. *U.S. Pet Ownership and Demographics Sourcebook.* Schaumberg, IL: American Veterinary Medical Association.

Anderson, Peter, Laura Guerrero, and Susanne Jones. 2006. "Nonverbal Behavior in Intimate Interactions and Intimate Relationships." In *The SAGE Handbook of Nonverbal Communication*, edited by Valerie Manusov and Miles Patterson, 259–77. Thousand Oaks, CA: Sage.

Arluke, Arnold. 1989."Living with Contradictions." *Anthrozoos* 3:90–99.

Arluke, Arnold, and Robert Bogdan. 2010. *Beauty and the Beast: Human–Animal Relations as Revealed in Real Photo Postcards, 1905–1935.* Syracuse, NY: Syracuse Univ. Press.

Arluke, Arnold, and Celeste Killeen. 2009. *Inside Animal Hoarding: The Case of Barbara Erickson and Her 552 Dogs.* West Lafayette, IN: Purdue Univ. Press.

Arluke, Arnold, and Clinton Sanders. 1996. *Regarding Animals.* Philadelphia: Temple Univ. Press.

Aubert, Didier. 2009. "The Doorstep Portrait: Intrusion and Performance in Mainstream American Documentary Photography." *Visual Studies* 24:3–18.

Baker, Steve. 1993. *Picturing the Beast: Animals, Identity, and Representation.* Manchester, UK: Manchester Univ. Press.

Bateson, Gregory, and Margaret Mead. 1942. *Balinese Character: A Photographic Analysis.* New York: New York Academy of Science.

Baxter, Leslie. 1987. "Symbols of Relationship Identity in Relationship Cultures." *Journal of Personal and Social Relationships* 4:261–80.

Beck, Alan, and Aaron Katcher. 1996. *Between Pets and People.* West Lafayette, IN: Purdue Univ. Press.

Beck, Lisa, and Elizabeth Medresh. 2008. "Romantic Partners and Four-Legged Friends: An Extension of Attachment Theory to Relationships with Pets." *Anthrozoos* 21:43–56.

Becker, Howard. 1995. "Backup of Visual Sociology, Documentary Photography, and Photojournalism: It's (Almost) All a Matter of Context." *Visual Sociology* 10:5–14.

Belk, Russell. 1996. "Metaphoric Relationships with Pets." *Society and Animals* 4:121–44.

Benson, Thomas. 1983. "The Clouded Mirror: Animal Stereotypes and Human Cruelty." In *Ethics and Animals*, edited by Harlan Miller and William Williams, 79–90. Clifton, NJ: Humana Press.

Berger, John. 1980. *About Looking*. New York: Pantheon Books.

Berger, Lynn. 2011. "Snapshots, or: Visual Culture's Clichés." *Photographies* 4:175–200.

Bogdan, Robert. 1999. *Exposing the Wilderness: Early-Twentieth-Century Adirondack Postcard Photographers*. Syracuse, NY: Syracuse Univ. Press.

———. 2003. *Adirondack Vernacular: The Photography of Henry M. Beach*. Syracuse, NY: Syracuse Univ. Press.

———. 2012. *Picturing Disability: Beggar, Freak, Citizen, and Other Photographic Rhetoric*. Syracuse, NY: Syracuse Univ. Press.

Bogdan, Robert, and Todd Weseloh. 2006. *Real Photo Postcard Guide: The People's Photography*. Syracuse, NY: Syracuse Univ. Press.

Booraem, Hendrick. 1995. *The Provincial: Calvin Coolidge and His World, 1885–1895*. Lewisburg, PA: Bucknell Univ. Press.

Bowlby, Sophie, Susan Gregory, and Linda McKie. 1997. "'Doing Home': Patriarchy, Caring, and Space." *Women's Studies International Forum* 20:343–50.

Brandes, Stanley. 2009. "The Meaning of American Pet Cemetery Gravestones." *Ethnology* 48:99–118.

Bridge, Kennan, and Leslie Baxter. 1992. "Blended Relationships: Friends as Work Associates." *Western Journal of Communication* 56:200–225.

Brower, Matthew. 2005. "Trophy Shots: Early North American Photographs of Nonhuman Animals and the Display of Masculine Prowess." *Society and Animals* 13:13–32.

Brown, Norman O. 1985. *Life Against Death*. Hanover: Wesleyan Univ. Press.

Buckley, Liam. 2006. "Studio Photography and the Aesthetics of Citizenship in the Gambia, West Africa." In *Sensible Objects: Colonialism, Museums, and Material Culture*, edited by Elizabeth Edwards, Chris Gosden, and Ruth Phillips, 61–85. New York: Berg.

Bulcroft, Kris, George Helling, and Alexa Albert. 1986. "Pets as Intimate Others." Paper presented at the Midwest Sociological Society meeting, Des Moines, Iowa, Mar. 28.

Burghardt, Gordon, and Harold Herzog. 1980. "Beyond Conspecifics: Is Brer Rabbit Our Brother?" *BioScience* 30:763–68.

Burgoon, Judee K., Deborah A. Coker, and Ray A. Coker. 1986. "Communicative Effects of Gaze Behavior: A Test of Two Contrasting Explanations." *Human Communication Research* 12:495–524.

Cadby, Carine, 1908. "Some Popular Branches of Cat Photography." *The Amateur Photographer* 47 (Mar. 31): 308–10.

Carmack, Betty. 1985. "The Effects on Family Members and Functioning after the Death of a Pet." *Marriage & Family Review* 8:149–61.

Casselman-Dickson, Marsha A., and Mary Lynn Damhorst. 1993. "Use of Symbols for Defining a Role: Do Clothes Make the Athlete?" *Sociology of Sport Journal* 10:413–31.

Chalfen, Richard. 1998. "Interpreting Family Photography as Pictorial Communication." In *Image-Based Research: A Sourcebook for Qualitative Researchers*, edited by Jon Prosser, 190–208. Thousand Oaks, CA: Sage.

———. 2003. "Celebrating Life after Death: The Appearance of Snapshots in Japanese Pet Gravesites." *Visual Studies* 18:144–56.

Clandinin, Jean, and F. Michael Connelly. 2000. *Narrative Inquiry: Experience and Story in Qualitative Research*. New York: Wiley.

Cohen, Susan. 2002. "Can Pets Function as Family Members?" *Western Journal of Nursing Research* 24:621–38.

Collett, Jessica. 2005. "What Kind of Mother Am I? Impression Management and the Social Construction of Motherhood." *Symbolic Interaction* 28:327–47.

Collett, Jessica, and Ellen Childs. 2009. "Meaningful Performances: Considering the Contributions of the Dramaturgical Approach to Studying Family." *Sociology Compass* 3–4:689–706.

Cronin, Orla. 1998. "Psychology and Photographic Theory." In *Image-Based Research: A Sourcebook for Qualitative Researchers*, edited by Jon Prosser, 61–73. Thousand Oaks, CA: Sage.

Darnton, Robert. 1984. *The Great Cat Massacre: And Other Episodes in French Cultural History*. New York: Basic Books.

DeVault, Marjorie. 1991. *Feeding the Family: The Social Organization of Caring as Gendered Work.* Chicago: Univ. of Chicago Press.

————. 2000. "Producing Family Time: Practices of Leisure Activity beyond the Home." *Qualitative Sociology* 23:485–503

Dubin, Steven. 1990. "Visual Onomatopoeia." *Symbolic Interaction* 13:185–216.

Eauclaire, Sally. 1996. *The Cat in Photography.* San Francisco: Chronicle Books.

Eddy, Timothy, Gordon Gallup Jr., and Daniel Povinelli. 1993. "Attribution of Cognitive States to Animals: Anthropomorphism in Comparative Perspective." *Journal of Social Issues* 49:121–32.

Ekman, Paul, Wallace V. Friesen, and Phoebe Ellsworth. 1972. *Emotion in the Human Face: Guidelines for Research and an Integration of Findings.* New York: Pergamon Press.

Elias, Norbert. 1998. "Informalization and the Civilizing Process." In *The Norbert Elias Reader*, edited by Johan Goudsblom and Stephen Mennel, 235–45. Oxford: Blackwell.

————. 2000. *The Civilizing Process: Sociogenetic and Psychogenetic Investigations.* Boston: Blackwell.

Epley, Nicholas, Adam Waytz, and John Cacioppo. 2007. "On Seeing Human: A Three-Factor Theory of Anthropomorphism." *Psychological Review* 114:864–86.

Farber, Jules. 2005. *Classic Cats by Great Photographers.* Paris: Flammarion.

Fernandez, Karen, and John Lastovicka. 2011. "Making Magic: Fetishes in Contemporary Consumption." *Journal of Consumer Research* 38:1–22.

Gillespie, Angus, and Jay Mechling, eds. 1987. *American Wildlife in Symbol and Story.* Knoxville: Univ. of Tennessee Press.

Goffman, Erving. 1959. *The Presentation of Self in Everyday Life.* New York: Doubleday.

————. 1961. *Encounters: Studies in the Sociology of Interactions.* Indianapolis, IN: Bobbs-Merrill.

————. 1963a. *Behavior in Public Places: Notes on the Social Organization of Gatherings.* New York: Free Press.

————. 1963b. *Stigma: Notes on the Management of Spoiled Identity.* Englewood Cliffs, NJ: Prentice Hall.

————. 1967. *Interaction Rituals.* Garden City, NY: Anchor Books.

————. 1971. *Relations in Public.* New York: Basic Books.

————. 1974. *Frame Analysis: An Essay on the Organization of Experience.* New York: Harper & Row.

————. 1976. *Gender Advertisements.* New York: Harper & Row.

Gould, Stephen Jay. 1980. *Panda's Thumb.* New York: Norton.

Grady, John. 2006. "Visual Sociology." In *21st Century Sociology: A Reference Handbook*, edited by Clifton D. Bryant and Dennis L. Peck, 63–70. Thousand Oaks, CA: Sage.

Green, Harvey. 1983. *Light of the Home: An Intimate View of the Lives of Women in Victorian America.* New York: Pantheon Books.

Greenebaum, Jessica. 2004. "It's a Dog's Life: Elevating Status from Pet to 'Fur Baby' at Yappy Hour." *Society and Animals* 12:117–35.

Grier, Katherine. 2006. *Pets in America: A History.* Chapel Hill: Univ. of North Caroline Press.

Guerrero, Laura, and Kory Floyd. 2006. *Nonverbal Communication in Close Relationships.* Mahwah, NJ: Lawrence Erlbaum Associates.

Haladyn, Julian. 2006. "Baudrillard's Photography: A Hyperreal Disappearance into the Object?" *International Journal of Baudrillard Studies* 3, no. 2. Available at http://www.ubishops.ca/baudrillard studies/vol3_2/haladynpf.htm.

Hall, Libby, and Tom Phillips. 2005. *Postcard Cats.* London: Bloomsbury.

Harper, Douglas. 1988. "Visual Sociology: Expanding Sociological Vision." *American Sociologist* 19:54–70.

Harris Interactive. 2007. "Pets Are 'Members of the Family' and Two-Thirds of Pet Owners Buy Their Pets Holiday Presents." *Harris Poll*, Dec. 4. Available at http://www.harrisinteractive.com/NewsRoom /HarrisPolls/tabid/447/ctl/ReadCustom%20Default /mid/1508/ArticleId/814/Default.aspx.

————. 2012. "Pets Aren't Just Animals; They Are Members of the Family." *Harris Poll*, Sept. 13. Available at http://www.harrisinteractive.com/vault/Harris% 20Poll%2054%20-%20Pet%20Ownership_9%20 13%2012.pdf.

Hayward, Bill. 1978. *Cat People*. Garden City, NY: Doubleday.

Hearne, Vickie. 1987. *Adam's Task*. New York: Knopf.

Henley, Nancy. 1977. *Body Politics: Power, Sex, and Nonverbal Communication*. Englewood Cliffs, NJ: Prentice-Hall.

Hermanowicz, Joseph, and Harriet Morgan. 1999. "Ritualizing the Routine: Collective Identity Affirmation." *Sociological Forum* 14:197–214.

Herzog, Harold. 2007. "Gender Differences in Human–Animal Interactions: A Review." *Anthrozoos* 20:7–21.

———. 2010. *Some We Like, Some We Hate, Some We Eat*. New York: HarperCollins.

———. 2011. "The Impact of Pets on Human Health and Psychological Well-Being: Fact, Fiction, or Hypothesis?" *Current Directions in Psychological Science* 20:236–39.

Hirsch, Marianne. 1997. *Family Frames: Photography, Narrative, and Postmemory*. Cambridge, MA: Harvard Univ. Press.

———. 1999. *The Familial Gaze*. Hanover, NH: Univ. Press of New England.

Hislop, Jenny. 2007. "A Bed of Roses or a Bed of Thorns? Negotiating the Couple Relationship Through Sleep." *Sociological Research Online* 12, no. 5. At http://www.socresonline.org.uk/12/5/2.html.

Holbrook, Morris, Debra Stephens, Ellen Day, Sarah Holbrook, and Gregor Strazar. 2001. "A Collective Stereographic Photo Essay on Key Aspects of Animal Companionship: The Truth about Dogs and Cats." *Academy of Marketing Science Review* 10, no. 1. At http://www.amsreview.org/articles/holrook 01-2001.pdf.

Irvine, Leslie. 2004. *If You Tame Me: Understanding Our Connection to Animals*. Philadelphia: Temple Univ. Press.

Jensen, Joan. 2001. "'I'd Rather Be Dancing': Wisconsin Women Moving On." *Frontiers: A Journal of Women Studies* 22:1–20.

Katcher, Aaron, and Alan Beck. 1983. "Safety and Intimacy: Physiological and Behavioral Responses to Interaction with Companion Animals." Paper presented at the International Symposium on the Occasion of the 80th Birthday of Konrad Lorenz, Vienna, Oct. 27.

———. 1987. "Health and Caring for Living Things." *Anthrozoos* 1:175–83.

Kennedy, Patricia, and Mary McGarvey. 2008. "Animal Companion Depictions in Women's Magazine Advertisements." *Journal of Business Research* 61:323–30.

Kestner, Joseph. 1995. *Masculinities in Victorian Painting*. Burlington, VT: Ashgate.

Konecki, Krzysztof Tomasz. 2008. "Touching and Gesture Exchange as an Element of Emotional Bond Construction: Application of Visual Sociology in the Research on Interaction between Humans and Animals." *Forum Qualitative Sozialforschung/Forum: Qualitative Social Research* 9, no. 3. At http://nbn-resolving:de/urn:nbn:de:0114-fqs0803337.

Kraut, Robert. 1979. "Social and Emotional Messages of Smiling: An Ethnological Approach." *Journal of Personality and Social Psychology* 37:1539–53.

Larsen, Jonas. 2005. "Families Seen Sightseeing: Performativity of Tourist Photography." *Space and Culture* 8:416–34.

Lawrence, Elizabeth. 1986. "Neoteny in American Perceptions of Animals." *Journal of Psychoanalytic Anthropology* 9:41–54.

———. 2003. "Feline Fortunes: Contrasting Perceptions of Cats." *Journal of Popular Culture* 36:623–35.

Lerner, Jennifer, and Linda Kalof. 1999. "The Animal Text: Message and Meaning in Television Advertisements." *Sociological Quarterly* 40:565–86.

Lewis, Charles. 1997. "Hegemony in the Ideal: Wedding Photography, Consumerism, and Patriarchy." *Women Studies in Communication* 20:167–87.

Lewis, Val. 2002. *Ships' Cats in War and Peace*. Shepperton, UK: Nauticalia.

Lorvic, Michelle. 2003. *Women and Cats: A History of a Love Affair*. Chicago: Chicago Review Press.

Lynch, Michael. 2006. "Foreword." In *Playing with My Dog Katie: An Ethnomethodological Study of Dog–Human Interaction*, by David Goode, xiii–xv. West Lafayette, IN: Purdue Univ. Press.

Manning, Elizabeth. 1997. "Kissing and Cuddling: The Reciprocity of Romantic and Sexual Activity." In *Language and Desire: Encoding Sex, Romance, and Intimacy*, edited by Keith Harvey and Celia Shalom, 43–59. London: Routledge.

Marcuse, Herbert. 1964. *One-Dimensional Man*. Boston: Beacon Press.

Margolies, Liz. 1999. "The Long Good-Bye: Women, Companion Animals, and Maternal Loss." *Clinical Social Work Journal* 27:289–304.

Margolis, Eric. 1988. "Mining Photographs: Unearthing the Meanings of Historical Photos." *Radical History Review* 40:32–48.

Marshall, Mac. 1994. "Engaging History: Historical Ethnography and Ethnology." *American Anthropologist* 96:972–74.

McMorris, Megan. 2007. *Cat Women: Female Writers and Their Feline Friends.* Berkeley, CA: Seal Press.

McShane, Clay, and Joel Tarr. 2007. *The Horse in the City: Living Machines in the Nineteenth Century.* Baltimore: Johns Hopkins Univ. Press.

Mechling, Jay. 2004. "Picturing Hunting." *Western Folklore* 63 (Winter–Spring): 51–78.

Melson, Gail. 2005. *Where the Wild Things Are: Animals in the Lives of Children.* Cambridge, MA: Harvard Univ. Press.

Mendelson, Andrew. 2007. "On the Function of the United States Paparazzi: Mosquito Swarm or Watchdogs of Celebrity Image Control and Power." *Visual Studies* 22:169–83.

Mennell, Stephen. 1999. *Norbert Elias: An Introduction.* Dublin: Univ. College Press.

Mitchell, Robert, and Alan Ellis. 2013. "Cat Person, Dog Person, Gay, or Heterosexual: The Effect of Labels on a Man's Perceived Masculinity, Femininity, and Likability." *Society and Animals* 21:1–16.

Morey, Ann-Janine. 2012. "Romancing the Dog: American Vernacular Photography, 1860–1950." Unpublished manuscript.

Morris, Desmond. 1971. *Intimate Behavior.* New York: Random House.

———. 1977. *Manwatching: A Field Guide to Human Behaviour.* Hertsfordshire, UK: Triad/Panther Books.

Morton, Christopher, and Elizabeth Edwards, eds. 2009. *Photography, Anthropology, and History: Expanding the Frame.* Burlington, VT: Ashgate.

Murphy, Bren. 1994. "Greeting Cards & Gender Messages." *Women and Language* 17:25–29.

New York Times. 1883. "A Strange Companionship." Oct. 16.

———. 1909. "Her Cat Wears Jewels." Sept. 3.

———. 1917. "Your Pet Cat May Have to Have a License Soon." Mar. 11.

Olson, Roberta, and Kathleen Husler. 2003. "Petropolis: A Social History of Urban Animal Companions." *Visual Studies* 18:133–43.

Palmer, Daniel. 2010. "Emotional Archives: Online Photo Sharing and the Cultivation of the Self." *Photographies* 3:155–71.

Patronek, Gary. 1999. "Hoarding of Animals: An Under-recognized Public Health Problem in a Difficult-to-Study Population." *Public Health Reports* 114:81–87.

Perrine, Rose, and Hannah Osbourne. 1998. "Personality Characteristics of Dog and Cat Persons." *Anthrozoos* 11:33–40.

Peters, Marsha, and Barnard Mergen. 1977. "'Doing the Rest': The Use of Photographs in American Studies." *American Quarterly* 29:280–303.

Phillips, Mary. 1994. "Proper Names and the Social Construction of Biography: The Negative Case of Laboratory Animals." *Qualitative Sociology* 17:119–42.

Phineas, Charles. 1974. "Household Pets and Urban Alienation." *Journal of Social History* 7:338–43.

Photo Era. 1898. "Art Photography in Animal Life." 2 (May): 20–22.

Pickering, Ernest. 1951. *The Homes of America.* New York: Crowell.

Pitt-Rivers, Julian. 1973. "The Kith and the Kin." In *The Character of Friendship*, edited by Jack Goody, 88–105. Cambridge: Cambridge Univ. Press.

Power, Emma. 2008. "Furry Families: Making a Human–Dog Family through Home." *Social & Cultural Geography* 9:535–55.

Prato-Previde, Emanuela, Gaia Fallani, and Paola Valsecchi. 2006. "Gender Differences in Owners Interacting with Pet Dogs: An Observational Study." *Ethology* 112:64–73.

Prosser, Jon, and Dona Schwartz. 1998. "Photographs within the Sociological Research Process." In *Image-Based Research: A Sourcebook for Qualitative Researchers*, edited by Jon Prosser, 115–30. Thousand Oaks, CA: Sage.

Ragan, Janet. 1982. "Gender Displays in Portrait Photographs." *Sex Roles* 8:33–43.

Ramanathan, Vaidehi. 2007. "Photos as Narratives, Photos with Narratives: Alternate Textualities, Minority Histories, and Indian Historiography." *Journal of Contemporary Thought* 26:39–56.

Ramirez, Michael. 2006. "'My Dog's Just Like Me': Dog Ownership as a Gender Display." *Symbolic Interaction* 29:373–91.

Ranck, Edwin Carty. 1915. "A Famous Photographer of Cats." *The American Magazine* 79 (Apr.): 56–60.

Ritvo, Harriet. 1989. *The Animal Estate: The English and Other Creatures in the Victorian Age.* Cambridge, MA: Harvard Univ. Press.

Rogers, Katharine. 2006. *Cats.* London: Reaktion Books.

Rose, Gillian. 2010. *Doing Family Photography: The Domestic, the Public, and the Politics of Sentiment.* Burlington, VT: Ashgate.

Ruby, Jay. 1983. "Images of the Family: The Symbolic Implications of Animal Photography." In *New Perspectives on Our Lives with Companion Animals,* edited by Aaron Honori Katcher and Alan M. Beck, 138–47. Philadelphia: Univ. of Pennsylvania Press.

Sanders, Clinton. 1990. "The Animal 'Other': Self Definition, Social Identity, and Companion Animals." In *Advances in Consumer Research,* edited by Gerald Gom, Richard Pollay, and Marvin Goldberg, 17:662–68. Provo, UT: Association for Consumer Research.

———. 1993. "Understanding Dogs: Caretakers' Attributions of Mindedness in Canine–Human Relationships." *Journal of Contemporary Ethnography* 22:205–26.

———. 1999. *Understanding Dogs: Living and Working with Canine Companions.* Philadelphia: Temple Univ. Press.

———. 2003. "Actions Speak Louder than Words: Close Relationships between Humans and Nonhuman Animals." *Symbolic Interaction* 26:405–26.

Saure, Jean Claude. 2004. *The Big Book of Cats.* New York: Welcome Books.

Scheff, Thomas. 2007. "Creating an Onion: Alternatives to Biopsychiatry." *Ethical Human Psychology and Psychiatry* 9:180–92.

Scherer, Joanna. 1990. "Historical Photographs as Anthropological Documents: A Retrospect." *Visual Anthropology* 3:131–55.

Schulte-Peevers, Andrea, Tom Downs, Ryan ver Berkmoes, Sara Benson, and John Viahides. 2006. *California.* Oakland, CA: Lonely Planet.

Schwalbe, Michael. 2009. "Framing the Self." *Symbolic Interaction* 32:177–83.

Schwarzenbach, Sibyl. 1996. "On Civic Friendship." *Ethics* 107:97–128.

Serpell, James. 1988. "The Domestication and History of the Cat." In *The Domestic Cat: The Biology of Its Behavior,* edited by Dennis C. Turner and Patrick Bateson, 151–58. New York: Cambridge Univ. Press.

———. 2005. "Anthropomorphism and the Human–Pet Relationship." In *Thinking with Animals: New Perspectives on Anthropomorphism,* edited by Lorraine Daston and Gregg Mitman, 121–36. New York: Columbia Univ. Press.

Shaw, Gwendolyn. 2006. *Portraits of a People: Picturing African Americans in the Nineteenth Century.* Seattle: Univ. of Washington Press.

Shell, Marc. 1986. "The Family Pet." *Representations* 15:121–53.

Shore, Elsie, Deanna Douglas, and Michelle Riley. 2005. "What's in It for the Companion Animal? Pet Attachment and College Students' Behaviors toward Pets." *Journal of Applied Animal Welfare Science* 8:1–11.

Simon, Clea. 2003. *The Feline Mystique: On the Mysterious Connection of Women and Cats.* New York: St. Martin's Griffin.

Simpson, Barbara, and Brigid Carroll. 2008. "Reviewing 'Role' in Processes of Identity Construction." *Organization* 15:29–50.

Spector-Mersel, Gabriela. 2006. "Never-aging Stories: Western Hegemonic Masculinity Scripts." *Journal of Gender Studies* 15:67–82.

Spencer, Sharon. 1981. "The Lady of the Beasts: Eros and Transformation in Colette." *Women's Studies* 8:299–312.

Spiegel, Marjorie. 1997. *The Dreaded Comparison: Human and Animal Slavery.* New York: Mirror Books.

Streeck, Jurgen. 2009. *Gesturecraft: The Manu-facture of Meaning.* Amsterdam: John Benjamins.

Tannen, Deborah. 2004. "Talking the Dog: Framing Pets as Interactional Resources in Family Discourse." *Research on Language & Social Interaction* 37:399–420.

Taylor, Louise, and Barbara Cohen. 1992. *Cats and Their Women.* New York: Little, Brown.

Tenner, Edward. 1998. "Citizen Canine." *Wilson Quarterly* 22, no. 3: 71–79.

Titus, Sandra. 1976. "Family Photographs and Transition to Parenthood." *Journal of Marriage and Family* 38:525–30.

Trachtenberg, Alan. 2000. "Lincoln's Smile: Ambiguities of the Face in Photography." *Social Research* 67:1–23.

Turner, Dennis, Gerulf Rieger, and Lorenz Gygax. 2003. "Spouses and Cats and Their Effects on Human Mood." *Anthrozoos* 16:213–28.

Twenge, Jean. 1997. "Changes in Masculine and Feminine Traits over Time: A Meta-analysis." *Sex Roles* 36:305–26.

Wallendorf, Melanie, Russell Belk, and Deborah Heisley. 1988. "Deep Meaning in Possessions: The Paper." In *Advances in Consumer Research*, edited by Michael Houston, 15:528–30. Provo, UT: Association for Consumer Research.

West, Candice, and Don Zimmerman. 1987. "Doing Gender." *Gender and Society* 1:125–51.

Wexler, Laura. 1997. "Seeing Sentiment: Photography, Race, and the Innocent Eye." In *Female Subjects in Black and White: Race, Psychoanalysis, Feminism*, edited by Elizabeth Abel, Barbara Christian, and Helene Moglen, 159–86. Berkeley: Univ. of California Press.

Williams, E. A. 2008. "Gags, Funnels, and Tubes: Forced Feeding of the Insane and of Suffragettes." *Endeavour* 32:134–40.

Willis, Deborah. 1996. *Picturing Us: African American Identity in Photography*. New York: New Press.

Willis, Deborah, and Carla Williams. 2000. "The Black Female Body in Photographs from World's Fairs and Expositions." *exposure* 33, nos. 1–2: 11–20.

Wilson, E. O. 1984. *Biophilia*. Cambridge, MA: Harvard Univ. Press.

Wondergem, Taylor, and Mihaela Friedlmeier. 2012. "Gender and Ethnic Differences in Smiling: A Yearbook Photographs Analysis from Kindergarten through 12th Grade." *Sex Roles* 67:403–11.

Wood, Lisa, Billie Giles-Corti, and Max Bulsara. 2005. "The Pet Connection: Pets as a Conduit for Social Capital." *Social Science and Medicine* 61:1159–73.

Zuromskis, Catherine. 2006. "Intimate Exposures: The Private and Public Lives of Snapshot Photography." PhD diss., Univ. of Rochester.

Index